THE THAMES AND HUDSON MANUALS
GENERAL EDITOR: W. S. TAYLOR

Woodcut Printmaking

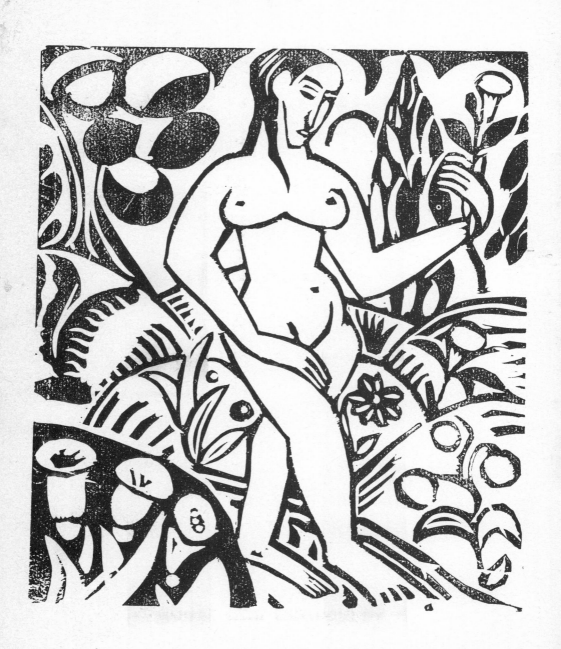

Walter Chamberlain

The Thames and Hudson
Manual of Woodcut
Printmaking
and related techniques

with 128 illustrations, in colour and black and white

Thames and Hudson T&H

Frontispiece: André Derain (1880–1954), plate from *L'enchanteur pourrissant* by Guillaume Apollinaire, 1909. 10½ × 8 (26.6 × 20.3).

© 1978 Thames and Hudson Ltd, London

Printed in Great Britain by
Cox & Wyman Ltd,
London, Fakenham and Reading

Contents

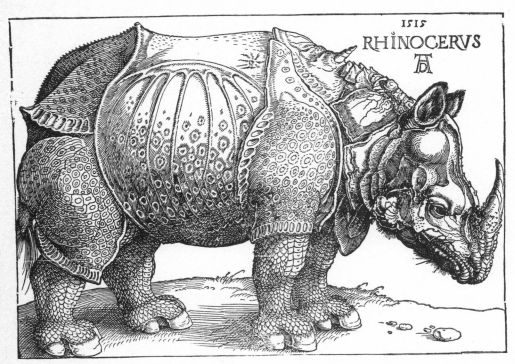

Albrecht Dürer (1471–1528),
The Rhinoceros, 1515. 8⅜ × 11¾
(21.2 × 29.9).

Acknowledgments

I am indebted to Trevor Allen, Jonathan Kaufman, Joan Lock, Ian Mortimer and Philip Sutton for allowing me to reproduce their prints. I only wish it had been possible to include even more.

I am also grateful to a number of galleries for their generosity in providing photographs of original prints, as well as giving useful information on individual artists and printmaking generally: these include Colnaghi & Co. Ltd, Lumley Cazalet Ltd, Fischer Fine Art Ltd, and Islington Graphics Ltd, all in London; Bradford City Art Gallery (International Print Biennale); and the André Emmerich Gallery Inc., New York.

My thanks are also due to my colleagues – both staff and students – at the Hull College of Higher Education, especially to Hamish Crowe for supplying information and advice on a wide range of technical matters – any omissions or over-simplifications are entirely my responsibility; to Alan Ackroyd and Andrew Payne for the photographs; to the faculty librarian, Graham Bullock, and his staff for their invaluable assistance; to Sylvia Nicholson and John Senior for their expertise in the print workshop; and to my wife for the line drawings.

Acknowledgments are due to the following for permission to reproduce the illustrations on the pages shown:

British Library, London 30, 32; British Museum, London 17, 18 (above), 22 (below), 24, 29, 36 (above), 53, 54 (below); Colnaghi & Co. Ltd, London 59; André Emmerich Gallery Inc., New York (photo Anne Freedman) 135 (above); Fischer Fine Art Ltd, London 52 (above), 66; John Hunnex (photo) 135 (below); Lumley Cazalet Ltd, London 107; Munch-Museet, Oslo 51, 118 (below); Museum of Modern Art, New York, Gift of Felix and Helen Juda Foundation 58, Purchase Fund 117, Gift of Victor S. Riesenfeld 56, Louis E. Stern Collection *frontispiece*, 54 (above), Gift of Mrs Donald B. Strauss 36 (below); National Gallery of Art, Washington D.C., Rosenwald Collection 49; Philadelphia Museum of Art, Estate of Carl Zigrosser 55; Rijksmuseum, Amsterdam 26 (above); Victoria & Albert Museum, London (Crown Copyright) 6, 10, 18 (below), 19, 20, 21, 22 (above), 23, 25, 27, 28, 31, 35, 38, 43, 44, 46, 52 (below), 71.

Introduction

I had originally intended, for practical and economic reasons, to include both woodcut and wood engraving in a single book. There were certain advantages in this: for instance, it would have enabled me, in the section on history and development, to place the technique of white-line wood engraving firmly where it belongs, in the older, wider and more varied context of woodcut printmaking; it would also have been easier, in the technical sections, to make useful comparisons between the two techniques which, in spite of having basic similarities, demand different approaches. Woodcuts and wood engravings are, for the most part, made as relief prints; consequently, most of the equipment and materials needed for printing apply equally to both techniques. On reflection, however, the fact that the two techniques have developed so very differently made separation more feasible, for by emphasizing the differences rather than the similarities it becomes easier to convey something of the unique qualities of each.

In this book I have concentrated almost solely on woodcut – the oldest and in many ways the simplest of the autographic processes – and especially on the most direct ways of cutting a design or image manually into a woodblock with a knife or gouge and printing from the inked relief surface. In addition, certain other more or less traditional relief printing methods have been included, mostly those that provide alternative surfaces to plankwood, for example lino cutting and printing from existing or adapted surfaces. The photographic processes and more sophisticated techniques such as vacuum-formed surfaces are not dealt with, chiefly because I am primarily concerned with the independent printmaker who may have limited means and resources. In any case, it seems to me that one of the advantages of woodcut over etching, lithography and screen printing is the virtual absence of photographic images. This is not, therefore, an attempt to introduce new materials or to pioneer a new approach to relief printmaking: without exception, the methods and materials described here are well proven, and some have been in use for centuries. Several excellent books dealing with recent developments in the wider area of experimental relief printmaking are available, notably those by Michael Rothenstein: printmakers more inclined towards experimentation would be well advised to read them (see further reading list).

The section on the history and development of the woodcut may appear rather long in what is first and foremost a practical manual, but in recent years I have found that younger students

who have become interested in making prints also want to know far more about the history of the subject. I hope, therefore, that the historical section – which can be no more than a general intro-duction, and a highly subjective one at that – will at least provide some background information. For those who wish to make a more thorough study of the subject, guidance will be found in the further reading list.

In writing the more technical parts of this book, I have tried to include the most practical and straightforward methods and the most suitable, cheap (the latter not always compatible with the former!) and generally available materials and tools. Many more expensive materials exist, and more complex methods can be developed from the relatively simple ones described here, if and when the need arises; but I see little purpose in devising complex methods for their own sake, or even for aesthetic effect, believing that the emphasis should always be on the quality and content of the final printed state and not on technical ingenuity or the process – a current preoccupation – by which the printing surface is made and the printed impression obtained. In other words, the 'craft' part of block cutting and surface printing is a means to an end, not an end in itself.

Finally, I hope that the reader – the printmaker – will make use of this information and then go on to develop his or her own technique; for there is, of course, no orthodox method, no single 'correct' approach to making a print. I have given little, if any, guidance on subject-matter and on the problems of design and composition: I leave such things to the individual printmaker.

For further advice, technical information or simply encourage-ment, the independent printmaker should approach those societies that exist primarily to encourage and maintain an interest in the subject of creative printmaking. In England, the oldest of these is the Royal Society of Painter–Etchers and Engravers (formed in 1880), which holds annual exhibitions at its London gallery (26 Conduit Street, London, W.1). There is also the Society of Wood Engravers, founded by Eric Gill, which admits relief prints. The most recently formed body is the Printmakers' Council (founded 1964) at 31 Clerkenwell Close, London, E.C.1. The latter pub-lishes a newsletter giving up-to-date information to members or associate members on matters, technical or otherwise, affecting printmakers.

In America, the young printmaker faces fewer difficulties than in England, if only because all the printmaking processes are much more widely encouraged at all levels, so that more opportunities exist to practise and to exhibit work. The Pratt Graphics Center, the Print Council of America, The Society of American Graphic Artists (SAGA), the International Graphic Arts Society (IGAS) and the numerous print workshops that have been set up throughout the country ensure that the situation remains healthy.

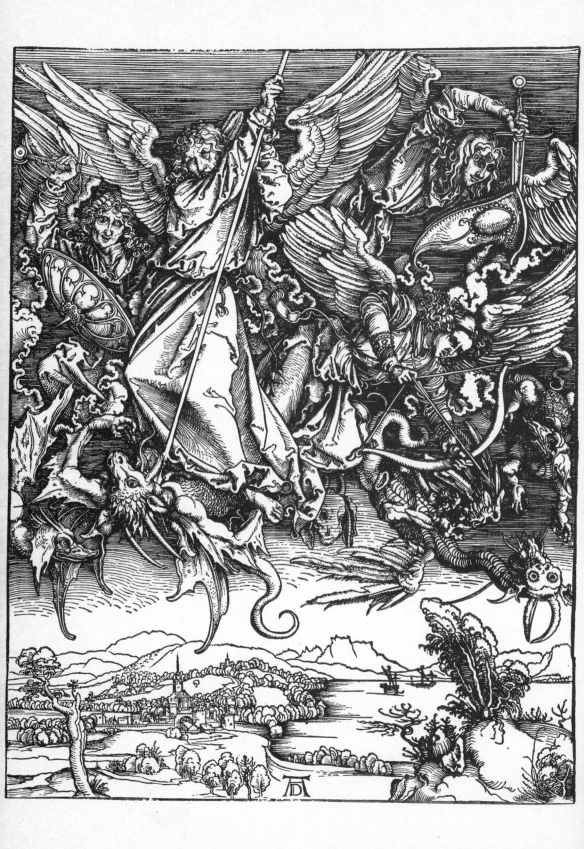

1 The history and development of relief printmaking

THE EUROPEAN WOODCUT FROM THE FIFTEENTH TO THE SEVENTEENTH CENTURY

The pictorial woodcuts of the early fifteenth century – which is almost, but not quite, where the history of European graphic art begins – came at a comparatively late stage in the development of woodblock printing. In Europe, carved woodblocks had been fairly extensively used for printing patterns on to textiles long before the first printed pictures – mainly figurative – were attempted. Most of these textile blocks would have been extremely simple in design and, more often than not, crudely cut, but on some surviving woodblocks the patterns have been skilfully drawn and carved, and a few late fourteenth-century examples also contain elements of pictorial imagery.

Records show that woodblock printing on fabrics had been practised by the Egyptians at least two thousand years before the Christian era. The oldest extant printed fabric – also Egyptian – dates from the fourth century AD. By the sixth century AD, woodblock printing had reached an advanced stage in Egypt. At the same time the craft seems to have been widely established, even commonplace, elsewhere, for example in India, Mexico, Persia, Peru – where the same techniques are still practised – and it was almost certainly employed by both the Japanese and the Chinese.

The use of carved relief surfaces, mainly as seals for stamping or impressing, had been perfected by the ancient civilizations of the Sumerians and the Babylonians.

According to the official Chinese records, paper was invented in central China in AD 105. Although a number of rudimentary printing methods were subsequently tried out, with some success, it was not until the seventh century that printing on paper, at least on a major scale, was seriously attempted. The earliest form entailed banging or stamping the inked woodblock on to a sheet of paper, but stamping was gradually replaced by another method, slower but rather more controlled and sensitive, known as rubbing. Instead of the block being forced down hard on to the paper, as in certain kinds of textile printing, the paper was placed over the inked surface of the block and rubbed or burnished until a clear, even impression was made. The modern hand-printed woodcut is made in exactly the same way.

Opposite: Dürer, 'St Michael fighting the Dragon', from *The Apocalypse*, 1498. $15\frac{1}{4} \times 11\frac{1}{8}$ (38.8 × 28.2).

The oldest surviving prints made by this rubbing method are
Buddhist charms, printed and distributed in Japan in AD 770.
These charms, however, consisted entirely of text; for the Budd-
hists, woodblock printing on paper was an ideal way to amass
copies of the scriptures from which they could recite. Pictorial
woodcuts may have appeared in the East some time before the
eighth century; the earliest examples positively dated occur in the
roll of the Diamond Sutra, an important Buddhist scripture,
printed in AD 868. The complexity of the design, the refinement
of the drawing and the overall quality of the impression suggest
that it was far from being the first of its kind.

Paper was first manufactured in Europe by the Spanish in the
twelfth century, although it had been imported since about
AD 950. Around 1276, a mill was established at Fabriano in Italy;
the town became a major centre for paper making, and through-
out the fourteenth century supplied most of Europe with fine-
quality paper – which it has continued to produce ever since. By
the fifteenth century, paper was also being manufactured in
Germany and France, and it was not long before both countries
became almost completely independent of imported material.
With the increasing availability of paper in Europe, the production
of identical printed pictures from both wood and metal was
natural and inevitable.

Line engraving on metal, which to a large extent was a develop-
ment from the goldsmith's craft of ornamenting and embellishing
armour and precious metals, did not emerge as a printmaking
technique until well into the fifteenth century. Copper, the metal
chiefly employed for engraving, cost far more than hard wood;
and the practice of engraving is generally more exacting and
usually takes longer than block cutting. More often than not, the
engraver was either a goldsmith by training or a practising painter.
He therefore designed and engraved his own plates, possibly even
printing them himself.

The carved woodblock, on the other hand, emerged not as a
work of art in itself, but essentially as a utilitarian means to an end.
The early woodblock cutters did not as a rule belong to a craft
guild, like the goldsmiths, but were usually classed with the car-
penters – an indication of their relatively humble position. This
was partly because of their connection with the textile block
cutters, their immediate predecessors, but was probably due more
to the fact that most woodblock cutters were not their own
designers. The job of the cutters was simply to imitate an original
design as closely as possible. The designer himself was usually a
practising painter, and as such had a degree of professional indepen-
dence seldom enjoyed by the craftsmen.

Records show that professional cutters and printers were active
in Germany at the very beginning of the fifteenth century; by the
end of the century, it would have been considered unusual for any
reputable painter to cut his own blocks. The job of the woodblock
cutter had by then become quite separate, and in certain cases it is
thought that an intermediate draughtsman may have been em-
ployed to re-draw an original design in order to make it more
suited to the woodblock cutter's idiom (or limitations). The vast

majority of fifteenth- and sixteenth-century woodcuts were thus the result of a division of labour, and were not 'original prints' in the modern sense, since they had not been created on the block by the artist himself. The 'facsimile' approach is not now regarded as a direct means of original expression, but the early prints were actually intended to be imitations of a drawing. On the other hand, the skill of the early woodblock cutters appears to have varied, and many prints would have been stylized versions rather than exact copies. It seems reasonable to assume, however, that most woodcuts, especially towards the end of the fifteenth century, were based on prepared line drawings made by artists who had a good working knowledge of the craft. By then most professional woodblock cutters would, of necessity, have been highly skilled craftsmen.

At first, the facsimile woodcut consisted almost entirely of black line, used in a somewhat raw, descriptive rather than decorative sense. With the black line method, the artist usually drew either directly on the block or on a sheet of paper which was then pasted on to the block. The undrawn or white areas were cut out, surplus wood being removed with knife and gouge to a depth of between 1/8 in. (3 mm) and 1/4 in. (6 mm), and the drawn image was left to stand out in relief. This relief was then coated with black ink, and the block printed by either stamping or rubbing. A small cloth pad stuffed with wool, known as a frotton, was normally used to rub the back of the print. It was not uncommon at this time for both sides of a woodblock to be used, for economy.

In the earliest prints – the so-called 'primitive' prints which corresponded roughly with the first quarter of the fifteenth century – the outlines, mainly depicting figures, tended to be broad and rather curving. Shading was seldom attempted, but backgrounds were frequently painted in black. The main outlines were deliberately simplified so that the shapes and areas defined could be more easily coloured in by hand, and black outline prints were sold more cheaply to customers willing to apply their own colours. Many surviving woodcuts of this period are coloured in this way, although the true colour print – in which the colours were applied to the block before printing, rather than added to the print by hand – came rather later. Gradually, during the second quarter of the century, the lines of the cuts became finer, with sharper angles and just a suggestion of shading. More thought also seems to have been given to the problem of how to represent background and landscape.

Woodcuts at this time were influenced to a varying degree by contemporary painting, especially by the altarpieces. With their strong black outlines and bright colours, prints made excellent wall decorations and served as cheap substitutes for paintings. Gradually, however, woodcut printmaking and the graphic processes generally were becoming more independent of painting, especially of the restraints of religious painting. Prints depicting secular subjects were beginning to appear and were eagerly sought after. Experimentation, both technical and pictorial, increased rapidly. Before long, prints were actually influencing the other visual arts, even helping to establish new styles. The production of

coloured woodcuts was, to a large extent, stimulated by the grow-
ing interest and the technical innovations in printing generally.

The obvious advantage of having printed text and visual images
together on one sheet was recognized by the monks who, well
aware of the possible threat to the Church offered by the new and
potentially independent graphic processes, saw the woodcut as a
means of disseminating knowledge and as an economic and effec-
tive way to further and strengthen the influence of the Church and
its teaching. It was not long before the monasteries began to turn
out printed pictures of devotional subjects, particularly crucifix-
ions, saints and innumerable versions of the life of Christ and of the
Virgin, all of which were sold in large numbers to pilgrims at the
shrines. Woodblock cutters are known to have entered the monas-
teries as lay brothers, for working within the monasteries often
ensured regular employment and, at the same time, allowed them
more freedom in their work than they would have had if tied to a
guild. Of course, the monasteries by no means had a monopoly on
the production and sale of woodcut prints: one of the most profit-
able areas of European printmaking, centred on Ulm and Venice,
was the production of playing cards.

Throughout the first half of the fifteenth century, an enormous
number of woodcuts with either text or pictures, or both, were
produced as single cuts on separate sheets of paper. Groups of
small prints were sometimes printed as a composite sheet from a
large woodblock and later cut into individual prints. The majority
of early prints measured no more than a few inches across –
15 in. × 12 in. (40 cm × 30 cm) is thought to have been large.
Large prints may not have been so uncommon at the time, but of
course they were less likely to survive than small works, which
were far more easily stored: many small prints have come down
to us in good condition because they were pasted inside the hard
covers of books or in caskets or travelling boxes. Although
Germany was responsible for most of this work, single cuts were
fairly widely produced also in the Netherlands, France and Italy,
and to a much lesser extent in England.

The first printed books began to appear during the second
quarter of the fifteenth century. Although the earliest examples
were made up in a number of different ways – sometimes leaving
space for decorations and illuminated capitals to be added by
miniaturists, sometimes containing handwritten text alongside
printed illustrations – most had text and pictures printed entirely
from woodblocks, hence their name of 'block-books'. Printing
was normally done on separate leaves, which were then bound
together in book form.

The content of most extant block-books is essentially biblical:
the purpose of the illustrations was functional, to make the mean-
ing of the stories as intelligible as possible to those unable or perhaps
even unwilling to labour over the difficult text. The necessity to
popularize the stories could account for the seemingly quaint and
idiosyncratic use of medieval detail, particularly in costume.

Although Germany and the Netherlands together were respons-
ible for a large proportion of all block-books published, the
Netherlands was clearly the more progressive and, therefore, the

more influential of the two. Woodcuts were to become more accomplished as works of art – they certainly became more elaborate in terms of technique – but the early single cuts and block-book illustrations are among the most direct and vigorous works in the entire history of graphic art.

The demand for the multiplication of text and picture was increasing all the time; block-books represented the transitional stage from the single-cut picture to the more technically advanced illustrated books of the late fifteenth century.

Germany

Experiments with movable-type printing were undoubtedly carried out in various parts of Europe, almost certainly in the Netherlands, but there seems little doubt that the dominant creative force behind the successful experiments in or around Mainz and Strasbourg, just before the middle of the fifteenth century, was Johann Gutenberg. Little of Gutenberg's own printing has survived; even the famous forty-two line 'Gutenberg Bible' of 1455, although planned by him, is now generally attributed to the press of Fust and Schoeffer, who were, at various times, Gutenberg's partners, his rivals and eventually his successors. Peter Schoeffer was responsible for what is possibly the first example of true colour printing, his Latin Psalter (1457), which contained decorative initial letters printed in red and light blue. The colours were registered perfectly and were evidently printed either from woodblocks or from engraved metal.

It seems probable that the very first printing presses were adapted from the then commonplace screw presses designed for crushing oil seeds or herbs or for even more domestic purposes such as pressing linen. Larger versions for pressing olives and grapes, also made of wood and known as beam presses, had already been in use for centuries, but because of their massive construction and necessarily heavy pressure they were less suitable for printing. Papermakers' presses, though somewhat more recent, also tended to be too cumbersome. Bookbinders' presses were also available, although these were less common than the domestic varieties. Most presses worked on the simple principle of direct vertical pressure, controlled by a central screw, at the lower end of which was attached a flat board or, as it later became known, a platen. Many of the earliest printing presses were evidently still in regular use well into the seventeenth century, and the basic design remained virtually unchanged until the nineteenth century, when they were largely replaced with iron presses.

Following the apparently successful completion of Gutenberg's press, other specially built printing presses began to appear. These were obviously larger than the conventional 'oil seed' or domestic screw presses: they had to be, to stand up to the wear and tear of constant use and to bring firm, even pressure to bear on the paper and blocks. In fact, it soon became normal practice to secure the press to both floor and ceiling for greater rigidity.

Because of its natural affinity with type, woodcut was practically the only method used to print pictures together with movable

type until late in the sixteenth century, when it was largely, though not always satisfactorily, replaced by line engraving. Both woodblocks and type are more or less the same height on the bed of the press, and since both are relief surfaces, and the same oil-based ink is applicable to woodblock and metal type, they can easily be printed simultaneously.

Ink was applied at that time with an 'ink ball', a leather-covered pad stuffed with hair or wool and tied round a wooden handle or stock. The ink itself resembled thick black oil paint (it was, in fact, a development from the earlier discoveries made by Flemish painters) and usually consisted of a mixture of linseed oil, boiled until free of fats, and various pigments. Varnishes were added to give the ink its correct consistency and to aid drying.

Book illustration was to be the major factor in the subsequent development of woodcut; its influence lasted until the nineteenth century. The aesthetic considerations of book design – the arrangement of text, ornamentation and pictures together on the page – demanded a particularly subtle and inventive approach to the formal problems of pictorial composition.

Each of the main printing centres in Germany made its own specific contribution to this development. The most impressive early illustrated book from Mainz is the *Sanctae Peregrinationes* of 1486, an account of a pilgrimage to the Holy Land made by Bernhard von Breydenbach. The 'official artist', Erhard Reuwich, accompanied the nobleman's entourage, and based his topographical woodcuts on drawings made directly from life, which was not normal practice for a fifteenth-century illustrator. Cologne and Lübeck are chiefly known for their splendid bibles. The Cologne Bible, printed by Heinrich Quentell in 1478–9, contained, in addition to decorative borders, over a hundred woodcut illustrations which influenced bible illustrators for many years by their clear, positive style. Printing in Nuremberg and its vicinity was completely dominated by one man, Anton Koberger, whose *Nuremberg Chronicle* of 1493 used 645 woodblocks, in some cases printed several times over, to produce as many as 1809 illustrations. The wide variety of subject-matter included portraits, genealogical charts, maps and views of towns.

A number of late fifteenth-century woodcut illustrations, especially those designed by Nuremberg artists such as Michael Wolgemut and Wilhelm Pleydenwurff, who worked on the *Chronicle*, show a much greater flexibility of draughtsmanship; the compositions are more involved, and there is an emphasis on fine, linear detail of a kind normally associated with pen drawing. During the last two to three decades of the fifteenth century, German woodcut developed from the single contour line, still to be seen in the block-book illustrations, to the infinitely more complex and powerful work of Albrecht Dürer (1471–1528). Five years after the publication of the *Nuremberg Chronicle*, Dürer's *Apocalypse* woodcuts also appeared in Nuremberg. As a creative achievement, as well as a feat of immense technical virtuosity, these fifteen large sheets surpassed all previous woodcuts, and they remain among the greatest works of Germanic art. Although several of the subjects reveal underlying compositional structures

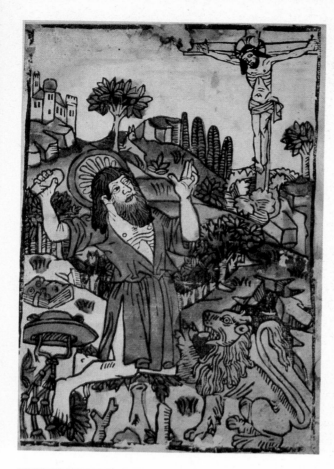

St Jerome and the lion. German hand-coloured woodcut, fifteenth century. $10\frac{3}{8} \times 7$ (26·5 × 17·8).

The Battle of Zonchio, 1499. Venetian hand-coloured woodcut taken from two blocks, c. 1500. $22\frac{1}{2} \times 32\frac{1}{2}$ (57 × 82·5).

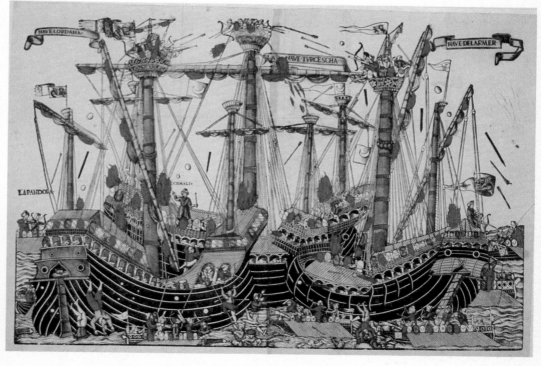

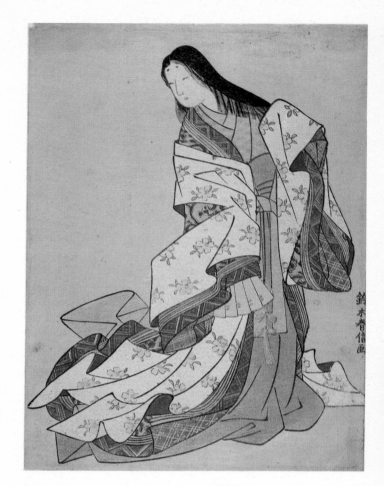

Suzuki Harunobu (1725–70).
Ono no Komachi in Court Dress,
1766–8. From ten colour
blocks, with overprinting,
10¾ × 7⅞ (27·4 × 20).

Kitagawa Utamaro (1753–1806),
'Lovers', from *The Poem of the
Pillow*, 1788. 9¾ × 14¾
(24·8 × 37·4).

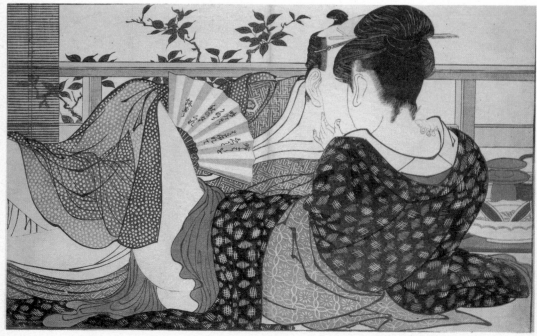

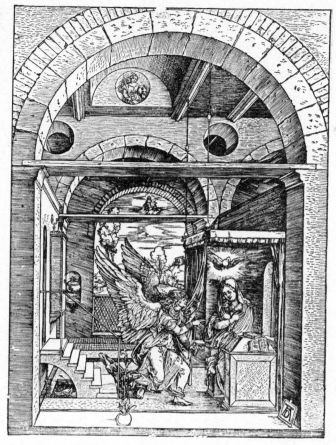

Dürer, 'The Annunciation', from *The Life of the Virgin*, 1500–1501. 11¾ × 8¼ (29.8 × 21). Note the variety of tones achieved by the use of closely laid lines, cross-hatching and dots.

clearly derived from Italian Renaissance art – trained initially in Wolgemut's Nuremberg studio, Dürer was much impressed by a visit to Italy in 1494–5 – they are intensely, almost overwhelmingly, Gothic in conception (see p. 10).

At least a year before the *Apocalypse* was published in 1498, Dürer began work on a second series of woodcuts, equally large in scale and hardly less ambitious in subject-matter. These were the first seven cuts for the *Large Passion*, and date from about 1497–1500. Eleven years were to elapse before the complete series appeared, a further four cuts and a title page being added before publication. The early cuts are not conspicuously different from those of the *Apocalypse* in drawing and style, but the theme of the *Passion* seems, in comparison, to be infinitely more subdued in mood and restrained in pictorial invention. In the later four cuts the designs seem to have been deliberately simplified. They have a distinct Italianate order and stability. Above all, there is a far greater emphasis on tonal values, built up of fine, closely laid lines and dots. Various cross-hatching techniques are employed, which create an almost undulating effect. Outlines are kept to a minimum. In these, as in most subsequent works, Dürer moves increasingly away from the late Gothic – perhaps typified by the dark

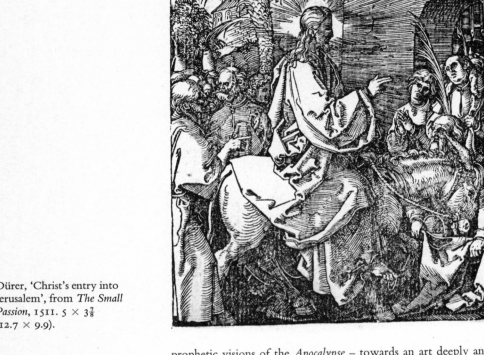

Dürer, 'Christ's entry into
Jerusalem', from *The Small
Passion*, 1511. 5 × 3⅞
(12.7 × 9.9).

prophetic visions of the *Apocalypse* – towards an art deeply and
consciously affected by the Renaissance ideals.

The third important series, *The Life of the Virgin*, though
designed a few years before the final cuts of the *Large Passion*, is
similar in style and conception, but the mood is gentler and more
refined. Lines are becoming increasingly delicate and tones more
varied and subtle.

In 1511 Dürer completed a further series, known as the *Small
Passion*, consisting of thirty-seven cuts. These are the simplest and
most economic of all the four main series. They also have less
spontaneity and movement, being solemn in mood and even
monumental in design. Dürer's mature woodcut style was, in a
sense, a fusion of late and essentially Gothic intensity and Renais-
sance order. In spite of this – or perhaps because of it – his woodcuts
were in complete contrast to contemporary Italian work of the
same period.

Each of the main series was printed and sold as separate sheets.
They were also published in book form, although in most cases
the text was minimal.

Dürer's last woodcut designs consisted of works commissioned
by or made in the service of the Emperor Maximilian, such as the
enormous and ornate *Triumphal Arch*, the *Great Triumphal Car*
and the *Rhinoceros*, completed between 1512 and 1518. These

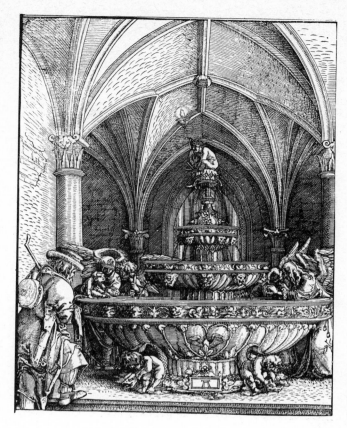

Albrecht Altdorfer (1480–1538),
*The Holy Family with three Angels
at a Font*, 1520. 9 $\frac{1}{16}$ × 7
(23 × 17.8).

were followed by various coats of arms, some 'theoretical studies' including the one on measurement, and a number of panoramic views of proposed fortifications.

To cut into a block of wood an exact facsimile of a Dürer drawing would have required long experience and considerable skill. Normally, Dürer drew directly on to the woodblock – which was usually of pearwood – thereby reducing the chance of inaccurate translation or tracing during the 'copying' stage. He took a close interest in both the cutting and the printing of his designs, and would personally have supervised much of the work. Considering the vast number of woodcuts he designed, Dürer was, on the whole, extremely well served by his cutters.

Although for practical reasons he had to entrust the actual cutting of his woodcut designs to others, as far as is known Dürer engraved all his own copper-plates. He was an unrivalled master with the burin, able to depict, with incredible accuracy and the greatest possible detail, the physical appearance of a wealth of natural forms. No doubt his increasing use of varied tonal effects in his woodcuts – achieved by fine, close linear cutting – was a result of his first-hand experience as a line engraver. Several of his middle- to late-period woodcuts have a more than superficial similarity to line engraving. This cannot be said of the *Apocalypse* series; and it can be said even less of the vast majority of fifteenth-

Dürer's influence can be seen in the fine black-line woodcuts of other leading artists of the early sixteenth century, particularly Altdorfer, Burgkmair and Baldung: all were accomplished and versatile draughtsmen who were well served by first-rate craftsmen–woodcutters.

Right: Hans Burgkmair (1473–1531), plate from *The Triumph of Emperor Maximilian I, c.* 1504. 15½ × 16½ (39.4 × 41.9).

Below: Hans Baldung (1476–1545), *The Bewitched Stable Boy*, 1544. 13⅝ × 7⅞ (34.5 × 20).

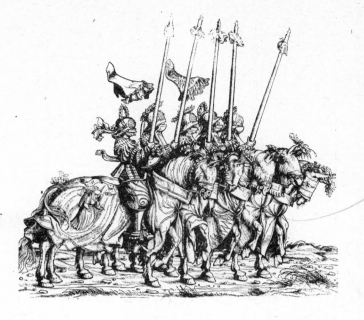

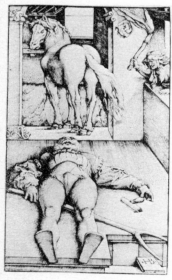

century woodcuts. It was inevitable, therefore, that one of the ways in which woodcut illustration developed after Dürer was towards an even greater use of linear shading – though of a much more systematic, even mechanical kind, than that employed by Dürer's cutters. By the late sixteenth century, it was quite common to find woodcuts that could be described, quite reasonably, as wood engravings. Dürer's woodcuts and line engravings greatly influenced German illustration, and even in his own lifetime his fame as an artist was due far more to the distribution of his prints than to his paintings, which were seen by relatively few.

• The dominant figure in sixteenth-century woodcut illustration, after Dürer, was Hans Holbein the Younger (1497/8–1543). Dürer had been less concerned with book illustration as such; Holbein, however, produced a mass of illustrative and decorative work designed specifically to accompany text. The most famous of all his woodcut illustrations are the set of forty-one cuts for the *Totentanz*, or *Dance of Death*. These may have been loosely based on the theme used by the Parisian printer Marchant in his 1485 version of *Danse Macabre*; but the idea was more probably taken from the *Dance of the Dead* mural cycles in Basle, where Holbein executed most of his woodcuts. The quality of the masterly drawings is exceptionally well translated by Holbein's cutter, Hans Lutzel, who was as much a collaborator as a craftsman. In each small cut there is a minimum of parallel shading and no cross-hatching; nor is there any display of decorative detail for its own sake. Indeed, the maximum dramatic effect is achieved by the most economic use of line. The skeletal figures, which appear in nearly every scene, are often the most expressive and active participants in the ominous events.

Neither Dürer nor Holbein showed much interest in the application of colour. Dürer, of course, had developed the tonal

possibilities of both woodcut and line engraving to a point where colour – habitually applied to earlier woodcuts – was totally unnecessary. It has been suggested that his exclusive use of black and white may have been a reaction against the traditional hand-coloured woodcut.

Colour printing at this time was very rudimentary, which may have deterred Dürer and others from serious experimentation. There was, however, another approach which did not depend entirely on black or white line. This has become known as the chiaroscuro or clair-obscure method, and was chiefly used to create tonal effects roughly similar to those of a wash drawing. It involved printing from a black-line block superimposed on one, two or even three tonal blocks, usually in sepia, ochre, pale grey, green or blue. A simple chiaroscuro effect could be achieved by printing a black-line block on a tinted paper. A more complex print might also have had white 'highlights' cut from the tonal blocks. Apparently the black-line block was usually printed last, but there were numerous printing variations and colour combinations. Dürer was familiar with the technique of chiaroscuro, but did not make serious use of it, although after his death some of his woodcuts were reprinted with additional tones.

Chiaroscuro prints appear intermittently throughout the sixteenth century, but the German cuts, especially those by Lucas

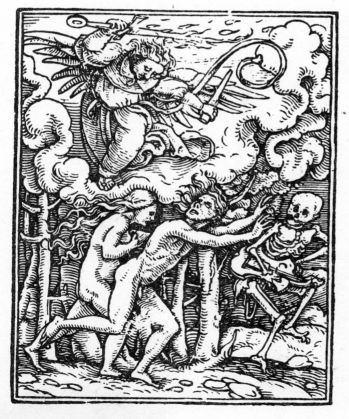

Hans Holbein the Younger (1497/8–1543), 'The Expulsion from Paradise', from *The Dance of Death*, 1538. 2½ × 2 (6.35 × 5.8).

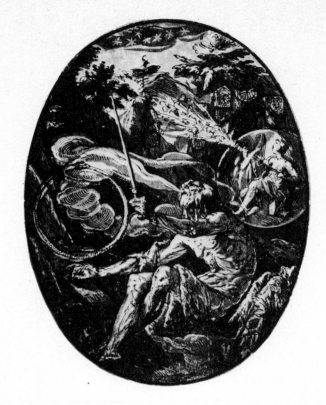

Ugo da Carpi (1480?–1520?),
chiaroscuro woodcut.

Cranach, Hans Burgkmair and Hans Baldung, were generally
made quite early in the century. The technique does seem to
have originated in Germany, but it was not by any means peculiar
to that country. In Italy, Ugo da Carpi was producing chiaroscuro
prints from about 1518, and in fact claimed to have invented the
technique. Hendrik Goltzius (1558–1616) was evidently respons-
ible for the most advanced chiaroscuro work produced in the
Netherlands. In his later work – towards the end of the sixteenth
century – he developed a purer form of the technique, in which the
over-all effect was achieved by using a number of equally import-
ant but closely related tonal blocks instead of relying on the usual
'key' black-line block and supplementary tonal blocks. This is
rather closer to modern colour-block printing, although it is
difficult to know to what extent the subtle qualities of overprinting
were deliberately exploited. Without doubt, the many technical
difficulties involved – for example, the problem of achieving exact
registration – discouraged most artists and attracted only those
with a real interest and considerable skill in this specialized form of
printing. This is one reason why these particular chiaroscuro
prints, though produced at irregular intervals from the late six-
teenth to the late seventeenth century, are comparatively rare.
Also, since chiaroscuro printing was obviously not suitable for the
mass production required for illustrated books, most prints were
designed and executed as single cuts, and these are far more vulner-
able to wear and tear than a print in a book. As single cuts they are
more closely related to the modern concept of the polychrome
print.

In general, Italian woodcuts of the fifteenth century show only minor traces of Gothic influence, and these were mostly due to the fact that German craftsmen were often employed to cut the blocks. The finest Italian woodcuts were nearly all book illustrations; the single print, both before and after the introduction of movable-type printing, was a comparative rarity. The main characteristics of a typical fifteenth-century Italian woodcut illustration are quite different from those of a typical northern or Gothic illustration. Southern woodcuts were part of a strong decorative tradition, and owed much to the earlier miniature. Above all, the illustrations were designed to accompany the text and embellish the page rather than to provide a straightforward, visual explanation of the text. They were much closer to the ornamental than the descriptive. Colour printing was the exception rather than the rule, but the use of black and white as decorative pattern, rather than for tonal effect, was clearly an important consideration. Ornate borders, classical and antique details abound. Realism is seldom, if ever, the main objective; the drama, vitality and directness of contemporary northern work is totally lacking. On the other hand, the illustrations are less heavy, oppressive and overwrought. There is a much more generous use of white paper, which creates a lighter, calmer, even tranquil effect. The linear drawing, though sometimes austere, is invariably stylish and elegant.

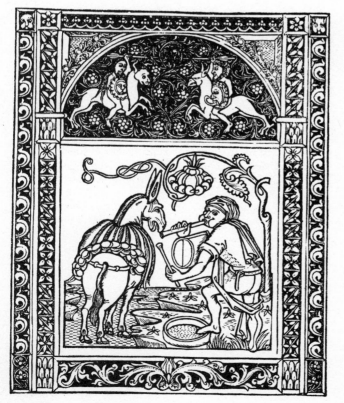

'The Ass and his Masters', from Aesop's *Fables*, Naples, 1485. $3\frac{3}{8} \times 3\frac{3}{8}$ (8.6 × 8.6). The classical decorative details are typical of the Italian treatment.

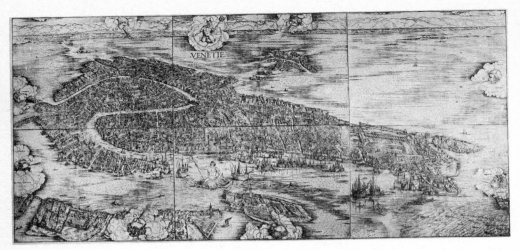

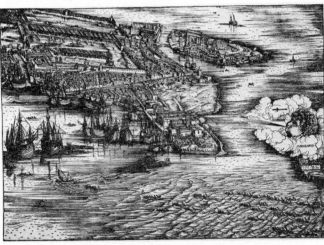

Jacopo de' Barbari (1440/50–1516), *Plan of Venice in 1500.* 52½ × 108½ (133.4 × 275.6). *Above*, the entire plan, showing clearly how it was composed from six blocks; *right*, the impression from one of the blocks, with a view of the Arsenal and a gondola regatta.

Around the turn of the century, a number of single cuts of considerable technical interest appeared, chiefly in northern Italy. Several of these show evidence of an extremely advanced cutting technique. The qualities of line engraving were being convincingly imitated in woodcut. Close, parallel linear shading – often based on the engraving style of Mantegna – is apparent in a number of contemporary works. Italian printmakers clearly had the skills necessary to exploit woodcut as a reproductive technique (as opposed to a simple facsimile process).

The Venetian painter and line engraver Jacopo de' Barbari (1440/50–1516) also designed some remarkable woodcuts, the most famous being the enormous, detailed *Plan of Venice in 1500.* The print was taken from six woodblocks, together measuring 4 ft 4½ in. × 9 ft ½ in. (133 cm × 275 cm). Barbari's work is believed to have interested Dürer, who visited Venice around 1494. Another highly individual but apparently anonymous single cut is the curiously stylized *Battle of Zonchio*, a late fifteenth-century coloured print (see p. 17).

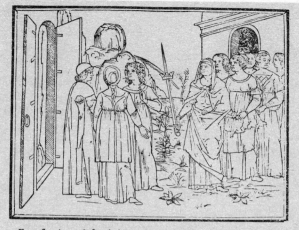

Ecco fencia præftolatiõe fue patefacta, & ítromeffi, Se fece ad nui una
Matrona chryfaora cum gliochii atroci & nella fpecto prompta, uibran-
te cú la leuata fua fpatha in mano & prælucéte. In medio della quale, una
corolla doro, & uno ramo di palmula itrauerfato fufpefa pendeua, Cum
brachii Herculei & da fatica, cum acto magnanimo, Cum il uétre tenue,
bucca picola, humeri robufti, Nel uolto cum demonftratione di non ter
rirfe di qualunqua factione ardua & difficile, ma di feroce & giganteo ani
mo. Et il fuo nomiatiuo era Euclelia, Et dixene nobile giouenette & obfe
quiofe uenerabilmente comitata. Il nome della prima Merimnafia, Del-
la fecunda, Epitide. Dell'altra, Ergafilea. La quarta era chiamata, A nectea.
Et Statia nominauafi laquinta. La ultima era uocata Oliftea. Il loco & fi-
to mi parea effere molto laboriofo. Per quefto auidutafi Logiftica prom-
pta icomícioe cú Dorio mó, & tono di cátare tolta la lyra di mano di The
lemia, & fonando fuauemente a dire. O Poliphile nó ti rencrefca in que-
fto loco uirilmente agonizare. Perche fublata & ammota la fatica, rimane
il bene. Tanto fue uehemente il fuo canto, che gia confentiua cum quefte
adolefcentule cohabitare, quantunque lo habituato di fatica appariffe,
Subito Thelemia politula & blandiuola, & cum dolce fembiante mi di-
xe. Cofa ragioneuola ad me pare, che ante che qui Poliphiletto mio ocu-
liffimo te affermi, debbi per omni modo & la tertia porta uidere. Confen

i

The Venetian 'Classical' school:
'Poliphilo confronted by Eucleia
(Worldly Fame)', from Francesco
Colonna, *Hypnerotomachia
Poliphili*, 1499. 4⅛ × 5
(10.5 × 12.7).

The unique qualities of Italian woodcut are perhaps best seen –
at least in their purest form – in the work produced in two main
centres, Venice and Florence, during the last decade of the fifteenth
century.

Arthur Hind, in his *Introduction to the History of Woodcut*, separ-
ates most Venetian woodcut illustration into two main schools,
the Popular and the Classic. The two distinct approaches to illus-
tration and page design are to be found in two editions of the
Bible in Niccolo Malermi's Italian translation. The 'Popular' edi-
tion appeared first, published in 1490 by Giunta. It contained
numerous illustrations based loosely on those of the Cologne Bible,
the average size being about 1¾ in. × 2⅞ in. (45 mm × 73 mm) –
roughly the width of one of the two columns of type on each page.
The cuts are entirely linear and, in spite of their small size, have a
light, almost spacious feeling, emphasized by the plain rule bor-
ders; they fit perfectly within the equally plain columns of type.
In Tridino's 'Classical' volume of 1493 the cuts are even smaller,
and are surrounded by decorative border strips to bring them into

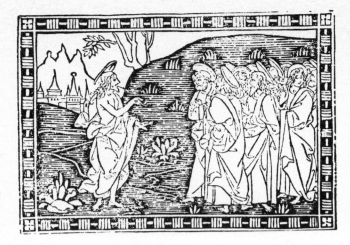

The Florentine style: illustration
to St John's Gospel, chapter 1 (the
calling of the apostles), from
Epistole et Evangelii, 1515.
2¾ × 4 (7 × 10.2).

line with the columns. A slightly heavier type, decorative initial
letters and ample border give a generally heavier, more dense
effect. Contemporary details, particularly in costume, add realism
to the Popular version, while Tridino's version relies on the almost
standard, classic form of costume and rather more austere
compositions.

Other important works in the Popular style include the *Vitas
Patrum* and the Livy, published by Giunta in 1491 and 1493
respectively, and the *Decameron* of Boccaccio (1492). The Classic
style is typified by Francesco Colonna's *Hypnerotomachia Poliphili*,
printed by Aldus Manutius in 1499, in which the relationship of
the typography, woodcut decoration and illustration – helped by
an extraordinarily high standard of presswork – is perfectly
balanced. The designer of the illustrations, which must rank among
the finest examples of the art of book illustration, has never been
positively identified, but his sensitivity to form and space and his
disciplined, economic line may have been due to the fact that he
was a sculptor and not a painter.

On the whole, book printing in Florence lacked the finesse of
Venetian work. But the quality of illustration is in no way inferior;
if anything, the Florentines surpassed the Venetians in acuteness of
observation and pictorial invention. The Florentine book illus-
trators also had the sensitivity to respond to and the ability to
express in visual terms the particular mood of a scene or incident.
A common feature of most Florentine woodcut is the decorative
border cut on the block, which surrounds the drawn illustration
on all four sides like a picture frame. Apart from these borders, few
decorative devices were employed.

Another stylistic feature in the actual illustration is the use of
white line. The fine, elegant outline typical of the Venetian cut is
much less apparent in that of the Florentines. Instead, areas of
black relieved by parallel white lines and dots give weight and
colour to the picture as a whole. Light-toned figures, drawn with a
minimum of line, are set against a dark background, their form
given substance by an encircling 'shadow'. Later Venetian illus-
trators also made use of this mannerism. This emphasis on positive

or 'white' drawing is a familiar characteristic of the much later, largely nineteenth-century, technique of wood engraving.

The most notable examples of Florentine illustration include the *Epistole et Evangelii* of 1495, Pulci's *Morgante Maggiori* of 1500, and Frezzi's *Quadriregio* of 1508, all published by Piero Pacini da Pescia. A large number of books and pamphlets on the tracts and sermons of Savonarola and many *rappresentazioni* – mystery plays – contain some of the very best of the typically Florentine woodcut illustrations.

The woodcut had been made – admittedly with some success – to imitate effects more efficiently achieved by line engraving. But it was unable to compete on equal terms for long with a graphic technique so very much more subtle and precise. Book printers were at last beginning to find ways of overcoming the technical problems of having to print intaglio plates separately from relief type. The majority of Italian illustrators were to abandon the woodcut in favour of line engraving several years before their German or Netherlandish counterparts. There was, understandably, a brief period, even in Italy, when both techniques were practised to an equal extent. About the middle of the sixteenth century, the engraved title page was becoming fairly common and a few engraved illustrations were appearing; by the end of the century, engraving had almost completely replaced woodcut illustration.

The Netherlands

Netherlandish book illustration contributed little to the stylistic development of the woodcut. Nor did it evolve an obviously recognizable character of its own, other than that associated with the block-book or with such works as the *Grotesque Alphabet* of 1464. This was probably because the strong traditions and exceptionally high standard of the painted miniature merely emphasized the comparative crudity of the woodcut, and inhibited further development.

France

French woodcut illustration was even more closely related to and modelled on the illuminated manuscript than the Netherlandish. Many of the early printers and publishers had previously worked on manuscript books, and a strong decorative tendency, derived from manuscript style, is apparent in the woodcut borders and initials that accompany nearly all the pictorial work. In the earliest printed books, spaces were often left blank for subsequent miniature painting; and in a few cases, the cuts were actually painted over. Illustrations were characteristically Gothic, but it was from the start an essentially French version, and remained, until after the first quarter of the sixteenth century, unaffected by the Italian Renaissance. Subject-matter as well as style had unmistakable Gothic traits: the medieval preoccupation with death, for example, so familiar in the early block-books, occurs again and again in numerous scenes on the 'dance of death' theme.

The letters E and F from the Dutch *Grotesque Alphabet*, 1464. Each letter c. 4½ × 3½ (11.4 × 8.9).

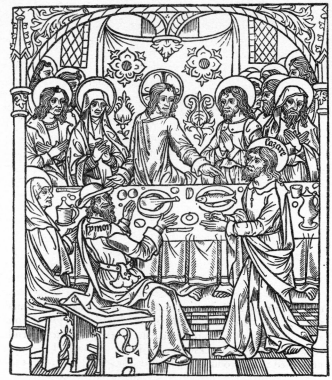

Ereydi the gof
pel of fant ioon
in the. rij. che-
ptur that the
Zaytterday be
foz palme foon Day the. Bj.

day/Befoz hefterday cowntant
the fayd faytterday z hefterday
wyth other .iiij.dayes in put.
That owr falwpour iefu cryft
com in bethany in the howf of
oen man callyt leprows .The
 f iiij

Jesus at Bethany, from *The Art of
Good Lyvyng and Good Deyng*,
1503, published by Antoine
Verard in Paris for export to
England. Page 10¼ × 7¼
(26 × 18.4). The influence of the
illuminated manuscript can be
seen in the arch enclosing the
illustration.

The purest and most characteristic of all the early French wood-
cuts were produced in Paris. Hind thought that the finest achieve-
ment of French woodcut during the fifteenth century was
probably Guy Marchant's *Danse Macabre des Hommes* and *Danse
Macabre des Femmes*, both published in Paris in 1491–2. These were
extremely popular and immediately comprehensible works, full of
vitality and, in spite of the theme, far from morbid; indeed, few
subjects could be more animated than these posturing skeletons.
The series is also noticeably free from the general influence of the
miniature.

By far the most famous, prolific and characteristically French of
all woodcut books produced in Paris are the Books of Hours – the
Horae – and particularly those printed by Pigouchet, Dupré,
Verard and Tory. Books of Hours were closely modelled on the
manuscript style, woodcut being extensively employed for the
decorative borders and initials as well as the subject cuts. Many of
the decorative borders contained vignettes, and were therefore
illustrations as well. The unified double-page spread design

employed was to have a profound influence on book design for centuries. The earliest cuts were mainly in fairly fine black line, but dotted backgrounds were used after about 1496. Occasionally, coloured prints occur, usually in red, blue and green, but these seem to be largely experimental works.

One of the greatest of mid-sixteenth-century French illustrators still actively designing for woodcut was Bernard Salomon, who worked in Lyons. The *Métamorphose d'Ovide* published by Jean de Tournes in 1557 is an excellent example of Salomon's illustrative woodcut. Many of the woodcut designs for which he was renowned were in fact vignettes, characterized by their smallness of scale, delicacy of line and fine detail – a combination of qualities normally more appropriate to the technique of copper engraving, or, in the nineteenth century, wood engraving.

England

The English made no appreciable contribution to the early development of the woodcut. Printing came relatively late to England, and English incunabula show that illustration was clearly of secondary importance – even, it seems, to Caxton. Most of the earliest printed books were translations of popular Continental works, reprinted and illustrated from blocks either borrowed from abroad or copied from the originals. During the late fifteenth century imported blocks would almost certainly have outnumbered those produced by local craftsmen. Also, a fairly sub-

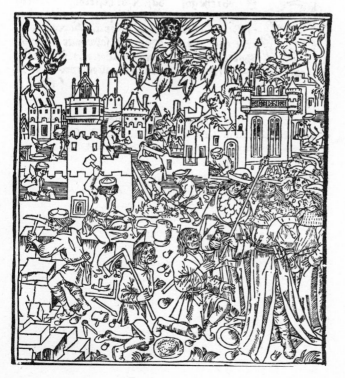

The Tower of Babel, from *La mer des histoires*, Paris, 1543 (a translation of an earlier German chronicle). 7 × 6 (17.8 × 15.2). The unusual freedom of line with which these illustrations are cut creates a strong sense of movement.

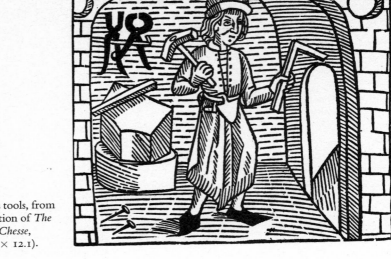

A blacksmith with his tools, from
William Caxton's edition of *The
Game and Playe of the Chesse*,
1483(?). 4 × 4¾ (10.2 × 12.1).

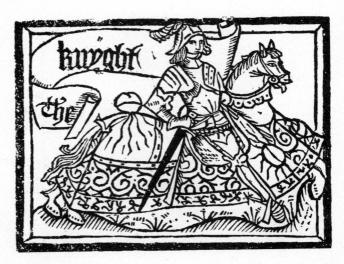

The Knight, from Chaucer's
Canterbury Tales, printed in
London by Richard Pynson,
c. 1490. 3⅜ × 4½ (8.6 × 11.4).

stantial number of Books of Hours were imported from France,
where they had been printed specially for the English market.
The few local designers and cutters were given little chance to
create any sort of recognizably national style. Yet French books
seem to have had conspicuously little influence on English design,
which remained, for some considerable time, essentially provin-
cial. This may have been due to the inability of English designers
to assimilate the highly developed French style.

The first English book to be published with original illustrations
is believed to be *The Mirrour of the World*, printed by William
Caxton in about 1481. Caxton's better known works include
editions of Aesop, *The Golden Legend*, *The Canterbury Tales* and
The Game and Playe of the Chesse, which was a morality, not an
instructional book. All were illustrated with rather primitive

broad line cuts, and though all are undoubtedly of historical and literary interest, in no case could the illustrations be described as distinguished.

During the first half of the sixteenth century, English printers still relied on imported Continental blocks, many of which were rather nondescript. In general, the quality of this work does not compare favourably with that produced in the great European printing centres. Holbein worked in England from 1532 to 1543, but evidently spent very little time illustrating books, though some of his earlier cuts, such as those imported from Basle by the publisher Richard Pynson, do appear to have had a beneficial influence on a slowly emerging English style. The best woodcut prints date from the latter half of the century, when both woodcut illustration and printing improved quite considerably. Prominent among the finest works are Cuningham's *Cosmographical Glasse* (1559) and Foxe's *Book of Martyrs* (1576), both from the press of John Day, one of the few English publisher-printers of distinction. These and other books by Day were illustrated with woodcuts, but by the end of the century English woodcut illustration followed the general tendency and was largely superseded by line engraving.

THE JAPANESE COLOUR PRINT

The Chinese may have developed the idea of making pictorial woodcuts from the ancient tradition of 'stone prints' – impressions taken from preserved inscriptions carved in stone or metal. Whatever their origin, by the T'ang dynasty (618–906) single-sheet woodcuts, mostly consisting of text but a few at least of them pictorial, are known to have been plentiful.

As in Europe several centuries later, these early pictorial cuts were intended to serve as devotional aids and as cheap substitutes for religious paintings. The purely pictorial cut, however, did not become firmly established until the early fourteenth century. Single cuts were followed in due course by book illustrations, though the great majority were of a simple linear design which soon became conventionalized, and were not, by later standards, particularly distinguished. This minimal, linear style of woodcut, which was to last for centuries, was evidently considered to be perfectly adequate as a means of reproducing drawings; no modelling of form by shading was apparently attempted. The quality of the printed line in these 'conventional' cuts was fairly crude, but it was usually far more fluid – and inevitably more calligraphic – than the often clumsy, angular lines of the early German cuts.

Hand colouring of prints was practised as early as the tenth or eleventh century, although this was chiefly in order to decorate, rather than to illustrate, Buddhist texts. Colour printing for book illustration appears to have been introduced during the seventeenth century; colour woodcut, like the black and white linear, was at its best from the mid-sixteenth to the mid-seventeenth century, later than in Europe. As a rule, colour was used either in flat, contrasting areas, or as a network of coloured lines; the two

approaches were never combined on one print. Colours even had their own traditional hierarchy, certain colours being applied strictly according to the importance of the object depicted.

Some book illustrations were also printed and sold as single cuts; other prints were designed solely for this purpose. Gradually, the production of separate colour prints became more important than the production of book illustrations. The popular theatre, for example, required a constant supply of colour prints to illustrate and advertise plays. The relative cheapness of these early printed ephemera, however, meant that hardly any of them were collected, and good examples are now extremely rare.

Among the most accomplished examples of Chinese wood-block printing are those depicting natural forms – flowers, fruit and birds; these are, in fact, nearly all reproductions of paintings. In some as many as twelve different coloured inks were applied, and an additional ten tints could be achieved by reprinting. The technique of gauffrage – a form of embossing without ink – was also perfected.

It is conceivable that the Japanese polychrome print evolved independently, but it is generally thought to owe a great deal to the Chinese techniques. The Chinese were certainly in a position to provide their Japanese counterparts with practically all the expertise they needed, though there is little doubt that the latter eventually refined the colour print – as an original art form – to an even higher level.

Both painting and woodblock printing were probably introduced into Japan from China during the eighth century, roughly a hundred years after the general acceptance of Buddhism. The earliest pictorial woodcuts were largely religious aids, and the simple linear style continued without conspicuous change until the fifteenth or even the sixteenth century, when subject-matter began to grow more secular and varied. Experiments with colour printing began in the early seventeenth century. Many black-line prints had, of course, been coloured in by hand after printing – in most cases rather crudely – and some would no doubt have been designed for colouring in. But as far as is known, no colour printing from separate blocks was attempted before 1627, and the technique was not to be fully developed for at least another 120 years.

The origins of the ukiyo-e school

By the mid-seventeenth century, a new school of painting was beginning to emerge under the name *ukiyo-e* – which, freely translated, means 'paintings of the floating world', or 'mirror of the passing (or drifting) world'. Originally a Buddhist term, *ukiyo* – 'floating world' – referred, in the traditional Japanese sense, to a transient place, without substance, even illusory. But during the seventeenth century, *ukiyo* took on a rather more worldly and less rarified meaning, though still with the implication of transience: the term was applied more directly to the hedonistic or sensual life of the pleasure-seeker, associated with the tea houses, the brothels and the popular theatre.

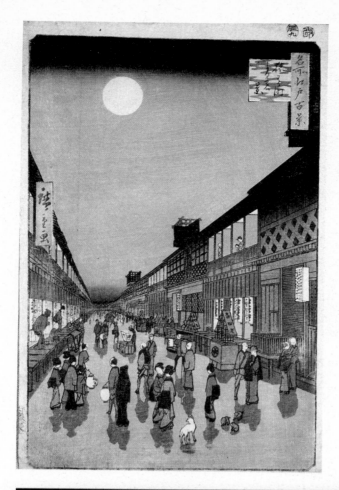

Ando Hiroshige (1797–1853),
Night Life (Saruwaka-cho).
14⅛ × 9¾ (35·9 × 24·8).

Katsushika Hokusai (1760–
1849), 'Fuji in Clear Weather',
from *Thirty-six Views of Mount
Fuji*, 1823–9. 9¾ × 14¼
(24·8 × 36·2).

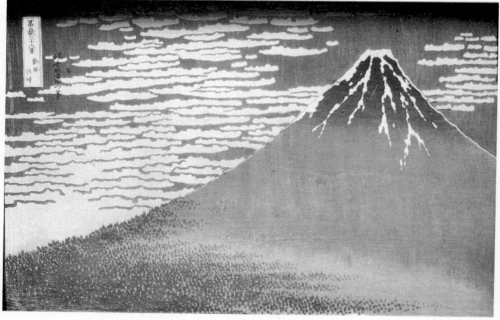

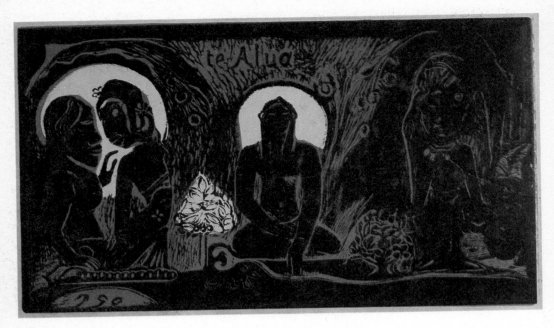

Paul Gauguin (1848–1903), *The Gods (Te Atua)*, c. 1891–3.
8 × 13⅞ (20·3 × 35·2).

Pablo Picasso (1881–1973), *Still Life under a Lamp*, 1962. Lino
cut, 20⅞ × 25¼ (53 × 64).

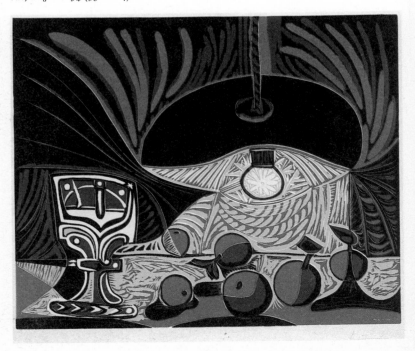

It was in Edo, a city founded about 1600 (now modern Tokyo), that *ukiyo-e* developed into a recognizable movement. By the late seventeenth century the city was rapidly becoming a centre of considerable commercial activity. Its merchant class, as well as many skilled craftsmen, chiefly from the older cities of Osaka and Kyoto, had grown increasingly prosperous. The Edo period – which lasted until the mid-nineteenth century – was relatively peaceful compared with the preceding century, and this was obviously encouraging for business. Beyond a certain point, however, further development, in terms of business and social advancement for even the most successful middle-class merchant, was made impossible by the archaic, though not entirely feudal, social system.

Unable to exploit their commercial expertise, their freedom of movement curtailed and foreign travel virtually forbidden, the merchant class turned instead to spending their accumulating wealth on extravagant living, on the readily available amusement of the 'nightless city', most of all in the 'pleasure quarters' and the theatres, and on the acquisition of luxurious objects. The two dominant schools of painting until this time had been Kano and Tosa; they were patronized almost exclusively by the aristocracy, and in any case their subject-matter – Chinese legend and life at the Imperial Court respectively – would have had little appeal for the common people. Within the large, affluent and evidently plebeian middle class, and to some extent among a 'better off' artisan and farming class, there was a growing demand for an art form that was closer to their own lives. For a time, an inexpensive form of 'painting' known as *otsu-e* – quick sketches in bold outline, crudely coloured in – met the demand, but it soon became apparent that a really cheap form of multiple print was necessary to supply the less prosperous classes.

Even before *ukiyo-e* painting evolved, a great deal of woodcut book illustration depicting everyday subject-matter had already been published, so that when painting at last came to deal with the 'common life' there was ample precedent in contemporary graphic art, albeit in the relatively expensive form of the printed book. There is, therefore, a link, almost a natural progression, from the mass of seventeenth-century book illustration then in circulation to the *ukiyo-e* colour print. Though initially expressed in paintings, the *ukiyo-e* movement found its most popular form of expression in colour prints – a gradual transition which was to take almost a century.

The first major artist to realize the full potential of the single-sheet woodcut print was Hishikawa Moronobu (c. 1625–94), who was already established as one of the most prolific and popular book illustrators of his time when he turned his attention in this new direction. When designing for the woodcut, Moronobu took into account the technical limitations of the cutters, and kept his drawings as simple as possible. Nearly all his prints were conceived in black and white, though many were afterwards coloured in by hand, often in an orange-red colour on a dull olive or yellow ground. His style was predominantly linear, though it was a free, vigorous line; he used comparatively little fine detail, but did

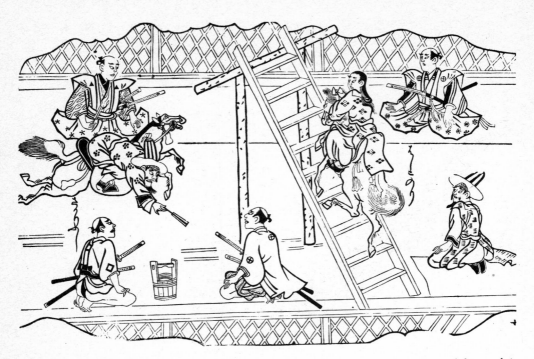

Hishikawa Moronobu (c. 1625–94), *Koreans exhibiting their skills at horsemanship before Intokwan, the Korean Ambassador and other exalted personages.* One of eleven sheets forming a continuous scene; each sheet 10¼ × 14½ (26 × 36.8).

employ areas of solid black, large and small. Although his work is almost always recognizable, Moronobu had an uncommon ability to adjust his style to fit a particular subject; despite this, he typifies the so-called 'primitive' period of *ukiyo-e* art.

The development of the colour print

After Moronobu's death the *ukiyo-e* print gradually developed – from the 'primitive' black and white or hand-coloured print to the colour print proper – through a succession of schools, each one generally initiated by a single master. Each school evolved a distinct style and approach, often concentrating on a particular aspect of the 'common life' in Edo, and was for ever refining and elaborating on the various techniques employed.

One of the first of these schools was founded by Torii Kiyonobu (1664–1729), chiefly known for his many lively and expressive portraits of *kabuki* (popular theatre) actors. These 'actor-prints' were drawn with a strong black outline and then coloured by hand, and Kiyonobu was a leading exponent of the then fashionable *tan-e* print coloured with a red-lead or yellow pigment. The characters and scenes portrayed by the *kabuki* actors – all the parts were played by men – rapidly became the main preoccupation of a great many *ukiyo-e* artists; and prints depicting the *kabuki* drama, which was so much a part of Edo life, have remained among the most popular of all *ukiyo-e* subjects. Indeed, *kabuki* has been described as the prime inspiration of the Japanese print.

Another artist to influence the early stylistic development of *ukiyo-e* was Nishikawa Sukenobu (1671–1751), a popular illustrator renowned for his drawings of an exceptionally gentle and

graceful type of young woman. Although Sukenobu worked in the older cities of Osaka and Kyoto, he was so essentially part of the *ukiyo-e* movement that he is usually considered in relation to Edo artists of the same period.

The era of the *tan-e* print was followed by a period – roughly from 1715 to 1745 – in which the *beni-e* flourished. *Beni-e* prints were hand-coloured with a deep pink pigment. Sometimes the pigment was mixed with glue to create a glazed, lacquered effect; such prints were known as *urushi-e*.

The demand for colour prints, however, continued to grow, and a better way of producing them had to be found. The multi-block print, in which the colour was applied directly to the wood-blocks, seemed to be the obvious answer. Two-colour printing, for example in pink and green, was introduced sometime during the third or fourth decade of the eighteenth century; no single artist can be credited with this invention. Hand colouring and limited colour-block printing existed side by side for a number of years, though by the middle of the century the majority of prints were still hand-coloured. A further technique employed at this time was the application of metal dust such as mica or even gold.

Curiously, as late as the 1740s the advanced colour-printing techniques developed by the Chinese, though not unknown in Edo, had inspired few imitators. It has been suggested that the probable reason for this was that the time and labour involved in producing multi-colour prints would at that time have made them far too expensive for the majority of the population of Edo.

One of the most enterprising and versatile of the early *ukiyo-e* artists was Okamura Masanobu (1686–1764). His work included an unusually wide range of subject-matter, although he is mostly known for his series of prints illustrating the domestic occupations of women. Masanobu became the dominant *ukiyo-e* artist of his time partly because of his versatility – he was also a publisher and print-seller – and partly because he, perhaps more than anyone, was responsible for the further development of the *beni-e* print, and is also thought to have pioneered early colour-printing methods (*benizuri-e*).

The main period of technical development in multi-colour printing took some twenty years, from about 1744 until about 1764. Sukenobu had already tried printing with six colours at Osaka as early as 1745. Torii Kiyomitsu (*c.* 1735–1785) experimented with a three-colour method which also incorporated overprinting, but this was not particularly successful. During the 1760s, several Edo artists had collaborated to unravel the problems of multi-colour printing in the Chinese manner, and much of the credit for the development of full-colour prints (*nishiki-e* – also known as 'brocade prints' because of their resemblance to the richly embroidered silk fabrics of the time) must go to them. Accomplished multi-colour prints, obviously the result of considerable technical expertise, were being produced in Edo around 1764; the culmination of this development was the later work of Suzuki Harunobu (1725–70), who turned from book illustration to designing single-sheet prints in about 1765. Having studied the *beni-e*, and helped also by a significant improvement in the standard of

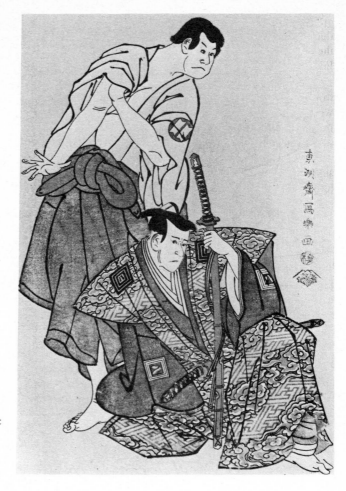

Toshusai Sharaku (1749–1803), *Kabuki Actors*, 1794. The actors Hangoro and Yaozo pose as priest and villainous samurai in a climactic moment from the drama *The Courtesan's Three Parasols*. Original in colour.

contemporary block-cutting and printing, Harunobu was able to develop a successful method of printing with at least five colours (see p. 18). He also made subtle use of overprinting and gauffrage (also known as 'blind printing' or embossing, usually uninked).

The production of a *nishiki-e* print was essentially a group enterprise, involving – apart from the publisher who commissioned the work – the artist himself and the various block cutters and printers, each an expert in his craft. The various materials and most of the techniques used at this time remained virtually unchanged throughout the eighteenth and nineteenth centuries. First of all the artist would make a clear line drawing with brush and black ink on translucent paper, which was then pasted face down on to the woodblock – usually of cherry wood, but occasionally of pear. This 'key block' was generally sawn from the hard wood close to the centre of the tree, the softer outer wood being preferred for the colour blocks. Various small chisels, both square and round, would be used to cut out the larger areas; the lines and any intricate work were cut with small knives.

The completed key block was passed to the printer, who took a number of proofs in black ink. No press was used at this or any other stage; ink was brushed directly on to the relief area, and the back of the paper rubbed with a 'baren' or pad made either of hempen cord or of twisted bamboo fibre enclosed in a 'skin' of bamboo sheath. The proofs were returned to the artist, who either indicated all the colours on one proof or marked each colour on a separate proof until the whole colour scheme and correct printing sequence had been planned. Marked proofs were then pasted on to the blocks; usually each colour required a separate woodblock, but in some cases two small areas of different colours might be printed from the same block.

Black ink was made from *sumi*, a mixture of soot and glue, and the coloured inks from a mixture of pigment and rice paste. Before the nineteenth century, most of the colours used were of vegetable origin, and many have tended to fade over the years. They may now be more subdued than the bright, fresh colours enjoyed by the citizens of Edo, but they are not necessarily less attractive. Later in the nineteenth century, aniline dyes were introduced from the West, with some unfortunate results.

After approving a 'specimen' proof, the artist was seldom directly involved in the final stages of the colour printing: although the printers usually worked to the artist's directions, they alone were responsible for the mixing and application of the colours, and the success or failure of a print depended very much on their skill and judgment. In the early days of colour printing, editions were relatively small – roughly between forty and eighty. Later, an edition of one to two hundred was fairly common, and by the nineteenth century the prints of the most popular artists were issued in thousands.

The acknowledged master of the *ukiyo-e* actor-print was an independent artist, Toshusai Sharaku, active as a designer of prints for an extraordinarily brief period around 1794-5. In his actor-prints, which totalled one hundred and forty in about ten months, Sharaku recorded with a striking realism the precise individual characteristics of his subjects and the intensity of their expression. He made dramatic, even bizarre, use of mica on a dark background, a technique also to be employed by Utamaro, and designed several unusually large bust-portraits of actors, for which he is perhaps best known. Sharaku's prints were never really popular with the Edo public, nor for that matter with many of the Edo actors, yet his highly original work had a strong and lasting influence on a number of his contemporaries.

Edo was far from being the only centre for the production of colour prints. A group of colour print designers and craftsmen were active in Osaka from at least the second decade of the eighteenth century. The Osaka group are particularly renowned for their theatrical prints and for their use of brilliant colours. Toyoto was another print centre of some importance, though hardly to the same extent as Edo.

One of the most individual and influential of all the *ukiyo-e* artists of the late eighteenth century was Torii Kiyonaga (1752-1815), who produced his finest work during the Temmei period

(1781–9). Kiyonaga was the first *ukiyo-e* artist to make full use of a
landscape background, and excelled at outdoor scenes, especially
on the theme of figures in a landscape – strolling along the river
bank, in crowded streets or around the temples. He also grouped
these compositions into three or even four related scenes, a method
which subsequently became extremely popular. Although 'sets' of
three prints were not previously unknown, Kiyonaga's concept of
'continuous composition' was something of an innovation. It
seems, however, that his figure compositions of tall, graceful yet
voluptuous women, shrewdly observed and quite unlike the
rather fragile, dainty women of earlier prints, were more immed-
iately and directly influential. The portrayal of beautiful, elegantly
dressed women remained a major preoccupation with most
ukiyo-e artists throughout the whole movement.

Kitagawa Utamaro (1753–1806), is considered by many to be
one of the greatest of *ukiyo-e* artists, if not the supreme master.
His fame, certainly outside Japan, is equalled only by that of
Hokusai and Hiroshige.

Utamaro was a most prolific and inventive artist. But although
he excelled in a wide range of subjects, illustrating books, for
example, on shells, insects, birds and fish, it is on his more mature
work on the seemingly inexhaustible theme of beautiful women –
especially the courtesans of the Yoshiwara district, a world which
he, like many other *ukiyo-e* artists, is supposed to have known
intimately – that his fame rests. In these middle- and late-period
works, he developed and carried to the extreme the contemporary
fashion among *ukiyo-e* artists for an unnaturally tall, slender and
sensual type of woman of 'strange proportions'. The success of
Utamaro's prints led, apparently, to over-production, and it was
necessary for him to employ assistants. Thus to some extent the
quality of his prints – or more probably of those attributed to him
– gradually declined; even so, he produced some of his finest
work, especially on the relatively new theme of mother and child,
during his last ten creative years.

The work of Hokusai and Hiroshige

The last phase in the development of the *ukiyo-e* print was com-
pletely dominated by two artists of astonishing originality and
creative energy, Katsushika Hokusai (1760–1849) and Ando
Hiroshige (1797–1858). Both turned to landscape, which was still a
somewhat minor theme in *ukiyo-e* art. For centuries oriental artists
had regarded landscape as the highest form of painting, and a deep
feeling for nature is a characteristic of the Japanese people; but,
more often than not, landscape in oriental art was of a classical,
idealized kind, and in this form was hardly in keeping with the
spirit of the *ukiyo-e* movement. Until the nineteenth century,
when Hokusai's landscape prints first began to appear, the subject
had been almost entirely restricted – at least in colour prints – to
'background scenery'. The occasional exceptions included Moro-
nobu's views of the Tokaido Road, published as long ago as 1690,
and the increasing number of *meishi-ki* – illustrated guide-books
for travellers. The importation of engraved views from the West

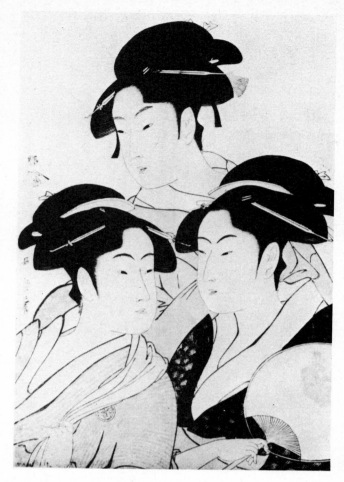

Kitigawa Utamaro (1753–1806), *Half-length Portrait of Three Beauties.* Original in colour, $14\frac{5}{8} \times 9\frac{5}{8}$ (37.2 × 24.5).

had already aroused some interest among artists such as Utagawa Toyoharu (1735–1814), whose work was no doubt familiar to Hokusai. Utamaro too had designed several 'pure' landscapes, quite apart from his many studies of natural history.

By the early nineteenth century, the *ukiyo-e* movement was showing distinct signs of entering the so-called 'period of decline' (roughly 1825–60), and to a very great extent Hokusai and Hiroshige, by developing the new theme of landscape, were able to revitalize and extend the art of the Japanese colour print.

It is generally accepted that Hokusai's finest work – certainly his finest colour prints – appeared after about 1810. He was a mature, vastly experienced artist when he began to devote himself to landscape prints, and it was in these that he revealed the full range of his 'inexhaustible invention'. The most famous of the various series of colour prints were published after 1820; the most widely known is the *Thirty-six Views of Mount Fuji*, later to be supplemented by a further ten views and published at intervals between 1823 and about 1832. *The Waterfalls of the Provinces* and *The Views of Famous Bridges* both appeared in 1829, as did the

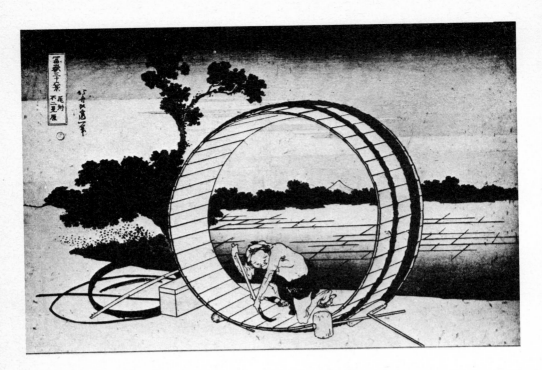

Katsushika Hokusai (1760–1849),
'A Cooper at Work', from
Thirty-six Views of Mount Fuji,
1823–9. Original in colour,
9½ × 14¼ (24.1 × 36.2).

large *Flowers* and the small *Flowers and Birds*. The success of the
vital and exuberant Fuji series with the somewhat jaded but exact-
ing print-buying public helped enormously to establish Hokusai
as the leading print designer of his time, and encouraged a new
and enthusiastic interest in landscape art.

Hokusai's work bore little resemblance to anything seen pre-
viously in the history of oriental art. Yet he was concerned with
many of the themes that characterize the *ukiyo-e* movement; his
landscapes are seldom 'pure', and figures, though usually small in
scale, are nevertheless an important part of the design. The differ-
ence is in the emphasis, placed here on the changing moods of the
seasons and the transitory atmospheric effects of weather on the
natural beauty of the Japanese landscape.

Although a great many artists studied Hokusai's work, surpris-
ingly few of distinction – the obvious exception being Hiroshige –
generally took up the theme of landscape, or were strongly
influenced by him; he had little impact on the future course of
Japanese art. Western painting styles were far more influential and,
in the long run, more harmful.

At the time of Hokusai's death in 1849 Hiroshige, regarded
inevitably as his natural successor, was at the height of his powers
and had already produced most of his finest and most highly
acclaimed landscapes. He was to outlive Hokusai by only nine
years or so. Though both artists seem to have been equally and
passionately devoted to the study and depiction of landscape, their
approach to the subject was quite different. In so many of Hokusai's
prints we are confronted first and foremost by his highly indivi-
dualistic approach, an almost demonic inventiveness enriched by

dramatic compositional devices inherited from the art of the past.
Hiroshige drew his scenes directly from nature, never allowing
his individuality to intrude to the same extent; nor did he con-
sciously emulate earlier masters. He was far more concerned with
the accurate representation of a scene and its particular mood and
atmospheric effect, and surpassed even Hokusai in his recreation
of 'pure' landscape.

In 1830 he designed his most famous series of prints, the *Tokaido
Gojusantsugi*, fifty-five single-sheet prints depicting all fifty-three
stations along the eastern sea road, plus views of the departure
point and the terminus at Kyoto. The series was published in 1834
and was a resounding success. During the next twenty-four years,
Hiroshige was to make a further twenty series on the same theme,
although the first is regarded as the finest. Each series recorded,
with a wealth of descriptive detail, the social life along the great
highway – posthouses, eating places, shops and inns, the people
who lived and worked in them and the many travellers who
visited them – as well as numerous scenes of the surrounding land-
scape, including the more familiar views of Mount Fuji and Lake
Biwa. This rich and varied subject-matter contained much that
was compatible with the characteristic and familiar themes of the
ukiyo-e movement. The 'pure' landscapes, on the other hand, in
which Hiroshige was chiefly concerned with the poetic and
dramatic effects of natural phenomena – heavy, slanting rain,
moonlight, the profound tranquillity of the countryside under
fresh snow or in the damp, misty dawn – were quite unlike the
traditional and largely 'sociable' *ukiyo-e* art, yet they were immed-
iately understood and accepted by the common people.

It is difficult for a Westerner fully to understand the appeal of
these prints; he can appreciate them for their decorative qualities,
exquisite use of colour and refined but expressive line, but cannot
be thoroughly familiar with their background of historical and
literary associations. Several other points of popular appeal, how-
ever, are more immediately apparent.

A high proportion of Hiroshige's views contained figures;
usually these are of ordinary people engaged in their normal day-
to-day activities or involved in some minor incident or chance
encounter. Yet such figures, though undemonstrative, add em-
phasis to the particular mood of a landscape. Human interest would
appear to be a more important element in Hiroshige's prints than
in Hokusai's.

Like Hokusai and others before him, Hiroshige also employed
Western perspective, which had already been fairly widely used in
eighteenth-century Japan, chiefly in the form of the *ukiyo-e* print.
This 'realistic' approach, coupled with a high degree of topo-
graphic accuracy, obviously appealed to the travelling public.

The 1834 Tokaido series was not the first complete set of prints
that Hiroshige had made; his *Toto Meisho*, or *Views of the Eastern
Capital*, had been published in about 1830. An enormous number
of prints were to follow, mostly published in series or sets. Among
the most celebrated are the *Sixty-nine Posting Stations of the Kiso-
kaido* – the Kisokaido being the alternative route, via the moun-
tains, to Kyoto. Hiroshige shared this series with Eisen, who

completed twenty-three out of a total of seventy prints. The Kisokaido prints, though probably begun about 1835, were published at intervals until 1839.

Hiroshige produced vast numbers of different views of Edo; the life of the city, birthplace of the *ukiyo-e* movement, was a constant source of inspiration for him. In fact, his later works – or works attributed to him – include as many as fifty sets of three-sheet prints and two sets of one hundred different views of Edo. In addition to the more familiar views he also designed sets of historical subjects and bird and flower prints, many of which also contain ancient poems. The total number of his prints published probably runs into thousands. Both single prints and sets were often issued in very large numbers; estimates vary, but it is probable that in some cases ten thousand copies may have been printed. Inevitably, this excessive production from deteriorating blocks resulted in a falling-off in the quality of printing. In this respect, Hiroshige's work suffered even more than Hokusai's.

After Hiroshige's death, the high standards and the essential spirit of *ukiyo-e* art were maintained for a few more years by two other artists of well-nigh comparable genius, Utagawa Kunisada (1786–1864) and Utagawa Kuniyoshi (1798–1861). Extremely successful in his own lifetime, Kunisada has been described as the quintessential *ukiyo-e* artist. He excelled particularly at the more traditional and still extremely popular subjects of actors and beautiful women. Kuniyoshi's fame rests mainly on his achievements in the art of the warrior-print, in which he depicted, with an absolute mastery of dramatic design, heroic episodes from Japanese history – conceivably a reaction to the way Japanese art was steadily losing its identity as contact with the West intensified.

By the middle of the nineteenth century the polychrome print was well into the final stage of the period of decline. Other talents were still to emerge, perhaps the liveliest and most original being Shofo Kyosai (1831–89), but by 1868, a year of political conflict and the beginning of the Meiji restoration, the *ukiyo-e* movement was a spent force. Prints in general, increasingly mass-produced, became more and more complex and elaborate, even extravagant, in colour and design, finally deteriorating into either vulgarity or melodrama. Various attempts were made in the late nineteenth and even the early twentieth century to revive the art, but in spite of the fact that the standard of craftsmanship in both block cutting and colour printing – though not the quality of all pigments used – had evidently not declined, all attempts, however well intentioned, were short-lived.

THE DEVELOPMENT OF THE MODERN RELIEF PRINT

Although traces of Western influence had been apparent in *ukiyo-e* prints as early as the eighteenth century, Japanese influence on the pictorial art of the West was virtually non-existent until the latter half of the nineteenth century. The French seem to have been the first to recognize the unique qualities of the Japanese

Opposite: Ando Hiroshige (1797–1858), 'Iris Garden', from *The Hundred Views of Edo*. Original in colour, 13 $\frac{1}{16}$ × 8 $\frac{13}{16}$ (33.2 × 22.4).

Félix Vallotton (1865–1925),
Le Bon Marché, c. 1893. 8 × 10¼
(20.2 × 26.1).

woodcut, although Whistler and Rossetti in England were considerably influenced by it. The first major public exhibition in Europe of Japanese prints took place in the Paris Universal Exposition of 1867. A hundred prints were shown in the Japanese section, and all had been sold when the exhibition closed. These particular prints are known to have been the work of later and somewhat lesser exponents of the *ukiyo-e* school. Japanese prints subsequently began to appear in Paris in steadily increasing numbers. By the 1880s the earlier *ukiyo-e* masters – Harunobu, Kiyonaga and Utamaro and, of course, Hokusai and Hiroshige – had also become more widely known, and their obvious superiority over all later artists was generally acknowledged. The influence of the Japanese colour print on French art during the latter half of the nineteenth century is evident in much of the painting; it is no less evident in the prints of the same period, even though these were, for the most part, etchings and lithographs.

The revival of interest in the practice of woodcut printmaking, which had been largely ignored by both painters and engravers since the early eighteenth century, has generally been attributed to Paul Gauguin. But although there can be little doubt that Gauguin's prints were to have as great an influence on the subsequent development of the woodcut as the Japanese prints had on the nineteenth-century painters, he was by no means the only artist, nor even the first, to take up the neglected art of the woodcut. In 1891, two years before Gauguin began to make prints from carved woodblocks, the Swiss artist Félix Vallotton, a member of a group known as The Nabis, had already produced the first of his 145 woodcut prints. In common with other members of the group, he owed much to Japanese art, as well as to earlier and more primitive art. Vallotton was, in the real sense, a professional artist – an accomplished designer and illustrator and an experienced commercial wood engraver (at that time wood engraving was still a popular technique for illustrating magazines). His interest in the flat, formal pattern and clear, assertive outline

characteristic of so many Japanese prints found particular expression in the form of woodcut printmaking. A common feature of the prints he produced during the nineties is the forceful, contrasting use of simplified black and white shapes unrelieved by half-tones and textures.

Other artists who made extensive use of the woodcut at that time included Emile Bernard, Henri Rivière and Auguste Lepère: the last two also employed water-based inks to make colour prints in the Japanese manner.

In 1893, Gauguin returned from the first of his journeys to Tahiti and began work on a series of woodcuts. These were conceived in collaboration with the poet Charles Morice as illustrations to Gauguin's Tahiti journal *Noa Noa* ('Of Fragrant Earth'). Like many French painters of the late nineteenth century, Gauguin was an admirer of Japanese prints; unlike most others, he was also deeply interested in primitive art, a subject which he seems to have introduced to, or at least promoted in, The Nabis. His approach to the woodcut was quite different from that of Vallotton. Though new to the woodcut, Gauguin had already made a number of lithographs; he had also, during his stay in Tahiti, carved some relief sculpture, apparently influenced by Maori carvings, although some authorities recognize Indian and Egyptian as well as purely local influences. In carving his woodblocks for printing, he used the same basic tools – a knife and a carpenter's gouge – as for sculpture, although he is known to have employed less conventional tools, such as needles and sandpaper, as well. His technique, compared with that of the *ukiyo-e* artists, was in part rough and crude; he seems to have deliberately chosen to emulate the much earlier, primitive Japanese prints rather than the later, more refined and more familiar works by artists such as Utamaro and Hokusai. It would in any case have been almost impossible for him, without the benefit of Japanese experience, to have

Paul Gauguin (1848–1903), *The Bearer of Bananas, c.* 1897. 6 × 11 (16 × 28.7). Gauguin's style, with deliberately rough edges and gouge-marks clearly visible, contrasts starkly with the refined Japanese prints being imported into Europe at that time – although Japanese influence can be discerned in his carefully balanced distribution of forms.

matched their technical accomplishments. Yet Gauguin used many of the conventions of the Japanese print. He freely exploited the grain and surface qualities of the woodblock, but often left areas of the surface intact to print as a solid black. Areas of texture were achieved by intermittent and shallow gouging followed by a light inking, which gave a mottled and luminous effect, and by extremely fine, closely laid white lines to create grey half-tones. Quite often the more important shapes, such as figures, trees and even letter forms, were surrounded by a pure white to give them maximum contrast and emphasis. But there is a lack of formality in the cutting of the outlines and a softness in tonal variation which is quite different from *ukiyo-e* work.

Most of the *Noa Noa* prints were made with black ink on a warm-toned paper. As the series progressed, Gauguin also made increasing use of coloured inks and overprinting. It seems that, because of the variety of the cut mark – fine white lines and shallow textures – he experienced difficulty in printing an edition from the blocks. It was obviously necessary to use a soft roller to enter the open textured areas, and this meant that the fine lines filled up with ink. He frequently adjusted the amount of ink on the block by localized wiping, and in fact the final printed effect relied heavily on the inking and printing processes.

The series was produced during the period 1893–5, in Brittany: Gauguin seems to have worked on all the blocks more or less together rather than completing one at a time. It was almost certainly these prints which enhanced his fame as an artist and earned him the reputation of having rediscovered the woodcut, thus introducing a new technique into the creative printmaking of the age. They can be regarded as the first essentially modern woodcut prints. They were certainly to impress Edvard Munch, and were a dominant influence on the German Expressionist printmakers, although the Expressionists may well have taken more from the later prints made in Tahiti in 1899.

Gauguin also produced some single cuts, including those made at Pont Aven in 1894. The following year he returned to Tahiti, where he was to remain until his death in 1903. During this last stay he made further woodcuts, often combining text and pictorial content, for the monthly broadsheet *Le Sourire*. These later prints were generally made in black or brown on a thick Japanese paper, and frequently involved overprinting with additional blocks and stencils, and even printing through tissue paper to increase the tonal range. An average numbered edition from each separate block or set of related blocks ran to about twenty-five or thirty prints.

In 1896, the Norwegian artist Edvard Munch was working in Paris at the lithographic workshop of the printers Clot and Lemercier. It seems probable that he had by then seen the black and white prints of Vallotton and the earlier prints of Gauguin; at any rate, he took up the technique of woodcut printmaking, and began to experiment with colour printing. Like Gauguin, Munch also approached the medium with a deal of technical ingenuity. He quickly developed his own methods of colour printing, using two or more blocks for multi-colour printing, and gradually

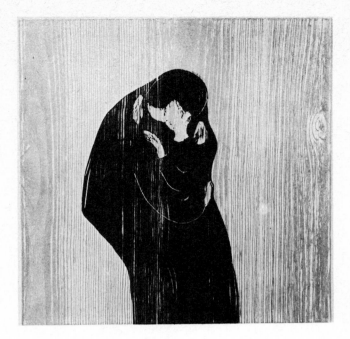

Edvard Munch (1863–1944), *The Kiss*, 1902. 17½ × 17½ (44.5 × 44.5).

advanced the art of the woodcut beyond even Gauguin's remarkable achievement. ›

In terms of technique, and particularly of the manipulation of the printing surface, he introduced several innovations which in many ways determined the future development of relief printmaking. For instance, he made much use of the wood grain and figure, deliberately selecting blocks of pine, spruce or mahogany. He also devised new ways of printing in colour from separate blocks or pieces of blocks, using various saws to cut a block into sections and inking each section with a different colour before reassembling them for printing. In many cases he would cut along the contours of the main shapes – around a head or figure, for instance, or between landscape and sky (see p. 118). His colours, which included watercolour and oil paint, were applied with a roller or occasionally with a paintbrush.

It was largely due to the work of these three artists that woodcut printmaking came to be recognized as an independent graphic medium capable of being used as creatively as either etching or lithography. Prior to Gauguin's *Noa Noa* series, the woodcut had been primarily a facsimile process, regarded as a rather coarse form of engraving on wood and, at best, as a method of interpreting drawings.

Although Munch continued to make his highly individual woodcut prints throughout a long and unusually productive working life, it was his earlier graphic works – those made around the turn of the century – which had the more direct influence on the subsequent development of the modern European woodcut.

In 1905 in Dresden four young architects – Ernst Ludwig Kirchner, Fritz Bleyl, Erich Heckel and Karl Schmidt-Rottluff –

Ernst Ludwig Kirchner (1880–
1938), *Five Coquettes*, 1914.
22¾ × 16¾ (57.8 × 42.6).

Karl Schmidt-Rottluff (1884–
1976), *Head of a Girl*. 15¾ × 7⅛
(40 × 18.1).

formed themselves into the group known as *Die Brücke*. These
four were soon to be joined by Max Pechstein, and for a short
while by Emil Nolde and Otto Mueller; all were to play leading
parts, especially in the field of graphic art, in the emerging Expres-
sionist movement in Germany. The woodcut, its potentialities
revealed anew by Gauguin and Munch, was recognized as an ideal
medium for Expressionist art. Its natural severity – the simplifica-
tion of stark black and white forms cut directly into the wood-
block, the ragged, splintered edge, the angular, almost brutal cuts –
suited the intensity of the *Brücke* approach, which has been
described as one of 'stressed romanticism'.

From the first, Kirchner was the dominant figure within the
group. His works may appear, in their psychological content as
well as in style and technique, to show the influence of Munch,
but this was denied by Kirchner, whose graphic style owed much
to other sources: to his interest in much earlier German woodcut,
and particularly the work of Dürer, for example, and in the primi-
tive Indonesian woodcarvings in the Ethnographical Museum in
Dresden. In his colour prints, he soon abandoned the convention
of a black-line or outline block and worked in areas of pure colour
(see p. 117). Schmidt-Rottluff's woodcuts are even more 'agitated'
in their direct, expressive style. Those of Heckel and Pechstein are
vigorous, but rather less aggressive.

The graphic work of *Die Brücke* was extremely plentiful: quite apart from numerous lithographs and etchings, Pechstein is said to have completed 160 woodcuts, Schmidt-Rottluff 300, and Heckel as many as 360. In the early days of the group's existence, poverty meant that many of their relief prints had to be printed on the cheapest paper, such as wrapping paper, using inferior paints instead of printer's inks.

Emil Nolde was associated with *Die Brücke* for a year (1906–7), but for the most part he worked independently of any group or movement. He is chiefly known for his watercolours of turbulent landscapes and for his etchings and lithographs, yet his woodcuts, initially inspired by the early work of the *Brücke* artists in 1906, are as powerful and individual as any by the Expressionists.

Other German artists more or less closely associated with the Expressionist movement who worked in woodcut included Conrad Felixmüller, Max Beckmann, Christian Rohlfs, Ernst Barlach and the sculptor Gerhard Marks.

By 1911 another movement, separate from but not entirely unrelated to *Die Brücke*, had been established in Munich. The group, which took the name *Der Blaue Reiter* from the title of a painting by Wassily Kandinsky, included Kandinsky, Franz Marc, August Macke, Heinrich Campendonk and, later, Paul Klee. Several other artists joined or were associated with the group, but on the whole they contributed less graphic work than either Kandinsky or Marc.

Both of the latter – co-editors of the *Blaue Reiter Almanac* – made extensive use of the woodcut medium; the main interest in

Erich Heckel (1883–1970), *Clown in front of a Mirror*, 1932. 8¾ × 7½ (22.2 × 19).

Wassily Kandinsky (1866–1944), illustration from *Klänge*, 1913. Original in colour, 11⅛ × 11 (28.3 × 28).

their work is stylistic, for they used woodcut during the formative stages of the development towards abstraction. This development is apparent in the fifty-six woodcuts Kandinsky made in 1913 to complement his poetical work *Klänge*, and in his few cuts for *Über das Geistige in der Kunst* ('On the Spiritual in Art'). Their prints are rather less forcefully cut than those by *Brücke* artists; the quality of the particular woodblock was seldom an important consideration in the design. Some have the deliberate, controlled look of a brush-and-ink drawing, and many could be mistaken for lino cuts; Kandinsky did, in fact, make numerous lino cuts. Marc is recorded as having made twenty-one woodcuts. The total output of graphic art made by *Der Blaue Reiter* was substantially smaller than that of *Die Brücke*.

Other artists who were, for a time, associated with the group include Lyonel Feininger, Moissey Kogan and Hans Arp. Fein-

Lyonel Feininger (1871–1956), *Street in Treptow*, 1931. 9¼ × 13 (23.5 × 33).

Käthe Kollwitz (1867–1945),
Death with Child in Lap, 1921.
9⅜ × 11¼ (23.8 × 28.6).

inger's approach to the woodcut was clearly influenced by French Cubist ideas and by his contact with Delaunay; his work has little in common with that of *Die Brücke* or Kandinsky. Landscape and architectural themes predominate, and the prints are characterized by their vibrant, linear structures; they are spacious, but because of the absence of conventional perspective the broken planes are almost two-dimensional. The Russian artist Kogan was extremely versatile, producing, as well as woodcuts and lino cuts, a wide range of work in different media. Arp was one of the original *Blaue Reiter* group in Munich in 1912, co-founder of the Dada movement in 1916, and closely associated with the Surrealists. His graphic work consists mainly of woodcuts, many abstract.

One of the most individualistic of the German artists working in woodcut was Käthe Kollwitz, whose long career began in the 1880s and lasted until her death in 1945. Most of her woodcuts – part of a vast output of graphic art – date from about 1919. Kollwitz is sometimes grouped with the Expressionists, but her work remained relatively unaffected by the drastic changes that occurred in art during the early years of the twentieth century. In general, her subject-matter differed from that of most of her contemporaries: she was deeply concerned with social problems, and her prints depict in a strong, simple and very direct manner the more tragic aspects of life. Of particular interest is the series on the theme of *The War* (1923).

Another artist concerned with social rather than purely artistic problems was the Belgian Frans Masereel. A series of woodcuts on the theme of *The Dead Awake*, made in 1917, earned him a considerable reputation in Germany during the twenties. He used a simple, illustrative style, influenced by primitive and folk art and to some extent by Expressionism.

Raoul Dufy (1887–1953),
Fishing, 1912. 12⅝ × 15¾
(32 × 40).

In France, the woodcut, and eventually the lino cut, developed along rather different lines. After Gauguin and The Nabis, the most notable of the numerous artists to take up the woodcut were André Derain, Raoul Dufy and Maurice de Vlaminck, all of whom belonged to or were associated with the Fauves. On the whole, French woodcut during the earlier part of the twentieth century was characterized by its freer, more fluid line and by its decorative qualities: abstraction was much less apparent than in Germany.

The sculptor Aristide Maillol, friend of Maurice Denis and other members of the Nabis group, produced woodcut illustrations for works by Virgil (*Eclogues*, 1926), Ovid and Longus (*Daphnis and Chloe*, 1937). These small woodcuts break no new ground technically – indeed, they are reminiscent of fifteenth-century Italian black-line cuts – but they are interesting for the quality of the drawing and the expressive, entirely sympathetic use of the medium. The illustrations for his first book, the Cranach Press edition of the *Eclogues*, were apparently cut by Eric Gill, who must take some of the credit. Maillol's evocative treatment of landscape – in perfect accord with the writings of Virgil and Longus – was the outcome of his travels in Greece in search of material for the books.

Lucien Pissarro's woodcut illustrations for the many small books he designed, printed and published through his own private press (the Eragny Press) are well worth close examination, al-

though, like most private press books, they are now difficult to get hold of. The twelve coloured woodcut illustrations designed by his father Camille (*La Charrue d'Erable*, 1912) are technically outstanding examples of relief printing in colour. Lucien invariably printed in four to five colours, often using a dark green key block to create an unusually rich and varied polychrome effect.

The private presses did much to encourage a renewed interest in the woodcut and to an even greater extent in the closely related technique of wood engraving, which was to flourish so remarkably in the 1920s and 30s.

Among other European artists whose output of graphic work includes a substantial number of original relief prints, mostly made during the first half of this century, are Otto Freundlich, Gustav Heinrich Wolff, Ewald Matare, Otto Dix, Marcel Gromaire, Karl Rossing, Joseph Fassbinder, Peter Lipman-Wulf, Luigi Spacal, Karl-Heinz Hansen and Palle Nielsen.

The majority of artists who made woodcut prints between 1905, when *Die Brücke* was formed, and the Second World War, during which several important artists died, produced work that was distinctly figurative or pictorial – obvious exceptions being Kandinsky and Arp. There can be little doubt that prints made by artists belonging to or associated with *Die Brücke* or *Der Blaue Reiter* have seldom been surpassed for originality, vigour and intensity. In the development of European graphic art, no other period since the sixteenth century had been richer in quality or quantity. A significantly high proportion of the most original works produced were made by painters or sculptors as opposed to graphic artists or printmakers, although this is no longer the case, presumably because printmaking has become increasingly 'acceptable' during recent years. Since the twenties and thirties, traditional relief printing techniques have continued to thrive, particularly in Germany and in eastern European countries, where there is a long tradition in this form of graphic art; although in England and elsewhere the relief print has for some years been noticeably less popular than either etching or lithography, and far less so than screen printing.

The European graphic tradition is still evident in American printmaking; indeed, a significant number of senior American graphic artists of distinction emigrated to America from Germany and eastern Europe. But many younger American relief printmakers derive much from contemporary Japanese prints, and the Japanese, in turn, have derived much from contemporary American painting. A large proportion of the woodcut prints by living Japanese artists could be described as largely abstract or, at least, non-figurative; in common with much contemporary printmaking, they have a superficially 'international' look. But in the best work the traditional qualities of the Japanese print, the subtlety of colour and delicacy of line and texture, are still apparent; these are quite unlike the essential qualities of, say, an eastern European print, many of which are still illustrative and owe much to folk art. English artists unfamiliar with recent Japanese work can now refer to two enlightening books on the subject: the techniques are dealt with in Robertson's *Contemporary Printmaking*

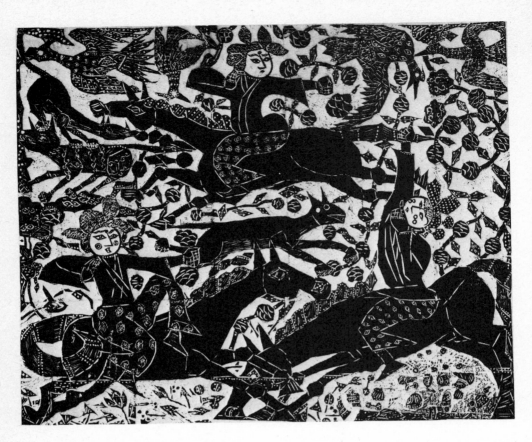

Shiko Munakata (b. 1903),
Flower Hunting Mural, 1954.
51⅞ × 55 (131.7 × 139.7).

in Japan, and Blakemore's *Who's Who in Modern Japanese Prints* describes and illustrates the work of 105 leading artists. Probably the best known and respected of all contemporary Japanese woodcut artists is Shiko Munakata, who must now be rated as one of the leading printmakers in the world.

In England, chapbooks and 'catchpenny prints' were commonplace throughout the eighteenth and early nineteenth centuries. Crawhall's reprints of chapbook ballads in the 1880s, William Nicholson's colour woodcuts, Ricketts' and Shannon's Vale Press illustrations – inspired partly by Morris's Kelmscott Press and early Italian work – and the prints of Edward Gordon Craig reawakened interest in woodcut and eventually in wood engraving.

Apart from the woodcuts of Edward Wadsworth, with their stark but carefully balanced patterns of black and white, and leaving aside the relief prints of Paul Nash, since these would seem to be best considered in the context of wood engraving, relief printmaking in England remained somewhat insular until the fifties, although the comparative scarcity of relief prints by professional artists makes generalizations on style and influence difficult. The artist-designer Edward Bawden has produced a large and extremely varied body of graphic work, including numerous lino cuts – a medium he has dominated for years in England – several of which are unusually large in scale. Bawden's lino cuts

Edward Wadsworth (1889–
1949), *Liverpool Shipping*, 1918.
10¼ × 7⅞ (26 × 20).

are characterized by his distinctive style and compositional in-
genuity, and not least by a sense of humour, a quality not often
found in contemporary printmaking. Michael Rothenstein is
perhaps the most widely known relief printmaker working in
England; he was particularly influential as a teacher during the late
fifties and early sixties. His books on the subject are still the most
authoritative works on the experimental approach to surface
printing, especially from ready-made or 'found' surfaces. Rela-
tively few contemporary English painters make woodcut prints;
one notable exception is Philip Sutton, whose multi-colour prints
– using a straightforward 'jigsaw' method on plywood – are
among the most impressive examples of relief printing in colour,
both in conception and in the craft of printing.

In the USA, relief printmakers are not quite so exceptional.
Although woodcut has not, of late, been the most commonly and
widely practised medium, some splendid work has been and still
is being produced. Among the internationally known artists work-
ing in America who have made extensive use of the woodcut are
Antonio Frasconi, Leonard Baskin and Carol Summers.

Some excellent examples of modern woodcut printing are found
in the finely printed, limited edition book, usually published by
the private presses. Such books are regarded as a 'major vehicle of
artistic expression', but they are inevitably expensive, and are

normally sold to private collectors or libraries. The artists' contributions – which may be illustration or decoration – are therefore not generally available, except as isolated examples in cheaper books or periodicals.

Although it is hardly common practice, contemporary graphic or typographic designers do occasionally employ the woodcut to print text and image for posters, broadsheets and other ephemera, but this tends to be confined to rather specialized work of a limited production. One of the finest modern typographic designers to have incorporated woodcut printing into his work is Hap Grieshaber. Also of considerable interest is Hendrik Nikolaas Werkman, a highly individual artist–printer executed by the Gestapo for his clandestine printing activities in wartime Holland.

To examine the development of woodcut in eastern Europe would require a separate book. The subject seems to be thriving far more than in many Western countries. Other countries where there is a strong and lively interest in relief printmaking include Mexico, several Latin American countries, and China. The best opportunity for students to study such work is offered by the International Print Biennales, though journals or magazines such as *Artist's Proof* are invaluable sources of information.

Philip Sutton (b. 1928), *Storm, Wiltshire*, 1962. 20 × 20 (50.8 × 50.8).

2 Materials and their uses

Any material from which relief prints are to be made – particularly if a large number of duplicates is required – must be durable enough to stand up to the repeated inking and printing without wearing out prematurely, and should remain stable enough for consistent, accurate registration. It must also be capable of being worked easily and freely with sharp tools, cutting cleanly without crushing, tearing or splintering – unless these effects are sought, in which case they will need to be 'fixed' and maintained in a static condition during the printing of the whole edition. Clearly, these conditions are fulfilled by a wide variety of materials, but because of its relatively low cost, general availability, durability and variety of density, texture and figure, the most practical and versatile of all relief-printing surfaces is still probably the wood-block.

In this section I have concentrated on those materials that can be repeatedly re-inked and reprinted to give exactly the same impression on a series of prints. In fact, the emphasis throughout the book is on making duplicate prints or multiples. The internationally accepted definition of an original print quite clearly excludes the monoprint or any unique or 'one-off' printed effect. While this definition has to be considered, it should not be allowed to inhibit an open-minded, questioning and genuinely experimental approach. One way of preventing the activity of printmaking from becoming too dependent on conventions and predictable effects is to widen the range of mark and texture and image, thereby extending the subject towards the fields of monoprint and drawing; for this reason I have included certain materials and methods with which it is difficult or even impossible to make identical prints. These range from the soft and fragile materials (fabrics, organic matter), which in certain cases might yield a number of similar if not absolutely identical impressions, to mono-printing itself, which is not intended to.

PLANK WOOD

It is obviously possible to cut a design into, or print directly from, an extremely wide range of wood surfaces: all kinds of wood, in all kinds of condition, are employed with considerable ingenuity by contemporary relief printmakers. But the range which can be fairly easily cut or carved with a degree of control and freedom is far more limited. Of all the species of timber that are readily available, at reasonable cost, from local timber merchants, only a

dozen or so will give fine, clean lines and solid, comparatively untextured areas, and permit relatively free cutting or gouging both with and across the grain without leaving a torn or splintered edge.

There is no standard or ideal timber suitable for every conceivable design; indeed, the image itself may well be conditioned by or even derived from the individual character of the wood. The choice of wood will clearly depend on a number of factors such as its overall dimensions, its individual characteristics and its 'working properties'; the latter can only be taken fully into account with experience. More often than not, the purely practical considerations of availability and cost tend to play a significant part.

The term 'grain' is often used very loosely to describe the appearance of the wood. Strictly speaking, 'grain' refers to the direction of the fibres in the wood; 'straight grain', for example, means that the fibres are parallel to the edges of the tree trunk. The word 'figure' is used to describe the pattern on the surface of the block formed by the growth rings indicative of age and by the particular character of the grain. 'Texture' refers to the number and size of the cell cavities; a fine-textured wood has small cell cavities, and is therefore far more suitable for fine work or solid unbroken areas of colour than a coarse-textured wood such as oak.

The woodblock used in woodcut printing is normally a section of plank which has been sawn along or parallel with the grain rather than across or at right angles to it, and is often referred to as 'plankwood'. A block which has been prepared by sawing across the grain is known as an 'end-grain block', and is chiefly associated with the technique of wood engraving.

A block of plankwood can be either hardwood or softwood. The categories are botanical, based on the structure of the wood, and need not greatly concern the printmaker: as a rough and ready guide, however, hardwoods are mostly deciduous and softwoods mostly conifers – usually evergreen. A wood which is literally soft is obviously far less suitable for cutting into than one which is harder. Ideally, the woodblock needs to be tough enough to withstand the action of cutting without crumbling at the edges or chipping, and to support the rigours of constant inking and printing, often under direct heavy pressure, without breaking down and splitting.

Hardwoods

For fine work and an even printed impression – as well as for large editions – the plankwood should be fairly hard and dense, with a fine, close, regular texture and a smooth planed surface, preferably free from knots. The best woods for this purpose are cherry, pear and apple – all hardwoods. Such fruitwoods can be cut or gouged with comparative ease in any direction and give a clean, smooth edge to a line and an even, consistent impression. Japanese woodblock cutters employed cherrywood almost exclusively throughout the period of the *ukiyo-e* print – the best possible recommendation, when one considers the exceptionally fine detail they achieved – and cherry is still favoured by many contemporary

Japanese printmakers. Fruitwoods unfortunately rate as a speciality item in parts of the USA; in Europe they are not always generally available from local timber merchants, although specially prepared blocks, usually of excellent quality, are supplied by certain dealers in artists' materials. These blocks are inevitably more expensive and usually smaller than unplaned wood bought directly from the local woodyard.

Other highly recommended hardwoods include sycamore, lime (linden), beech, chestnut, maple, willow and haldu. All share in varying degrees the 'working qualities' of the fruitwoods, although they tend to be rather more difficult to work with. Plank sizes in the woodyard vary somewhat, but a 'large' plank is generally about 16 in. (40 cm) wide.

Makore (sometimes known as cherry mahogany) is another useful timber, being relatively finely textured and usually straight-grained, with good working qualities. It appears to be readily available in the UK, and is supplied in planks up to about 24 in. (60 cm) wide. African utile is also worth trying: planks may be up to 21 in. (53 cm) wide. Mahogany (African, Honduras, Brazilian etc.), although rather less suitable, having a somewhat obtrusive textured surface, should not be dismissed; plank widths seem to be somewhat smaller than those of either makore or utile.

Boxwood and holly, being far too hard for normal wood-cutting purposes, are more suitable for wood engraving. Balsa, the lightest hardwood, is unsuitable for most relief-printing purposes, although it can be usefully employed for experimental surface printing in the school art class.

Softwoods

The most useful softwoods are pine (clear, white, yellow or parana pine – common pine is cheaper but contains more knots) and poplar (known also as American whitewood or basswood). Both are cheap (most softwoods mature far more quickly than hardwoods) and readily available, and are supplied in larger sizes than most of the hardwoods.

Pine tends to be too soft for fine lines or precise detailed work, but is excellent for large, solid areas and coarser lines and texture. It is easily scratched or bruised, but it is possible to harden the surface before cutting by coating it thinly with shellac, diluted with about 50 per cent alcohol for greater penetration. When dry, the surface should be rubbed smooth with sandpaper. It is essential to use only the sharpest knives and gouges in order to cut cleanly across the grain, otherwise the tools will tear and pull at the fibres, giving a rough, broken line or edge. Poplar is a little harder than pine, and therefore rather more suitable for fine work.

Unseasoned softwood is to be avoided: more often than not it will split during cutting. 'Wet' wood containing a high proportion of resin also tends to curl up and split, and is in any case difficult to work. Poplar blocks are usually made from strips glued edge to edge rather than sections of solid plank, and are therefore much less liable to warp. The surface is usually excellent for cutting.

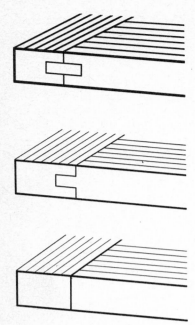

Fixing strips of wood to the ends of the woodblock to prevent it from warping: *top*, tongue-and-groove joint (loose tongue); *centre*, tongue-and-groove joint (half-tongue); *bottom*, edge-gluing.

In the UK, further information on woods traditionally used for woodcut can be obtained from two authoritative bodies, the Timber Research and Development Association and the Building Research Advisory Service of the Department of the Environment.

Buying and preparing timber

Few timber merchants are prepared to handle the small individual order that the majority of printmakers might place, and most are unwilling to cut a section of two feet or so from a standard plank eight feet long, especially in the case of the more expensive hardwoods. It is difficult to generalize on a situation which can vary so much from yard to yard, but most local merchants will insist on a minimum order charge which will probably amount to at least the cost of a whole standard-length plank.

Teachers in college printmaking departments can always requisition their supplies from the woodyard – either from local or from specialist dealers – and many timber merchants clearly prefer to deal with 'official' orders. Planks can then be cut to individual student requirements within the department. Independent printmakers will need to be rather more resourceful in finding suitable wood, but they should at least be able to select their own planks, thus avoiding 'degrade' wood which has split, warped or cracked during seasoning.

Planks are usually measured and priced as sawn: planing reduces the thickness of the plank by about ⅛ in. (3–4 mm), and will naturally add a little more to the cost. The thickness of the woodblock is not a particularly crucial factor if the print is to be made by burnishing; if it is to be made on a conventional letterpress printing press, then the thickness of the block should be not more than 0·918 in. (23·3 mm) – the height of the type for which the press is normally adjusted. Blocks of plywood or linoleum thinner than this can easily be built up to the required height.

Timber stacked in yards – usually in open seasoning sheds – is bound to contain moisture, and should be allowed to dry out gradually by storing it for a while in the workroom until it has 'acclimatized'. Avoid storing a damp plank too close to radiators: sudden or extreme changes in temperature can cause the wood to split or warp. A relatively wide plank – say 18 in. (45 cm) or over – which is less than 1 in. (25 mm) thick is more susceptible to warping than a comparatively thick plank, although even the thickest planks can warp quite drastically. Blocks substantially thicker than 1 in. are too thick for most letterpress printing presses, but they can sometimes be printed on the platen press – and, of course, by hand.

To a large extent, a block can be prevented from warping by fixing strips of wood of the same thickness along the ends of the block with their grain running at right-angles to the grain of the block. Tongue-and-groove joints seem to be the best method of fixing the strips, but edge-gluing may be adequate. Alternatively, plankwood blocks less than ¾ in. (19 mm) thick can be glued to a plywood base (two- or three-ply) to ensure greater stability. It is advisable to do this before cutting into the block.

Slightly warped blocks are not difficult to burnish by hand, but cannot be printed on the flat bed of a press, especially a letterpress machine. Perhaps the simplest and most effective way to straighten a warped block is to dampen it thoroughly (for example by steaming), and then place it under very gradually increasing pressure. It is easiest to do this with an adjustable screw press, but if none is available the block should be laid on a hard, flat surface and weighted, the weight being progressively increased as the wood dries out and straightens.

Apart from planks bought from the woodyard and the specially prepared blocks bought from a dealer, the other main sources of plankwood are discarded furniture (although this is no longer the rich source it used to be now that so much is used for the reconstruction of 'antiques') and derelict buildings. Most timber rescued from old property will no doubt be partially decayed, but it should not be too difficult to find pieces which, when cleaned up and sanded, are still sound or at least in reasonable condition. The textured qualities found on many of these worn and weathered timbers are extremely varied, although their working qualities are not likely to be very good. They should be regarded as 'ready-made surfaces', to be enjoyed more for their own sake than as conventional working surfaces; the dangers in relying on what are often undeniably attractive surfaces should be obvious.

To some extent a waterlogged or rain-soaked plank can be 'force-dried' by standing it upright in front of a stove or close to a radiator – rather drastic treatment, but with weathered, partially decayed wood it is a risk worth taking.

If wide planks are not obtainable – and good quality hardwood planks wider than 12 in. (30 cm) are not always easy to find – blocks can be made up by gluing several narrow planks together. The standard method is tongue-and-groove, which is more stable than simple edge-gluing, though the latter may suffice if a good glue is used and firm, constant pressure applied with clamps. The maximum size of a woodblock is limited only by a few purely practical considerations such as the size of the bed on a printing press and the size of the printing paper. Few printing presses will take a block larger than about 2 ft × 3 ft (60 cm × 90 cm), and very few hand-made or similar quality papers are larger than 40 in. × 27 in. (1016 mm × 686 mm) (Double Elephant). If the block is to be printed by hand and a paper other than hand-made quality is to be used, these restraints clearly do not apply. However, really large woodblocks which require the largest of the generally available Japanese papers – normally 71 in. × 31 in. (1803 mm × 787 mm) – present some formidable printing problems; consequently, relief prints larger than Double Elephant are relatively uncommon.

Woodblocks cut from softer, more open-textured woods can be hardened by coating them on both sides with boiled linseed oil, which may also help to prevent warping due to humidity. Oiling must be carried out well before any cutting takes place. An oiled surface, when thoroughly dried, is inclined to accept ink rather better than raw, freshly planed wood; it is less likely to absorb the oil from the ink which so often results in poor quality printing, at

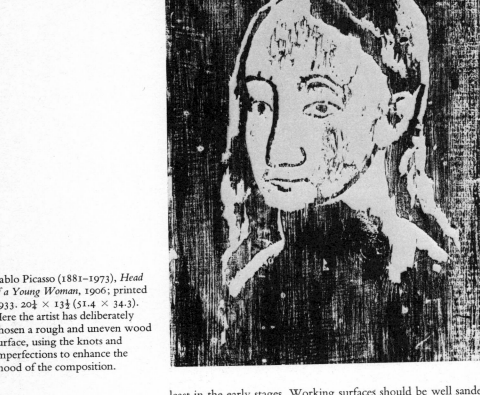

Pablo Picasso (1881–1973), *Head of a Young Woman*, 1906; printed 1933. 20¼ × 13½ (51.4 × 34.3). Here the artist has deliberately chosen a rough and uneven wood surface, using the knots and imperfections to enhance the mood of the composition.

least in the early stages. Working surfaces should be well sanded before oiling. Both sanding and oiling will generally improve the working surface of a woodblock.

The woodblock can, of course, be left unsanded or unplaned if a rough, textured effect is required. This will obviously apply more to those blocks chosen for their particular shape and figure and for the arrangement of knots, cracks and other imperfections carefully avoided by the purist and by those who require a more 'neutral' surface for controlled cutting. But even the most complex surfaces can usually be planed and sanded, and this may in fact be necessary to bring out the subtleties of a particular surface pattern. Alternatively, the texture of a block can be exaggerated by brushing the surface with a stiff wire brush or by scrubbing it with steel wool and hot water – the reverse of the protective oiling process.

Applying a solution of nitric acid to the surface will also emphasize an already obvious texture. First roll up the block with a thin coating of oil-based ink, then brush the solution on to those areas where the texture is to be heightened. As a rule, the stronger the acid solution and the longer it is allowed to soak into the wood, the more dramatic its effect will be; but this depends also on the kind of wood used. Accentuating a surface texture in such a way

is a somewhat drastic method that should perhaps be confined to 'reconditioned', cheaper or noticeably rough-textured woods that are not suitable for controlled cutting.

On certain plankwoods, especially reconditioned timber, grain can also be accentuated by lightly charring the surface of the wood with a flame: the soft parts tend to char more easily than the harder wood.

Oddly shaped blocks and conspicuously textured or patterned surfaces can be printed as complete images or as effects for their own sake with the absolute minimum of 'interference'; more often, individually interesting blocks are integrated with other blocks – perhaps totally different in character and shape – to form part of a complex design.

The surface of any woodblock can, of course, be deliberately marked, indented, textured or roughened in all kinds of ways, for example by scratching or filing with a wide variety of abrasive materials and sharp tools. There are no orthodox techniques for this; each printmaker must devise his own to suit his particular requirements. It is worth remembering, however, that the effect achieved on the block has to work on print; an interesting or attractive wood surface is not always equally effective when printed on paper. If it is to print clearly through an edition, the texture should be as positive and enduring as possible.

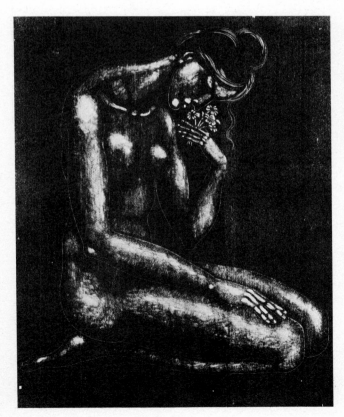

Ian Mortimer (b. 1934), *Nude Woman with Flowers*, 1972. $18\frac{5}{8} \times 15\frac{5}{8}$ (47.5 × 39). Prints such as this, taken from a relatively shallow and finely cut surface, with graduated tones, need very careful printing: over-generous inking or excessive printing pressure would almost certainly ruin the impression (see also chapter 6).

Although it is far more limited than the traditional hardwoods, plywood has certain advantages over plankwood for relief print-making: it is more generally available, in a far greater range of sizes, and is comparatively cheap. In addition, the thicker boards (over about 6·5 mm) are much more stable than many varieties of plankwood, especially the cheaper softwoods, and far less likely to warp; nor does plywood require further seasoning or any special treatment, apart from a final sanding, before use. Even the smallest local timber merchants carry stocks of assorted plywoods, and often sell generous off-cuts at reduced cost.

Thicknesses vary, but the readily available plywoods range from about 3 mm to about 22 mm. For woodcut purposes, the most useful boards are probably those between 6 mm and 12 mm thick, although, if these are not available, thicker – rather than thinner – boards can also be used. The outer skin of some of the medium-thick boards (9–12 mm) might be no thicker than 2 mm, or even less. For cutting into, a thicker skin is preferable, and this could mean a thicker board, since it is almost impossible, even with the sharpest tools, to cut cleanly down into and through the second layer, where the grain runs at right-angles to that of the first layer. The lines and cavities are therefore necessarily shallow, and unless they are correspondingly narrow they are liable to fill up with ink from the roller, especially from a soft roller. A hard rubber roller will give the best impression on fine work. This difficulty in achieving a sufficiently deep, clean-edged cut is one of the main problems when working into plywood. The outer layer of most plywoods, when cut or gouged, can usually be peeled away; an obvious exception to this is the 'marine' quality plywood, which for this reason should be avoided.

Some plywoods have a much thicker central layer or core, and are known as 'stoutheart'; others have alternate hardwood and softwood layers, and as such may also be too difficult to cut freely.

The types most frequently recommended for woodcutting are pine (especially the softer, less grainy type), birch, gum maple, poplar (basswood or American whitewood) and walnut, the latter being much harder and therefore more expensive. All these have reasonably good surfaces, enabling fairly detailed, controlled cutting, but most are inclined to splinter and chip unless cut with great precision and deliberation with the sharpest tools. Fir, cedar and mahogany plywoods are not regarded as workable surfaces for cutting, though they can be employed for printing large, fairly simple textural areas. Smooth, well finished plywood boards are probably unsurpassed for printing large, flat, clearly defined areas of colour, and may be used for underprinting or overprinting on multi-colour prints.

Plywoods with a special veneer (usually on one side of the board) are also employed in woodcut, notably by contemporary Japanese printmakers. Traditional fruitwood veneers tend to be selected for their cutting qualities, but surface texture and pattern should also be taken into consideration: katsura and silver magnolia are particularly interesting in this respect. Veneered boards

are more expensive than the less specialized plywoods, but should be cheaper and more readily available than most hardwoods in plank form.

The thickness of veneered plywood board varies from about 4 mm to about 12 mm, though imported boards seldom exceed 6 mm – just about adequate for working into.

If necessary, plywood boards can easily be backed with other thin boards to bring them up to the required height for letterpress printing.

COMPOSITION BOARDS

A number of other processed woods known generally as 'composition boards' may be considered for woodcut purposes, but are normally used only as supplementary surfaces, since few if any of them have any real advantages over plywood, and they may even be more expensive. Plain or normal grade chipboard is perhaps the least useful to the printmaker: its composition makes it totally unsuitable for cutting into, and it is of little use as a printing surface unless it too has been veneered. The make-up of blockboard is completely different, although its surface may be similar; like chipboard it is also available faced with various 'decorative' veneers. Provided the outer layers or veneers are thick enough to work into or interesting enough to print from, both substances may be of use.

WOOD VENEERS

Apart from their uses in the form of veneered plywood or composition board, individual sheets of different wood veneers can be cut into the required shapes and glued on to a wood base to form a collage-type surface. In such cases the surface character of the block is made by adding rather than removing material – although the block can, if necessary, be worked into. (This additive or collage approach is by no means limited to wood veneers; other materials which fall outside the scope of 'pure' woodcut are briefly described on pp. 78–81.)

A veneered surface may be printed as a complete image or composition in its own right, relying for its effect on the particular arrangement of wood textures and grain, or it can form part of a multi-block or multi-colour print – the latter alternatives being the most usual.

HARDBOARD

Hardboard (masonite) is one of the cheapest and most easily obtained of all relief printing surfaces. It is somewhat similar in the uniformity of its surface quality to linoleum, though not so easy to work into. Compared with plankwood and the more interesting

plywoods, its totally uniform surface is monotonous and predictable; but it will permit moderately fine detail and either free or controlled cutting and gouging, especially on the harder of the two main grades. The softer grade is perhaps too soft for most woodcutting purposes. Strong, sharp tools are absolutely essential, for the smooth, flat surface can be tough, slippery and unyielding. Shallow cutting is clearly unavoidable; but for large areas of colour – solid, broken or textured – hardboard compares favourably with plywood. For general printing, a fairly hard roller and a stiff ink are advisable. Hardboard is easily backed with other boards to bring it up to type height.

LINOLEUM

As a relief surface, linoleum has some of the working qualities of a smooth, fine-textured plankwood: it can be cut or gouged in any direction and is capable of quite fine detail, its surface has no obtrusive texture, and if handled with care it is durable enough to stand up to repeated printing without wearing out or breaking down.

The main advantages of lino over plankwood are that it is much softer and entirely uniform in density, and therefore easier to work; also, if a large surface area is required, linoleum is, or used to be, more readily available – although, if sheer size is the main factor, plywood might be a better alternative. Nor does lino warp, although it may need to be glued down to a board to prevent it from curling up during printing.

On the other hand, the surface of linoleum does tend to look and feel decidedly dull when compared with a block of attractively figured plankwood, especially one which is 'interesting' enough to suggest an idea. In fact, lino as a working surface is not as docile and mundane as it may appear, and it does have a very slight but definite texture, perhaps best described as granular. This texture is apt to show up on the print unless a fairly thick ink is applied; it can, of course, be utilized, or it can be completely removed by scraping the surface of the linoleum with a razor blade or by smoothing it down with fine sandpaper.

The best type of linoleum for relief printmaking is the domestic canvas-backed variety known as 'brown', 'cork' or 'office' lino, about $\frac{1}{4}$–$\frac{3}{10}$ in. (6–7 mm) thick. The minimum useful thickness is probably $\frac{1}{8}$ in. (3 mm) – less than this and it becomes difficult not to gouge through the canvas backing. The thickest and therefore the most expensive is the heavy-duty type $\frac{1}{4}$ in. or more thick (sometimes referred to as battleship linoleum), but this quality is not essential for most printmaking purposes.

Plain colours such as dark brown or light grey are obviously preferable to bright or mottled colours, though even these can be used if nothing else is available. A drawing made directly on to the surface with indian ink (a usual method) or even pencil will show up more clearly on the lighter colours, but it is easier to see the progress of the actual cutting on a dark surface. Inlaid, embossed or patterned lino is normally of little use to the printmaker.

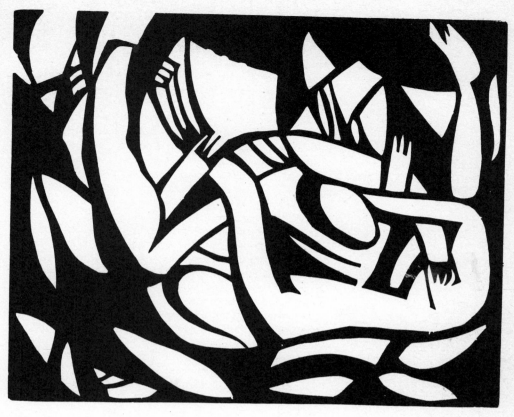

New lino tends to be rather too soft and crumbly for controlled cutting – ideally it should be fairly stiff and not too pliable – but if left for a few weeks it will gradually harden. Any which is too old and hard can be softened by warming it until it becomes more malleable. Soft linoleum is also more easily marked, and can be deliberately indented or pitted by impressing into it some hard, textured material such as grains of sand or sandpaper, wire or fragments of metal, and utilizing the heavy pressure of an etching press. If this is done, the roller and bed of the printing press must be protected with thin but strong cardboard.

To cut a section of linoleum from a larger piece, simply cut well into the surface with a sharp knife – preferably along a steel straight-edge for greater accuracy – then fold back the section until it breaks along the incision; turn the lino over and cut through the remaining canvas from the back.

Linoleum is easily built up to the standard height of type for letterpress printing by gluing it on to a block of wood about $\frac{3}{4}$ in. (19 mm) thick; pieces of lino larger than about 8 in. \times 10 in. (20 cm \times 25 cm) should normally be backed with wood anyway, for greater stability. It is probably more convenient to do this before working into the surface. After gluing, the block should be left under heavy weights until completely dry and flat. Fine adjustments can be made by placing additional padding under the block during the printing. If, however, the lino is to be printed

Henri Gaudier-Brzeska (1891–1915), *Wrestlers, c.* 1914. Lino cut, $8\frac{7}{8} \times 10\frac{7}{8}$ (22.5 \times 27.6).

on an etching press, a wooden backing is not necessary. Almost all the newer etching presses can be adjusted to take a woodblock 1 in. (25 mm) thick, but older ones will not easily take a block or plate thicker than ⅜ in. (10 mm).

Prepared blocks of linoleum mounted to type height on wood are supplied by many art shops, although they are usually rather limited in size and are naturally more expensive than the home-made variety. Linoleum used to be easily obtained from any large floor-covering or department store, but in recent years the popularity of vinyl floorings for domestic use has meant that the particular quality suitable for printmaking has become increasingly hard to find. It should still be possible to buy from stores supplying offices and industry rather than the home, and offcuts could well provide the cheapest source for most students. If the linoleum has been stored or delivered in a roll – it is usually sold in either 6 ft or 2 m rolls – it should be flattened out at the earliest opportunity, cut into manageable sizes, and kept flat.

Although linoleum offers little resistance to the knife and gouge, it contains a somewhat gritty, abrasive substance which will soon blunt the sharpest tools. To avoid slips, knives and gouges need constant resharpening. The comparative softness of the material can, of course, cause problems when cutting; even with sharp tools, slips are easily made and errors may be difficult, even impossible, to correct.

Linoleum invites bold, clean-edged cutting and is especially good for multi-colour printing.

As a cutting and printing surface, hard rubber has similar qualities to linoleum, and it is equally easy to cut. It is available in at least two thicknesses – 2 mm and 4 mm – and is useful for fine lines and flat areas, especially for additional colours. The flexibility of hard rubber in sheet form makes it an ideal material for rotary printing, i.e. as a relief surface wrapped around a roller for direct printing.

Etching linoleum

Different textural effects can be obtained by applying a solution of caustic soda (sodium hydroxide) to the surface of linoleum, a process which is, in effect, etching. The solution eats into the compact granular structure of linoleum, leaving a distinctly rough-textured printing surface. A shallow etch, therefore, will print as a textured or tonal area. White or uninked areas are achieved by deep etching, which creates cavities into which the roller cannot (or need not) penetrate.

The solution can be applied directly to the lino, but in order to control its action, and confine it to specific marks or definite shapes for maximum variety of effect, some form of surface protection or 'acid resist' is necessary. Stopping-out varnish as used in metal etching, or bitumen from hardware stores, will adequately protect the surface, but ordinary paraffin wax (candle wax) seems to be as good as anything, and is likely to be cheaper and more easily obtainable. White powder colour added to the wax makes it more opaque and easier to see on a dark-coloured linoleum.

Before applying the wax, all traces of grease should be removed from the surface of the linoleum, first with scouring powder and then with methylated spirits. The wax is heated until it melts – preferably in a double container, at a constant temperature to keep the wax hot, although a saucepan will serve almost as well – and is applied when semi-liquid, either as a free brush drawing or as a coating or wax ground covering the entire surface. In the latter case the design is then scraped or scratched through the wax with a variety of tools, thereby exposing the linoleum to the etch, which means that these exposed areas will appear white on a relief print. Conversely, if the wax is applied with a brush then the brush marks form the relief or positive image, and it is the remaining exposed surface which will appear on the print as the white or negative areas. A drawing made with hot wax must be made quickly; if the wax is allowed to become cool, it will soon thicken and turn opaque, and may not adequately seal off the surface from the soda. Whichever method is used, the resultant marks are more free and varied than those made with conventional cutting tools.

There is no standard mixture for a caustic soda etch; the proportion of water to soda is bound to vary somewhat according to circumstances. Like all corrosive liquids, though, a solution of caustic soda can be extremely dangerous if carelessly handled. It is essential to use only well diluted mixtures, not just for safety but also for greater control during the etching process. A dessert-spoonful – generous without being heaped – of caustic soda to one pint (about half a litre) of cold water should be adequate for localized etching.

It is necessary to stir this mixture thoroughly to prevent soda crystals forming, and since it tends to heat up it must be allowed to cool before use. The solution can be topped up and strengthened as it becomes progressively weaker.

Etching into lino can take anything from one to six hours, depending on the strength of the solution and the texture and depth of bite required. For instance, a coarse-textured but shallow bite may take an hour or so, whereas, with a similar mixture, large areas of deep etch may take six hours or even more.

Although it is possible to etch linoleum simply by leaving caustic soda lying on the surface, this is really only practicable for shallow etching where small areas of surface are exposed through relatively large areas of wax. When deep etching small, separate areas, it may be advisable to concentrate the solution by confining it to those areas. One way to do this is to build walls of plasticine, perhaps $\frac{1}{2}$ in. (13 mm) high, round each area; the solution is then carefully poured into the enclosures. Check the depth and condition of the bite every hour or so, pouring away, with the same care, the old, spent solution. Clean the bitten areas with a fairly stiff plastic or nylon scrubbing brush and warm water. If further etching is necessary, continue the process using fresh solution.

The most practical way to etch a larger block with extensive areas of exposed surface – especially if they require deep etching – is to immerse the whole block in a bath of solution, for example in a polythene or plastic dish or tray of the kind used by photographers for developing large prints and now in general use in

most etching departments of colleges. If such a bath is not available, build a plasticine wall 2–3 in. (50–75 mm) high round the edge of the block to contain the solution. This will be fairly expensive, but far cheaper than buying a new plastic dish. The solution required will be about ½ lb. caustic soda to a gallon of cold water (c. 230 g to 5 litres). Before completely immersing the linoleum block, protect the hessian back and the edges with a coating of PVA liquid plastic or a similar hard-drying substance to prevent unwanted 'foul biting'.

When the block has been sufficiently etched, wash it thoroughly in a sink filled with water – warm if possible. Old solution and the residue of lino are then removed with a nylon brush. Any remaining paraffin wax can be absorbed into a sheet of newsprint with a hot iron.

The block can be printed in the conventional manner, with ink applied only to the unetched or relief surface, or it can be printed with ink also applied to the etched or lower surfaces with a soft roller. The two methods – intaglio and relief – are often combined using different colours. The whole process of etching linoleum is described in more detail by Trevor Allen in Stephen Russ's *Complete Guide to Printmaking*.

CARDBOARD

Ordinary cardboard can be employed as a printing surface in a variety of ways. The simplest way is to cut the card into shapes and apply ink to each with a roller, perhaps applying a different colour to each shape. These are then assembled and printed, either separately by burnishing or simultaneously with a press. A more stable surface can be made by gluing the shapes to a plywood base. Depending on the quality of the cardboard – its composition, thickness and flexibility – the most elaborate shapes can be printed, but special care must be taken during inking and printing because of the relatively fragile nature of the material. The design, too, needs careful consideration if the card shapes are to survive the wear and tear of printing. This essentially two-dimensional jigsaw-puzzle method is used more for printing well defined areas of flat colour, which may be used in conjunction with other materials, such as wood or linoleum, for multi-colour printing.

A simple, quick and practical way of applying specific areas of additional colour to the card surface – or to any kind of relief or intaglio block – is by stencilling. This is normally done either by rolling the ink through a conventional cut stencil or over masking tape or paper shapes covering part of the block surface, or by placing paper shapes around the inked roller itself. Numerous variations on simple stencilling methods are described in Peter Green's extremely clear and concise book *Introducing Surface Printing*.

Other ways of employing cardboard for relief printing include the traditional cutting into and removal of the surface, and the building up of the surface in the manner of a collage. Most cardboards are easily cut, and the only tool necessary for most work is a

single-edged razor blade or a model-maker's knife, though this should be kept very sharp. Cardboard does not really lend itself to finely drawn detail or free cutting, but it should be possible to cut clean edges and definite or geometric shapes. Time can be saved by peeling away the surface of the negative areas within previously made cuts; this technique may also be used to provide a slight variation in the depth of the relief.

Much greater variations in depth can be achieved with a built-up surface, made by gluing specific shapes to a wooden base in successive layers. Prints made from such blocks are usually much more positively embossed, and are frequently printed uninked or only partially inked.

One effective way to print relief blocks made from cardboard is to apply a coloured ink into the lower areas with a soft roller and a different coloured ink to the raised portions with a hard roller. Applying two or more colours to a single plate in this way is normal practice when printing a relief etching.

The surface of a relatively soft cardboard is easily scratched or pitted, and this can be deliberately utilized by impressing hard, textured materials into the card with a printing press, particularly an etching press. The relief surface can also be enriched with a variety of cardboards or papers of different thicknesses and textures, as well as masking tape.

Other commonplace materials such as wire and flat pieces of metal can also be glued on to the card to form a simple collage surface. In the context of contemporary relief printmaking, such definitions as 'cardboard print' or 'collage' mean very little, serving mainly to indicate an emphasis on a specific material or a particular approach; a 'collage', for instance, usually entails a considerably wider range of materials and a correspondingly greater range of printed marks or imagery.

Whether the block is incised or built up or both, it will need sealing and hardening before printing. Sealers include gesso, lacquer, polyurethane varnish, and any similar substance un-affected by the usual cleaning solvents. A thicker, more plastic sealer such as an acrylic, applied with a stiff brush, will also provide an additional means of building up the surface. Fabrics and other soft materials can be stiffened to make them rigid enough for printing by soaking them in diluted Marvin medium or Uni-bond and leaving them to dry, if necessary covered with newsprint and placed under a weighted board. The newsprint is removed by damping it with water and peeling it away from the surface. When printing from cardboard, it is advisable to use only oil-based inks.

PLASTER

Ordinary builder's plaster is yet another of the many basic substances from which the most varied printed effects can be obtained. It can be used to build up a relief surface on a flat base, and for this purpose the tougher plaster known as gesso can be made by mixing

liquid plaster with a strong glue, preferably heated in an iron glue pot. Pearl glue, soaked in a little water for an hour or so before being heated, is often recommended.

Alternatively, plaster can be employed quite independently for relief modelling, carving, gouging or engraving. With reasonably careful handling, a block of dry plaster, strengthened internally, is hard enough for surface printing, if only by burnishing. The block is made by pouring liquid plaster into a simple wooden frame of 3 in. × 1 in. (75 mm × 25 mm) or 2 in. × 1 in. (50 mm × 25 mm) timber placed on a hard, flat surface such as plate glass. The mixture should be thin enough to pour and spread easily, and sufficient in quantity to make a block at least ¾ in. (19 mm) thick; it should be thoroughly stirred to eliminate lumps and air bubbles. It is essential, too, that the surface of the glass be perfectly clean, since this will form the basic working surface of the block. To strengthen the block, pour only half of the plaster into the frame; then, when it has spread out evenly and begun to thicken slightly, place on it a piece of stiff wire mesh cut to size and cover this with the rest of the plaster.

The block can be worked on as soon as it is stable enough to be removed from its frame; in this damp, fairly soft state it is easy to impress with objects or textures or to draw into, although it does need to be worked rather quickly. Dried plaster is not easy to work in a free manner, but it provides an excellent surface for carving or engraving with sharp cutting tools. No special tools are needed: the usual gouges or gravers used in woodcut should be adequate for most work on dry plaster, but even these are not absolutely necessary, and many other kinds of tool can be utilized or improvised.

Some printmakers apply black (indian) ink to the surface of the block before commencing work: any line or cavity cut into the plaster will then appear as a white mark against a black background.

Hard plaster can be softened again simply by soaking it in water for a few minutes. Fresh plaster may also be added to an existing block in order to fill in unwanted lines or hollows; the new plaster is allowed to dry, and is then smoothed down with fine sandpaper.

When the block is ready for printing, it can be sealed and toughened by spraying it with lacquer before any printing ink is applied. This will also make it much easier to remove ink after printing.

The block itself is often kept (in an inked-up state) as a decorative object in its own right.

PLASTICS

A large number of plastics or similar substances are now employed by relief printmakers. They can be in solid form, as flat, rigid sheets which can be cut, gouged or engraved like a wood or lino block, or in a malleable form for drawing into or shaping and moulding into relief surfaces which can be printed in relief, intaglio or both.

For cutting and gouging in the woodcut manner, the rigid sheet
– e.g. Lucite (trade name for Dupont's acrylic resin), plexiglass or
perspex – has relatively few advantages over wood or linoleum.
It is certainly cheaper than some hardwoods, but not significantly
cheaper than plywood or linoleum. Its general availability makes
it worthy of serious consideration, plus the fact that it can be
obtained in large sizes.

The transparency of the rigid sheet, however, can be a great
advantage. In multi-block colour printing, the problems of achiev-
ing exact registration are greatly reduced by using sheets of clear
plastic as printing surfaces. In addition, outline drawings or dia-
grams placed under clear plastic can be accurately traced with a
chinagraph pencil or felt-tip pen or freely interpreted with knife,
gouge or graver. If preferred, the surface can easily be made opaque
with a thin layer of ink – preferably water-based, for easy removal
– applied with a roller.

Of course, the limitations of a new material will always appear
more obvious if one's approach to them is based on a conventional
approach to traditional materials. For example, although it is
possible to work into rigid sheet plastics with knife and gouge in
the orthodox woodcut manner – provided the tools are kept
razor-sharp – the surface is smoother than that of hardwoods, and
the material harder and denser and, of course, entirely uniform.
This makes it perhaps more suitable for engraving.

The polished surface of most rigid sheet plastics is easily
scratched or scored, a characteristic that can be deliberately
exploited. Scratches are more conspicuous on a surface used pri-
marily for intaglio work, and unless very deep they are less likely
to be obtrusive on a relief surface when ink is applied with a roller.

Rigid sheet plastic is an ideal substance to work into with
electric hand tools of the flexible shaft type fitted with fine drills.
It can be abraded, sandblasted, filed and textured with great effect
in all kinds of ways, manually or mechanically, and is easily cut
into sections with a fine-tooth saw, a jig-saw with a suitable blade,
or a circular saw fitted with a TCT (tungsten carbide tipped)
blade.

Rigid sheet plastic will also make an excellent flat base on which
to build up a relief surface.

Polystyrene – available in blocks or sheets – is sometimes used
as a relief surface: it is easily cut into with a specially designed tool
operated from either mains or battery. As a printing surface, its
use is extremely limited, and printing obviously has to be carried
out by the burnishing method.

Liquid plastics

Plastics in liquid form – liquid acrylics, polyester resins, polyvinyl
acetates – are probably more attractive than the solid varieties to
the resourceful printmaker. They have been increasingly employed
in relief printmaking since the mid-1950s, following their develop-
ment and more general availability in workable form. Much of the

Right and opposite: Impressions taken from the inked surface of textured fabrics.

early experimentation in this field was carried out by the American artist Boris Margo.

A thin solution can be used to make a flat surface for subsequent cutting and engraving by applying it to a flat base or pouring it into a 'tray' of edged hardboard or sheet metal. Thicker and therefore more malleable mixtures can be shaped into three-dimensional relief surfaces which will dry hard enough to be printed – with extreme care – on an intaglio press. Other materials and small objects with interesting surfaces, contours or profiles may be impressed into the plastic while it is still soft to enrich the surface texture. For these relief surfaces, a firm base of wood or metal is usually necessary.

An invaluable guide to plastics for the artist is Thelma R. Newman's book *Plastics as an Art Form.*

COLLAGE RELIEF SURFACES

The 'collage relief' print relies for its effect on the qualities of the various materials which make up the surface, and the way they are assembled. The process is essentially additive, as opposed to the reductive techniques of conventional woodcut or relief etching.

Apart from the more conventional materials already discussed, any of which may be used to provide a firm base on which to assemble the component parts of the collage, the range of materials with which one can create or enrich a surface is almost limitless. Literally anything that can be inked and printed is of use. It is worth bearing in mind, however, when assembling what may be disparate or incongruous materials into a composite, unified printing surface, that the collage itself is first and foremost a

means to an end; it is the printed image and the quality of the impression that count, not the quality of the collage as an object. A great many materials, though attractive enough in themselves and apparently having positive textures or clearly defined patterns and outlines, turn out to be quite nondescript when inked and impressed on to paper; even with experience, it is not always easy to visualize what a particular surface will look like on print. Bizarre materials used for the sake of novelty will not necessarily guarantee an unconventional printed effect, whereas the most accessible and 'conventional' materials, when used imaginatively, can be extremely effective on print.

Very few materials, especially man-made ones, with a distinctive, mechanical or regular pattern, prove sufficiently interesting to form the sole 'content' of a print; even organic materials, no matter how beautiful, tend to work better as part of a composite design. Experimentation is clearly most important, but in order to avoid familiar clichés it must be combined with a practical, workmanlike approach to the construction of the surface and the problems of printing it.

Because of their variety of absorbency, texture and depth of relief, collage surfaces are normally inked with soft rollers and may require rather forceful inking; in all other respects, they are printed in much the same way as a woodblock. Burnishing is perhaps the most suitable method, since the more uniform pressure of the printing press is inclined to understate the individual character of the various materials. When printing by burnishing, two sheets of paper are advisable: a fairly strong paper placed on top of the thinner, absorbent printing paper may help to prevent the latter from tearing as it is pressed over the relief surface. This is even more necessary if the printing paper has been dampened.

A stamped image made with the inked relief surface of a found object.

FOUND OBJECTS

A 'found object', in the context of printmaking, is any object, natural or man-made, old or new, broken or whole, which may be utilized as a printing surface. The surface from which the print is made may be cleaned, polished or even reworked in some way, but to all intents and purposes it is a 'ready-made' surface.

Surface printing from found objects has played an increasingly important part in the recent development of the relief print. Although such impressions are often made and exhibited as complete prints, most printmakers employ objects as a means of introducing shapes, textures or images impossible to achieve by hand-drawn or hand-worked methods into composite designs, integrating the objects with other, perhaps more conventional materials in a relief collage. The 'metal graphic' (see below) and the plastic-based relief surface are two of the more obvious methods.

Michael Rothenstein, undoubtedly a major influence as a teacher in the field of experimental relief printmaking, has made extensive use of found objects in his own prints, and his books, especially *Frontiers of Printmaking*, are an invaluable source of information on the aesthetic and practical problems connected with the technique.

Objects too thick and bulky for an orthodox printing press can be hand burnished; even so, when assembling a collage relief, the contrast between the various surface levels is an important consideration. If there are contrasts in height of more than about $\frac{1}{8}$ in. (3 mm) within a relatively small area, it will not always be possible to reach the lower surfaces with even the softest roller; nor will it be possible to make an adequate impression by hand on even the thickest, softest printing paper. In any case, forcing the paper down to meet sudden and abrupt changes in level will soon cause it to tear. For the same reason, materials with jagged edges or sharp protuberances should be burnished with extreme care or avoided altogether.

THE COLLOGRAPH

The most highly developed form of collage surface for printing is the collograph – a comparatively recent term applied to collages designed to print in both intaglio and relief. Much of the pioneer work on intaglio collage surfaces was carried out during the 1930s by Rolf Nesch, who is chiefly known for his 'metal graphics' – a term generally used to describe assemblages of bits and pieces of wire, industrial waste, pressed metal, machine parts etc. attached to thin sheets of metal.

There can be no doubt that the qualities of certain kinds of materials are revealed and enhanced by this combination of intaglio and relief printing. The same surfaces, when printed in relief only, lack tonal variation, subtlety and refinement. Metal in particular is often more suited to intaglio printing.

In order to print a collograph, an etching press is required, as well as inks, wiping muslins, hot plates and sundry items of equip-

ment peculiar to an intaglio workshop. In most art school print-making departments access to these facilities should present no problem, although it is advisable to seek expert advice before using an etching press for the first time; but the independent print-maker equipped for relief printing may not always have access to intaglio facilities. The collograph, therefore, though very closely related to relief printing, should be regarded more as an intaglio process. For further information on these aspects of intaglio printing, read Ross and Romano's *The Complete Printmaker* and Hayter's *New Ways of Gravure*.

METAL

Sheet metal, particularly zinc and copper of the thickness and finish normally used for intaglio printmaking, can be 'deep etched' to create a positive relief surface by drawing directly on to the metal with an acid-resistant substance and then 'lowering' the undrawn or negative areas by exposing them to the action of acid. This is the reverse of the more usual intaglio etching, where the drawn or positive image itself is corroded down into the metal. The relief plate is inked with a roller and printed in much the same way as a wood or lino block, except that it can be printed on almost any press. Where an etching press is used, the plate can be inked and printed in intaglio and relief simultaneously. If a platen press is to be used, the plate can be raised to type height by fixing it to a block of wood.

Zinc is probably the most suitable metal for this purpose: it is soft and can therefore be etched relatively quickly, and is cheaper than copper which is, in any case, a finer quality metal more suited to engraving, drypoint and fine line etching. Sheet iron and steel, though cheaper than zinc, are too hard for most relief etching. A 16 wire gauge metal is advisable for really deep etching (and embossing), but an 18 wire gauge metal should be adequate for most relief work, especially if the bitten areas are not too wide and open and if a hard roller is employed.

The image is drawn on to the clean, polished surface with a brush and a conventional stopping-out varnish such as the asphaltum-based varnish or liquid hard ground obtainable from the usual suppliers of etching materials, or the bitumen varnish obtainable from most hardware stores. The back and edges of the plate should be carefully protected in the same way. When the varnish is completely dry, the plate is immersed in a bath of dilute nitric acid and left for anything from a few minutes to two or even three hours, depending on the accuracy and depth of bite required, the strength of the solution and even the temperature of the solution and the workroom.

A solution of acid is normally mixed in an open tray or dish, such as a photographic developing tray made of plastic or stainless steel, or even a home-made wooden tray treated with several coats of stopping-out varnish or bitumen. Always pour water into the tray just before adding any acid, and add the acid with great care to avoid splashing. Never pour undiluted acid into a dry tray;

apart from damaging the tray, it is inclined to spatter and can create dangerous fumes. And never pour water into a glass bottle containing undiluted acid; this can generate so much heat that the bottle may explode.

The strength of the solution can vary between 4 and 8 parts water to 1 part nitric acid. An even stronger solution may be used, or a depleted solution topped up with pure acid, but very strong solutions (less than 4 parts water to 1 part nitric acid) are more difficult to control. For example, the acid is inclined to undercut the varnished surface around the edges of the exposed areas, which can result in the crumbling and consequent widening and coarsening of the edges; it can also cause printing problems due to the build-up of ink in the cavities. During a lengthy immersion, the edges of exposed areas may need 'touching up' from time to time. An excessively strong solution can foul-bite through a protective layer of varnish, even away from the exposed areas, and might even cause the varnish to lift; it can also overheat due to chemical reaction and create extremely dangerous fumes, especially where it is corroding into large areas of bare metal. A supply of cold water for cooling the plate should be accessible during the etching, and good ventilation is essential.

Hydrochloric acid, commonly used for etching on copper, is generally less suitable for etching deep, open areas into zinc.

A drawn plate can be etched with one immersion; this will produce an image with a distinct edge. Alternatively, the plate can be taken from the acid at regular intervals and the bitten areas successively stopped out to produce a greater variation in depth.

The range of effects which can be achieved with brush and varnish is almost infinite. Notable among the more famous examples of relief etching are William Blake's illustrations on copper for his *Jerusalem*. The work of the nineteenth-century Mexican artist Posada is also worthy of study.

For further information on relief etching, see my *Manual of Etching and Engraving* or refer to the books by Buckland-Wright, Hayter, Peterdi, Gross, and Ross and Romano listed on p. 171.

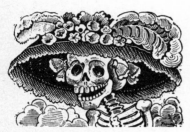

José Guadalupe Posada (1852–1913), metal relief print. Posada practised both relief etching on zinc and engraving on zinc or lead (type metal); both types of block were printed in relief, and the printed results are virtually indistinguishable.

ALTERNATIVE METHODS OF SURFACE PRINTING

Among the alternative methods of making printed or embossed impressions on paper related in one way or another to relief printmaking proper are stamping (as in fifteenth-century block printing or modern rubber-stamping), rubbing (as in early Chinese stone rubbings or the comparatively recent pursuit of brass rubbing) and monoprinting (essentially a 'one-off' process). All these methods are technically undemanding and therefore suitable for younger children, and are frequently grouped together under the general heading of 'simple printmaking'.

Stamping

Printing by direct stamping, though rather limited in scope, does have certain advantages. For example, it may be possible to

Image taken from a weathered
stone-carving by the conventional
rubbing method.

utilize an object too awkward or fragile to be used in a collage, or
even burnished, by inking it with a roller or ink pad, or pressing
it into ink rolled out on a slab, and then stamping it gently but
firmly on to the printing paper. It is also quite common practice
for relief printmakers to cut their own stamps from rubber, wood,
cork or cardboard, or even to use a ready-made stamp, in order to
repeat exactly the same image several times on one print. Complete
prints have been made entirely by stamping.

Rubbing

The technique of rubbing a wax 'heelball' or crayon on a sheet of
paper placed over a relief surface, instead of inking the surface
itself, clearly relates closely to relief printing proper. It is a useful
way to obtain a quick but accurate impression of the true state of a
block, but it can be more than just a method of making working
proofs. Rubbing enables the printmaker to transfer to paper the
textures of various 'found' surfaces which might, for practical
reasons, be difficult to print from – for example floors, walls,
signposts, manhole covers or ironwork. Another advantage of the
method is that the impression is always the right way round,
which makes it particularly suitable for letter forms, numbers and
specific images inappropriate for reversal.

Thick wax crayons or even a medium soft pencil may be
adequate for some rubbings, but the best material for most pur-
poses is a black wax heelball, specially made for brass rubbing.
Heelballs are also available in various shades of grey, both hard

Monoprint effect taken from a drawing made with a wooden point on an ink-coated slab.

and soft, and in brick red, bronze, gold, silver, coppery brown and white. For additional colours use thick wax crayons. Black, white, silver and gold wax sticks are available in most art material stores. The paper on which the rubbing is made should be thin and soft, but strong. For good, clear definition, avoid heavy or excessive rubbing. The paper can also be inked with a roller, provided the ink is stiff and the relief clearly defined, but surface rolling seldom gives as clear an image as surface rubbing.

There is no shortage of useful books on brass rubbing. Apart from this largely specialist literature, the printmaker Harvey Daniels devotes an informative chapter to the subject of surface rubbing in his book *Printmaking*, and some practical information is contained in Peter Green's *Introducing Surface Printing*.

The monoprint

The term 'monoprint' (or monotype) means a single or 'one-off' impression made, loosely speaking, by relief printing methods; the word is not usually used to describe single prints made by other autographic processes, which are more often referred to as monographics. Monoprints are usually made by drawing with pigment, or working into a coating of pigment – or a combination of the two – on a flat, non-absorbent surface, and then transferring the wet image to a sheet of soft, fairly absorbent and usually damp paper by hand pressure, burnishing, or with a printing press. It is obviously not possible to make two identical prints by these

methods, since the drawn image invariably changes with each separate printing.

Suitable pigments include printing ink, oil paint and dyes – textile printers' pigments with the appropriate binder – and the working surface can be an inking slab of plate glass, marble or litho stone or a sheet of perspex, formica or metal.

The ink can be applied to the slab with brush, knife, roller or rags, thinned with solvent for transparent washes, and worked into with a wide range of tools and implements. A smooth layer of ink will provide an excellent 'wet' surface for line drawing, for example with a wooden point. The most vigorous, colourful and complex effects can be achieved with the minimum of materials by this simple and direct method, and other materials can be added to the inked surface to increase the range of mark or texture. One of the more straightforward variations on the basic method is overprinting, for instance by rolling over cut paper shapes placed on the inked surface. Monoprinting can also be combined with other printing processes, particularly on worked etching plates.

Although each printed image is unique, the possibilities of close variations on a theme are endless. A certain amount of uniformity can be maintained, if required, by basing each print on a drawing placed under a sheet of glass or clear perspex. The method is especially useful as a means of producing large numbers of similar or varied printed effects in a relatively short time, perhaps as surfaces for drawing on to at a later stage, or simply as material for collages.

Monoprint effect achieved by placing the paper on an ink-covered slab and drawing on the back of it.

As a rule, organizers of print exhibitions do not include the monoprint in their definition of an original print because it cannot be produced in editions. Monoprinting tends to be regarded more as a means of drawing than of printing, and it does invite a painterly approach.

Another version of monoprinting worth experimenting with is the transfer method. Roll up the slab with a smooth, even layer of oil-based ink, but instead of drawing directly into it place a sheet of absorbent paper gently on the surface and draw on the back of the paper with a hard but not sharp point such as that of a pencil or ballpoint pen or the handle of a paint brush. As the point is drawn, with moderate pressure, across the paper, a line of ink will be transferred from the slab to the underside of the paper. The thickness of the line can be varied by using different tools or by adjusting the pressure on the point; the type of paint or ink used, its consistency, and the texture and absorbency of the paper, can all affect the quality of line. Some tonal variation can be achieved simply by pressing the paper down on to the inked slab with the hand.

It is even possible to print from a flat block of plasticine which has been drawn into or impressed with objects. A few duplicate prints may be obtained, but the block is normally cleaned and rolled flat after each impression has been printed, in which case the prints become monoprints.

Further information on monoprinting can be found in Daniels and Green, and in Rothenstein's *Linocut and Woodcut*, but probably the best single book on the subject is Henry Rasmusen's *Printmaking with Monotype*. Rasmusen deals extensively with both the technical aspects of the subject and its history, from the work of the seventeenth-century Italian artist Castiglione to the various American schools of monoprinters of the nineteenth century and beyond, discussing the work of such diverse masters as Blake, Degas and Gauguin and, in the twentieth century, Matisse, Klee, Ernst, Rouault and Dubuffet.

OFFSET ROLLER PRINTING

Offsetting is a simple but effective means of obtaining a specific printed effect without burnishing, stamping or using a press.

The required relief surface is thoroughly inked with one roller and the inked image or texture then picked up on a second, clean roller and offset on to a sheet of paper. Numerous variations are possible.

3 Tools

THE WORKSHOP

Planning or adapting the workroom for block cutting and block printing is largely a matter of common sense. In any case, circumstances will obviously vary enormously with each individual, so I will confine myself to general guidelines rather than attempting to describe an ideal layout.

A room with a north light for daylight working is preferable, but if this is not possible some kind of sunblind or shade should be fitted to control direct sunlight. Fluorescent lighting is considered to be the most suitable for working at night or on a grey day, since it gives an even, diffused light. An anglepoise lamp is also useful for concentrating the light source on to the working area.

Good ventilation is another important factor, especially if acid is to be used for relief etching. Air conditioning, commonplace in the USA, Canada and Australia, is almost non-existent in the UK and much of northern Europe; without it, there is not much one can do to maintain a cool, even temperature in hot weather. A workroom temperature of 65–70°F (18–21°C) is considered ideal. Printing in a hot, poorly ventilated room, apart from being extremely uncomfortable, can create difficulties when mixing and applying inks.

Running water is an essential service; a large, flat, shallow sink, vital for etching and lithography, is useful, though not quite so necessary, for relief printing.

In general, relief printmaking, even with a press, requires less space and essential equipment than any of the other autographic processes. The most important item of furniture is a solid workbench or table suitable for cutting and, if necessary, printing. Find (or make) as large a workbench as possible. Since there is usually a need to economize on space, it is a good idea to fix shelves under at least half its length for storing materials, leaving enough room to sit and work in comfort. The height of the bench is crucial. A fairly low bench can always be built up to the appropriate height with blocks of wood, but one which is too high is more of a problem, since it is not comfortable to work from a high stool. The relative heights of bench and stool should be such that the movement of the cutting hand and arm is not restricted in any way. It goes without saying that two workbenches or tables are better than one, since this allows the different processes of cutting and printing to be more or less permanently separated. Even in the

largest workshops, there never seems to be quite enough table space; folding tables save space and may be useful for preparatory work such as drawing or laying out colour blocks and proofs, but are not usually solid enough for the heavier work of cutting and printing.

Clearly, if one is buying a printing press the workroom needs to be large enough to accommodate it in addition to the basic workbench and some storage units or racks. A medium-sized press, for example an etching press suitable for printing relief blocks, with a bed measuring 26 in. × 42 in. (66 cm × 106·7 cm), would probably require an area of floor space – depending on the type of press – of roughly 10 ft × 6 ft (300 cm × 180 cm), in order to use it properly. A moderately large platen press, such as a Columbian, with a bed measuring 36 in. × 22 in. (91·4 cm × 55·9 cm), would require an area of at least 8 ft × 5 ft (240 cm × 150 cm). With a little ingenuity and careful positioning, it is usually possible to manage with less than ideal space. Bear in mind, too, that a moderately large platen press can weigh half a ton, while a large etching press or a cylinder press such as the Vandercook may weigh over a ton: it is advisable to check whether the joists and floor supports are capable of holding such a massive and concentrated weight. One possible way to get round this problem is to distribute the weight over a larger area by positioning the press on two lengths of 4 in. × 4 in. (10 cm × 10 cm) timber or on two large sheets of ¾ in. (19 mm) plywood. The printing bench containing ink slab, rollers, paper and so on should stand reasonably close to the press.

The placing of bench and press will depend to a large extent on the position of the windows and main light source, since it is better, if you are right-handed, to have the source of light – at least on the workbench – in front or to your left. The amount and arrangement of additional furniture for storage – racks for woodblocks, cupboards for paper, inks and tools – depends entirely on the space available. Drying racks for wet prints will be necessary, although if conditions are cramped, as they often are, a clothes line hung above and well away from the working areas may be adequate.

It is important to have a supply of rags, preferably of an absorbent but not fluffy material. If old clothes are used, remember to cut off buttons, hooks and zips, and tear up rags well away from any exposed ink on slabs, rollers or blocks. Do not keep rags which have been soaked in solvent in a waste bin, as this has been known to cause spontaneous combustion; dry them thoroughly in the open air before packing them together. Use a separate box for clean rags. Newspaper is invaluable for general cleaning up and for packing under blocks before printing; paper towels are useful but expensive. It is a good idea to keep a supply of barrier creams and hand-cleansing creams such as Swarfega.

Solvents should be kept in suitable containers – usually metal cans, preferably of the sprinkler type – for economy and safety. Each container should be clearly labelled.

A small two-tier trolley for moving tools and general materials around can be a most useful asset in a workroom.

TOOLS FOR WOODCUTTING

The principal tools for cutting woodblocks are knives, gouges and, to a lesser extent, chisels. These, and especially the knives, have proved the most serviceable and versatile for controlled cutting of precise lines and shapes, for instance when working from a drawing. It is not essential to use only specialist tools: an ordinary pocket knife can be used, or one of the many model-maker's knives sold with a wide range of spare blades, and even scalpels have been successfully employed. All manner of wood-work gouges and chisels are sold in more general tool shops or hardware stores. In addition, various steel points, rasps and files, as well as much less conventional tools, can be used to create particular effects. In fact, any implement may be utilized which is hard enough to make cuts, scratches, bruises, indentations or areas of rough texture or regular pattern on the surface of a piece of plankwood, either directly, or indirectly when hammered or punched.

Those who are inexperienced in the technique of cutting plank-wood for printing would be well advised to try out first the tradi-tional tools made especially for the purpose. Wherever possible, buy only the finest quality tools from a reputable dealer: such tools do not necessarily cost much more than poor quality ones, but will almost certainly give better results and need less frequent sharpening.

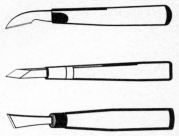

Woodcutting knives: *from top to bottom*, European; Japanese facsimile; Japanese.

KNIVES

The traditional knives in general use are known as the European knife and the Japanese knife.

The European knife is a rather awkward looking tool, but surprisingly efficient. With practice, it should be possible to use it for fine, precise lines and detail, but it does seem to invite a par-ticularly free approach to cutting. The complete tool consists of a steel blade some 3–4 in. (7·5–10 cm) long, half of which is fixed into a plain wooden handle also about 4 in. in length. The blade is shaped rather like a flat hook or claw, with a cutting edge about 1 in. (25 mm) long of which only the point enters the wood. In most cases, the cutting edge slopes back and inwards towards the handle, which makes it virtually impossible to cut with the full length of the blade except at the very edge of the woodblock. When resharpening the tool, it is advisable to sharpen the entire cutting edge and not merely the tip; this will prevent the edge from becoming curved and consequently less efficient.

For fine, detailed cutting, the European knife is held in much the same way as an ordinary pen – between the first two fingers and the thumb, close to the blade and at an angle of between 40° and 45° to the block, or a little less for really fine cutting. For broader, deeper cutting, the knife is generally held with an overhand grasp as if holding a stick. Normally, each cut is made with a smooth,

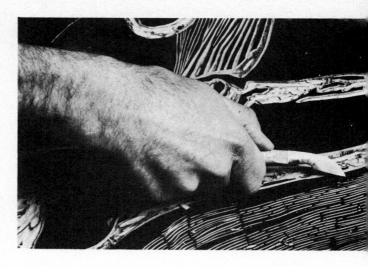

Holding the European knife in an overhand grip for deep cutting, for instance when defining the outlines of a design.

firm pulling action, drawing the knife more or less towards the body.

The Japanese knife most commonly used by woodcut print-makers consists of a straight steel blade some 2–3 in. (50–75 mm) long set into a simple round 'chisel type' wooden handle. (Flat wooden handles are also available and are often considered more comfortable to hold.) The cutting edge is also straight – although the tip does most of the work – and is raked back from the point at an angle of about 30°–45°. On some knives, the blade becomes wider towards the cutting edge.

When cutting fine detail, the knife is held like a pen in the same way as a European knife, but for defining larger shapes or cutting stronger lines it is gripped rather like a dagger and held more or less upright, and is drawn back towards the body.

Japanese knives are also available with the blade sharpened to about 45° on the right-hand side and the top edge of the blade bevelled slightly towards the point. These are made in a range of sizes, the smallest blade having a cutting edge only $\frac{1}{8}$ in. (3 mm) long, and are intended primarily for precise, facsimile cutting on hardwoods. Although there are several other types of Japanese knife, they do not appear to be generally available in Europe.

A useful woodcutting tool is the Stanley knife fitted with a heavy-duty blade. This can be held between finger and thumb, like a pen, or gripped in the upright position for deeper, larger-scale cutting. Model-makers' knives are good for fine, detailed cutting; pocket knives may work best with a shortened blade or partially bound with string to give a better grip and to prevent the blade from closing.

The use of the knife

Most new knives will probably have been sharpened slightly on both sides; they can be used like this, with a cutting edge in the centre of the blade, but most printmakers sharpen the blade on the left-hand side only (assuming they are right-handed) so that, in

cutting, the flat side is held next to the shape that is to be left intact.

Unless a substantial amount of the surrounding area is removed, a 'V' shaped trench or white line at least $\frac{1}{8}$ in. (3 mm) wide and deep is needed round shapes and black lines. This is cut by making two angled incisions which meet to release a 'V' shaped sliver of wood. Assuming that the knife is held in the right hand and the block steadied with the left, incline the knife to the right – between 45° and 50° – and make the first incision; then turn the block completely round and make the second incision parallel to the first and at the same angle. A relatively wide line – say $\frac{1}{4}$ in. (6 mm) – will need to be cut somewhat deeper than one $\frac{1}{8}$ in. (3 mm) wide, otherwise the angle of the cut will be too shallow. Wider lines may require several cuts before the sliver is removed cleanly, but with a little practice repeated cutting should not often be necessary; in any case, deep cutting is tiring and not normally conducive to free or expressive lines. For really fine lines the knife is held almost perpendicular to the wood.

As an alternative to turning the block round every time, try inclining the knife to the left and making the cut in the usual way. This may seem difficult at first, for the angle of cutting is more awkward, but once the technique is mastered it will save time and effort. A simple turntable device can speed up the cutting process, but is hardly essential equipment.

Black lines, or for that matter any area left standing in relief and especially small isolated shapes, should always be wider at the base; in other words, relief surfaces should never be undercut. The edges of an undercut shape tend to collect ink during printing, which can easily spoil the definition of a print; and even a vertically cut black line can crumble and break away under printing pressure. Where there is complex detail in confined areas it is not always possible to cut at an angle, and a vertical cut has to be made, but this should be avoided wherever possible.

Avoid dragging the knife too forcefully through the wood, especially if the blade is not razor-sharp; too much pressure will make it more difficult to control, and a blunt knife will tear the wood rather than make a clean cut. A cut made across the grain is often more difficult to control than one along the grain, and an extremely sharp knife is essential. Even when cutting in the direction of the grain, the blade can sometimes slip off course into relatively soft wood, or run along a ridge of hard grain in a jerky fashion.

If necessary, the free hand can be used to guide the knife when cutting. An even greater degree of pressure or control can be maintained by pushing on the knife with the first or middle finger, or even the thumb, of the free hand, but for this a bench-hook or clamp is essential. A simple bench-hook is easily made from a flat board, a little larger than the block, with a strip of wood nailed to each end, one on top and one underneath. An extra strip can also be nailed along one side of the board – usually on the left. Metal clamps are a rather less convenient way of holding the block down; if they are used, the surface of the block in the places where they fit should be protected with a piece of card or wood.

A simple bench-hook, used to hold the block steady during cutting.

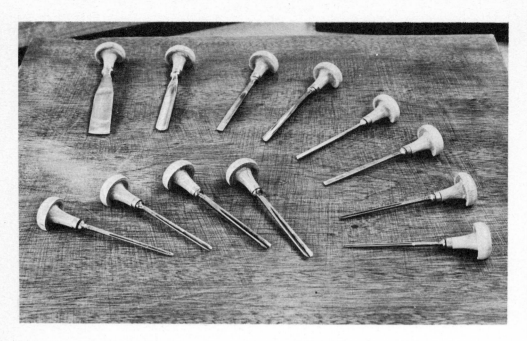

A selection of 'V' tools (front) and curved gouges (back) in graver handles, known as 'short' gouges.

If it is necessary to follow a drawing with absolute accuracy, a certain amount of spontaneity must be sacrificed; rather than cutting exactly on the drawn line of the design, cut the initial 'V' trench just short of it and then work up to the line gradually.

On softer woodblocks, negative or white areas can be cleaned out with the knife: two sets of 'V' shaped trenches, at right angles to each other, are cut across the area to leave only a few high spots or ridges standing, and these are then cleaned away with a chisel. White areas on hardwood blocks, however, have to be cut out with gouges or chisels, usually with the help of a mallet.

Knives will dot, score, scratch or scrape the woodblock surface, although there are numerous other tools more suited to producing these effects. Even so, the most varied and complex designs can be made entirely with the knife.

Sharpening the knife

To sharpen the knife, place the bevelled edge of the blade flat against an oilstone or whetstone (e.g. India stone, carborundum or aloxite) and rub it back and forth, firmly and methodically, without haste or excessive pressure. Above all, avoid rocking the tool in any way. The flat side of the blade will need only one or two light rubs to remove any burr; a few rubs too many, or too much pressure, and the fine cutting edge is lost. To avoid this, it may be easier and quicker to remove the burr with a slip-stone – a small wedge-shaped oilstone with both flat and rounded edges.

After sharpening, hone the blade to a fine cutting edge on a natural stone, such as an Arkansas or Washita stone, generously smeared with fine, thin oil such as Three in One, Pike or any non-gumming machine oil, but *not* linseed oil, which is too heavy and

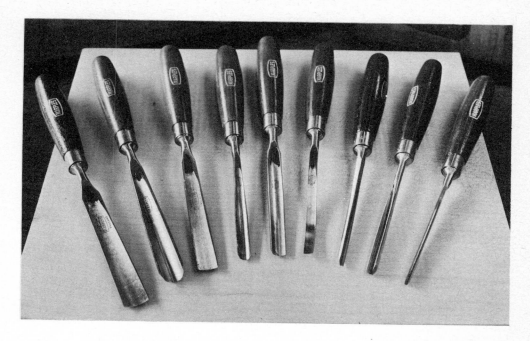

sticky. The oil is essential to prevent the particles of metal from clogging the stone and glazing its surface. A softer whetstone is recommended for Japanese tools, which, because of their softer steel, are more easily over-ground. A final polish on a leather razor strop will improve the cutting edge still further.

A selection of curved gouges in chisel handles, known as 'long' gouges.

'V' TOOLS

The 'V' shaped gouge – also known as the 'V' cutter, scrive or veiner – is chiefly used for cutting lines. Since one stroke of the 'V' tool will produce a uniform white line, whereas at least two careful, parallel cuts have to be made with the knife, some print-makers regard the former as the more easily controlled drawing tool, but in spite of its undoubted usefulness it does not have the versatility of the knife.

'V' tools specially made for woodblock cutting are available with the blade – usually about 3 in. (75 mm) long – set into either a small round or half-round wooden handle, similar to those used on burins or gravers, or a longer, thinner handle in the Japanese style. Whichever kind of handle is used, the blade and cutting edge are basically the same. The shorter tool is held and used in much the same way as a graver, while the Japanese version is held between the fingers and thumb of the right hand, its movement forward being guided by the thumb of the left hand. Cuts are generally made away from the body, though the exact direction can vary. Rather larger versions of the 'V' tool, in 'chisel' type handles, are designed primarily for woodcarving or wood sculpture and intended mainly for use with a mallet for more extensive cutting.

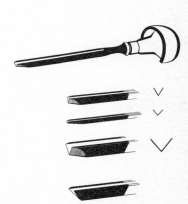

The 'V' tool with graver handle, showing a selection of blades. At the bottom is the raked blade for cutting across the grain.

The blade of a medium-sized, general-purpose 'V' tool would measure about ¼ in. (6 mm) across and ¼ in. in depth. The smallest blade generally available is about ⅛ in. (3 mm) across; a ½ in. (13 mm) blade is used for heavier lines and for gouging out large areas, while gouges up to ¾ in. (19 mm) or even 1 in. (25 mm) may be useful for large-scale cutting. The blades can be quite open and shallow, or narrower and deeper, depending on the kind of line required.

Both sides of the 'V' shaped blade are straight, except at the cutting end where the outside edges are bevelled on both sides to form a sharp point. It is this point that penetrates the surface of the wood, and therefore the bevelled edges must be sharpened equally on both sides and maintained in a razor-sharp condition. With the graver-type gouge, the angle of attack has to be fairly low; for this reason, such tools tend to have a longer and more gradual bevel than the chisel variety. The 'chisel' tool is designed and ground to be pushed into and through the wood at a fairly steep angle – about 40° to the horizontal. Perhaps the most practical way to use this tool is to grip it with the left hand and drive it forward with the flat of the right hand or with the mallet.

As the 'V' tool is used mainly for line work, the two cutting edges are usually at right-angles to the length of the blade, or perhaps set back very slightly from the cutting point. For cutting across the grain, it is better to use a tool with the top edges projecting beyond the lower cutting point, since a gouge raked in this way is less likely to tear the grain of the wood. Cross-grain cutting with the Japanese gouge should be avoided wherever possible, especially on coarse-grained wood.

A minimum of three 'V' tools is recommended: one small, one medium and one raked for cross-grain cutting.

Sharpening the 'V' tool

The cutting edge of a blunt tool will be polished enough to reflect the light; a correctly sharpened edge should reflect little or no light. It is best to resharpen tools little and often during the cutting process, rather than having to labour over each one when the edges have become really blunt.

The bevelled edges of the 'V' tool are sharpened flat against the stone; it is important to ensure that the correct length of the bevels is maintained and that the angles of the two edges correspond exactly. The point where the two bevelled edges meet is the most crucial part of the tool; no matter how sharp the edges, clean, controlled cutting will be impossible if the point is neglected. Grind the point up carefully on both sides, holding the tool at a steady angle all the time, and very slightly round off the tip: this will prevent the tip from breaking off as it enters the wood, and also makes it easier to cut with the tool at a low angle. The inside edges of the tool should be rubbed gently with the narrow edge of a slip-stone, taking care to keep both edges perfectly flat.

Although it may be possible to test the sharpness of a gouge on the fingertip, it is better to try out a resharpened tool on a spare piece of plankwood, preferably across the grain.

A badly worn or distorted edge will have to be reground on a grindstone (coarse carborundum stone) or grinding wheel before it can be properly sharpened: hold the cutting edge at 90° to the flat edge of the wheel until the edge is straight again. This also applies when converting a straight 'V' tool into a raked tool. To bevel the tool, hold it against the flat of the wheel at the required angle and maintain the same angle until the bevel is achieved. Excessive grinding, however, can cause the tool to overheat, and the temper of the steel will be lost.

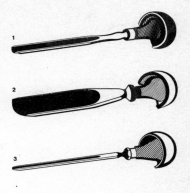

The curved gouge with graver handle, showing a selection of blades.

CURVED GOUGES

Although the 'V' tool is classed as a gouge, the term is more normally applied to the hollow-ground tool with a curved cutting edge, whether shallow or deep and 'U' shaped. Woodcutting gouges are available with blades ranging in width from about $\frac{1}{8}$ in. (3 mm) to about $\frac{3}{4}$ in. (19 mm); heavier gouges, designed for carving and used mainly with a mallet, are useful for clearing out very large areas. Like the 'V' tools, hollow gouges may be fitted into graver, Japanese or chisel type handles.

Gouges are mainly employed for clearing areas and for making broad, textured effects, normally of a non-linear type. Being rather inflexible, they are not particularly suitable for drawing or shape-defining, and the characteristic scooped marks they make can become rather monotonous *en masse*; in spite of this, it is possible to work a woodblock entirely with gouges.

All curved gouges, no matter which type of handle is fitted, cut away from the body, although in this respect those fitted with the graver handle are probably the most versatile. In general, the angle of attack is fairly shallow – about 30° to the horizontal – and cutting too should be kept shallow for maximum control. Large white spaces may need to be rather more deeply gouged to prevent ink from entering the hollows, although this is less likely to happen if a large, moderately hard roller is used. A gouge driven into the wood at a steep angle against the grain is inclined to undercut the grain, forcing it up above the surface.

Before gouging out an area previously defined with a knife or 'V' tool, make sure that the outline incisions are deep enough – at least $\frac{1}{16}$ in. (1·5 mm), and probably more – especially those made across the grain. A gouge pushed or driven towards a relief surface can easily slip and overrun, and the damage is likely to be greater if the outline incisions are shallow. One way to prevent this is to start gouging from the line or from close to it, pushing the gouge halfway towards the next line and then turning the block completely round and repeating the process until the area is clear. Untidy edges can be cleaned up afterwards.

It is worth remembering that the density of some plankwood blocks can vary quite considerably within as little as two or three inches; be prepared for the resistance of the wood to vary suddenly.

For general cutting, one or two medium-sized gouges are essential, but for maximum variety of function and effect it is advisable to have at least four in assorted sizes.

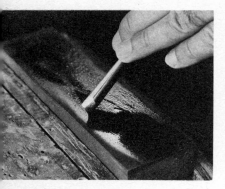

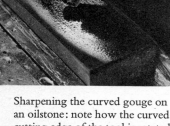

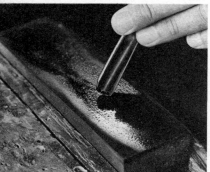

Sharpening the curved gouge on an oilstone: note how the curved cutting edge of the tool is rotated, to ensure that the whole of the bevel is sharpened at a consistent angle.

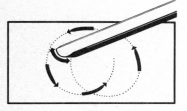

Alternative movement for sharpening the curved gouge. This spiral motion – or the figure-of-eight pattern seen above – prevents clogging or excessive wear on one section of the oilstone.

Sharpening the curved gouge

The majority of hollow gouges, like the 'V' tools, are bevelled on the outside cutting edge of the blade. When sharpening this outside edge, it is necessary to rotate the tool as it is moved across the stone, either by rolling it between the fingers and thumb or by holding it firmly in the hand and moving the wrist from side to side. The tool must be held at the same angle throughout the whole operation, with the bevel flat against the stone. Any burr on the inside edge is removed with the curved edge of a slip-stone, a very small slip-stone being necessary for the finer gouges. Some gouges, intended for finely controlled cutting, are bevelled on the inside edge, and these are sharpened entirely with a slip-stone.

CHISELS

Flat chisels, though perhaps not as essential as the various gouges, are nevertheless the most useful of all tools for clearing away rough, uneven texture from a negative area, especially a completely white area. The characteristic ridges left by a curved gouge or 'V' tool, which often receive ink from the roller, are easily removed with a broad, flat chisel ½ in. (13 mm) to 1 in. (25 mm) wide. Alternatively, a different kind of texture can be obtained simply by clearing only the upper layer of the ridges, leaving just enough surface to take the ink and give a grey, tonal effect on print. The mallet is usually employed for such work – more so when large areas have to be cleared.

Direct the chisel across the grain wherever possible, and never against it. Chisels are also useful for deliberately rounding off or softening hard lines or abrupt edges, especially those made with a knife. A small chisel, for example the ⅛ in. (3 mm) size, is useful for cleaning out small corners.

Woodcut chisels are obtainable with either the graver, Japanese or chisel type handles. Straight chisels – the conventional wood chisels used by carpenters – range from ⅛ in. (3 mm) to over 3 in. (75 mm) in width, and 'skew' chisels, with a raked cutting edge, from ⅛ in. (3 mm) to 2 in. (50 mm).

SETS OF TOOLS

A number of tool manufacturers supply sets of five or six assorted 'V' tools, gouges and chisels specially designed for woodcutting; both the graver and the chisel type handles are generally obtainable. Some sets are made up of tools with slightly bent blades, specially designed for cutting close to the surface of the woodblock, rather like smaller versions of the woodcarving gouges known as long or short bend gouges. The majority of these tools are already hardened, tempered and ground sharp when supplied, but most will need honing before use. Honed tools can be obtained, but cost rather more. A few sets may also include a sharpening stone.

Most main dealers in artists' and printmakers' materials supply single woodcut gouges in various sizes. Woodcutting tools – the larger type, intended for use with a mallet – are much more generally available, either as sets or as single tools, from hardware stores. The term 'woodcarving tools' may be used by some firms in preference to 'woodcutting tools', so check the catalogues carefully for details before ordering.

SHARPENING STONES AND SLIP-STONES

The same tool firms and general dealers usually supply a range of oilstones and slip-stones. An India combination stone – a round, flat stone, measuring 4 in. (10 cm) diameter × 1 in. (25 mm) thick, with a fast-cutting hard stone on one side and a fine finishing stone on the other – is one of the most useful and widely recommended of sharpening stones. A hard Arkansas slip-stone such as Nova-culite, with one rounded edge and one 'V' shaped edge, is also very useful.

TOOLS FOR LINO CUTTING

The best tools for lino cutting are the smaller woodcutting 'V' tools and gouges, particularly those with the graver handle or the short, bulbous type, both of which fit into the palm of the hand. The straight, cylindrical Japanese gouges are less easy to control on soft, crumbly lino.

Woodcarving tools with chisel handles, intended for use with a mallet, are too heavy and awkward for even the thickest linoleum, but woodcarving gouges fixed into shorter handles are useful for clearing out large areas, provided the angle of attack is kept shallow to avoid cutting through the canvas backing.

If woodcutting tools are used, they will need to be sharpened frequently, for although lino is far softer than wood it contains a gritty abrasive agent that gradually dulls the cutting edge. Blunt tools will soon slip and can easily ruin existing work.

Special lino-cutting tools, consisting of a wooden holder with a socket at one end to hold interchangeable blades or chisels, are obtainable from most general art materials or craft shops. 'V' shaped and 'U' shaped cutters for these tools, as well as straight knife blades, are available in various sizes. A 'U' shaped cutter with straight sides is also made, and this is particularly useful when cutting close to a drawn or cut line. Since all these blades are interchangeable, only one holder is needed, but it is much more convenient to have a separate holder for each blade. Unless the holder is fitted with a durable metal 'screw chuck' (as with the Speedball type), sooner or later the slot in the end of the wooden holder will cease to grip the blades firmly; the 'screw chuck' tool is naturally more expensive, but it is well worth the extra cost. Blades are still cheap enough to be discarded when no longer sharp. They can be sharpened on an oilstone, but because they are so small and relatively thin, this is rather difficult.

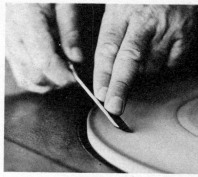

Sharpening the curved gouge on a motorized grinding wheel.

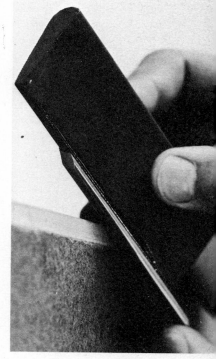

Removing the burr from a hollow-ground gouge, after sharpening, with a slip-stone.

Close-up and section of the blade of a lozenge graver, which can be used for cutting into lino.

Although most lino-cutting tools cost less than woodcutting tools and are certainly more practical for general use in schools, the serious student would be well advised to try out the woodcutting tools first. In any case, only a few tools are really necessary for cutting linoleum: for instance, one medium-sized 'V' tool with edges set at 45°, which can be used for both fine and coarse lines simply by varying the depth of the cut; two or three gouges or 'U' tools – small, medium and large (¾ in., or 19 mm); and a sharp knife, preferably a conventional Japanese woodcutting knife or a Stanley knife.

Many other tools, of course, can be utilized for cutting into or roughening the surface of the linoleum: penknives, razor blades, gravers and multiple gravers, steel points, drills, wire brushes and so on. Texturing effects can be achieved by using coarse sandpaper or a similar abrasive material and the heavy pressure of an etching press.

Linoleum is so soft and uniform in density that it can be cut freely in any direction, but as a rule it is safer to cut away from the body, and never towards the hand holding the block.

POWER TOOLS

A small power drill with flexible-backed sanding disc (left), wire wheel brush (right) and an assortment of rotary files or burrs.

Power tools, particularly the ordinary electric drill designed to hold various attachments, are now standard equipment in most relief printmakers' workshops. Some college art departments and printmaking sections will own several. The most useful attach-

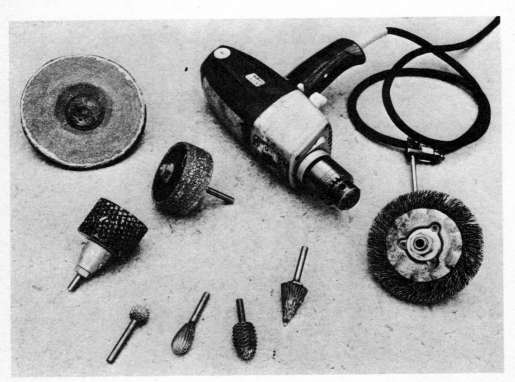

ments include circular sanding discs, circular saws, an assortment of steel drill-bits, grinding heads, carborundum and similar rasps, wire brushes and jig-saws, all of which can save a great deal of time and effort. In addition, such tools can produce certain effects unobtainable with hand tools.

The circular saw is useful for general purposes such as cutting up sections of plank and plywood, and a jig-saw is essential for cutting woodblocks into curved or fairly complex shapes for separate colour printing.

An electric drill with a circular sanding disc is the quickest and most effective tool for smoothing a roughly gouged surface or a peeled and splintery layer of plywood. It will also soften a sharp edge, make a flat area convex or concave, and make fine adjustments to the height of the relief surfaces for tonal variety.

Most of the other attachments are used for roughening the surface and creating textured or tonal effects. For instance, the natural grain of a block of plankwood can be made to show up more clearly on the print simply by wearing away the softer wood with a circular wire brush, leaving the hard grain standing in relief. This effect can be achieved manually, with a brass wire brush of the kind used for cleaning files, or with steel wool or coarse sandpaper, rubbed over the block parallel with the grain, but this will obviously require much more effort. Bear in mind, though, that it is easy to overdo the mechanical brushing and create a muddy grey tone instead of exaggerating the character of the grain.

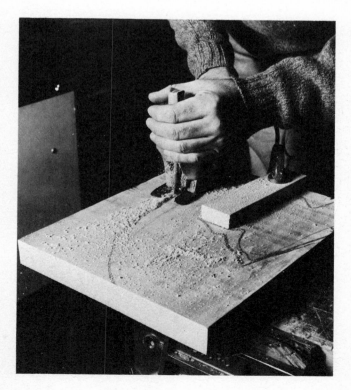

Sawing a block of plankwood into simple shapes with a jig-saw.

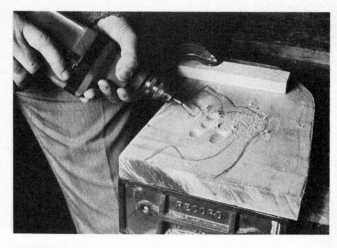

Hollowing out the surface of a piece of plankwood with power drill and grinding head.

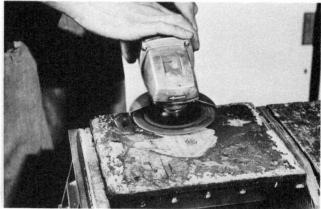

Resurfacing old weathered plankwood with a power tool and coarse sanding disc.

A circular rasp can be used to churn up the surface if an irregular, coarse texture is required.

Power tools can be especially useful for cleaning the surface of found objects made of wood or metal and preparing them for printing.

Before working on any surface with a power tool, secure the block firmly to a bench or table-top with a clamp.

CARE OF TOOLS

When not in use, all tools should be lightly oiled and stored in a dry place to prevent rust from forming. They should not be left around on the workbench. If possible, keep all cutting or engraving tools in a soft-lined box or a denim or felt hold-all with a separate compartment for each tool. To save space, arrange the tools in an alternate point-next-to-handle sequence. All this will ensure that the points and cutting edges are not damaged in any way, as they certainly will be if thrown together or against the hard sides of a box.

4 Drawing and Cutting

DRAWING AND TRACING ON THE RELIEF SURFACE

This is one of the most difficult aspects of woodcut printmaking on which to offer positive advice. The problem is not so much a technical one – there are various perfectly straightforward methods of drawing for woodcut – as a basic question of whether one should put any drawing on the block at all, and if so, how complete a statement it should be and how closely it should be followed. After all, a line cut into plankwood with a knife or gouge bears little relation to a line made with pen, pencil, crayon or even brush and ink – unless the drawing is adapted for the woodcut medium and the cutting tools made to imitate it, thus producing a printed facsimile, as in early European and *ukiyo-e* work. It must also be borne in mind that any directly drawn image will be reversed on print.

Some relief printmakers regard most – if not all – forms of preparatory drawing, whether on paper or on the actual block, as too inhibiting. They prefer to cut directly into the wood, responding to its particular character, rather than imposing upon it a preconceived view. The majority of artists probably do make use of some kind of preparatory drawing, but in most cases this is not intended to be much more than a guide or a rough plan showing the disposition of main lines and masses; the real work is achieved with the knife. Clearly, there can be no single recommended approach; each printmaker, after familiarizing himself with the various tools and practising cutting into the woodblock, must sort out his own working method.

Even if one starts by cutting directly into the woodblock without any preparatory drawing, it may be advisable first to darken the surface of the block with diluted indian ink, applied with a rag, to make the open cuts more visible. Alternatively, a direct drawing can be made freely and boldly with a brush and indian ink – perhaps the most sympathetic way of drawing for woodcut. If freely applied to an untreated wood surface, indian ink is inclined to spread or bleed, which can make controlled brushwork difficult. The usual way of preventing this is to seal the surface of the block before drawing with a thin coat of shellac – a method frequently used to harden the wood surface before cutting. When the indian ink is dry, wipe the entire surface over with diluted oil-based printing ink. This will make it easier to see the newly cut wood without obscuring the drawing. As a rule, brush marks indicate the positive or relief parts of the image, the undrawn or negative parts being cut away to print as 'white'.

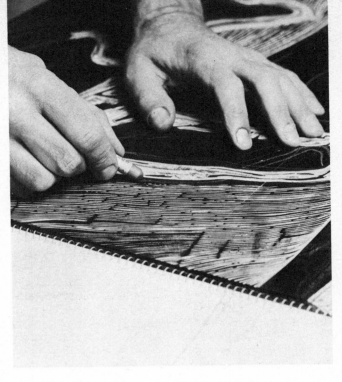

Drawing on a partially cut woodblock with a coloured crayon. Wax will tend to repel printing ink, and therefore any parts of the drawing remaining should be removed with solvent before the ink is applied.

A method apparently favoured by many Japanese printmakers is to coat the surface of the block with a thin layer of white paint (e.g. poster colour) before drawing with a black pigment such as indian ink. The white areas, being the negative parts, are then cut out. If you prefer, cover the surface of the block with black ink and then draw in the negative areas with white paint – or even, for very free work, chalk. Peterdi points out that, when the working background is light, white areas tend to dominate the design, whereas on a black background the darks predominate.

It is also quite normal practice for printmakers to draw directly on to the block with a medium pencil, a wax crayon or a felt-tip pen. (Avoid, if possible, using a hard pencil or any other hard point which may score the surface, creating a white line on the print.) Before drawing, cover the surface of the block with a thin layer of white or grey poster paint to obtain a clearer, more stable and less absorbent drawing surface. Such line drawings can be mere outline sketches or more detailed plans; but the character of a drawn line is generally alien to the essential character of a line cut into wood, and wherever possible a line drawing should serve only as a guide which can be liberally interpreted, altered or even disregarded as the cutting develops.

The main problem with direct cutting – although not all printmakers regard it as a disadvantage – is the obvious one of ending up with a reversed image on print. If the woodcut print is to be closely based on an existing drawing, and if for some reason it is considered essential that the print reads the same way as the drawing, for instance for the sake of topographical accuracy, then direct cutting is clearly inappropriate. The usual way to solve this problem is to transfer the main outlines of the drawing to the

block in reverse, either by a simple transfer or offset method or by tracing. Alternatively, try literally drawing the mirror image, looking at the original in a mirror; or, if the drawing has been made on reasonably translucent paper, tape it, reversed, against a window-pane, and copy the outlines on to the block.

These methods should not normally be necessary; the problem of reversing an entire image for a woodcut seldom arises. Letter forms and numerals, though, occur surprisingly often in contemporary printmaking, especially in the context of graphic design for posters and broadsheets, and these must be traced and cut in reverse in order to read correctly on print. A tracing of a drawn form can be made with a charcoal pencil or a soft (6B) 'lead' pencil, then taped face down on the woodblock and burnished to offset the lines; as a variation on this method, the drawing can be made directly on to the tracing paper. Check the processes of tracing and transferring from time to time, to ensure accuracy and good definition. Before offsetting a drawing, prepare the woodblock surface with a thin coat of grey poster paint, thus making both the darker drawing and the lighter cuts more visible; the charcoal or pencil lines can then be sealed in with a fixative spray. Another simple method uses both tracing paper and carbon paper, with a medium-soft pencil. The carbon paper is placed between the reversed tracing paper and the wood surface, which has been

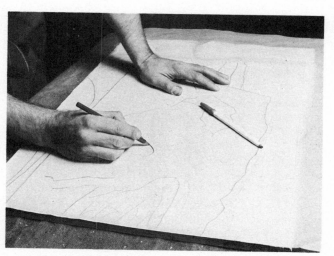

Tracing a drawing through white carbon paper on to a woodblock surface darkened with black printing ink. The drawing may, of course, be much more elaborate than the one shown here.

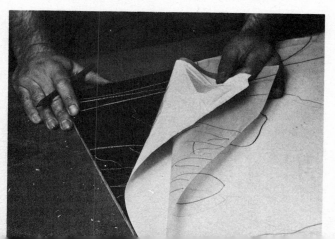

Examining the carbon drawing.

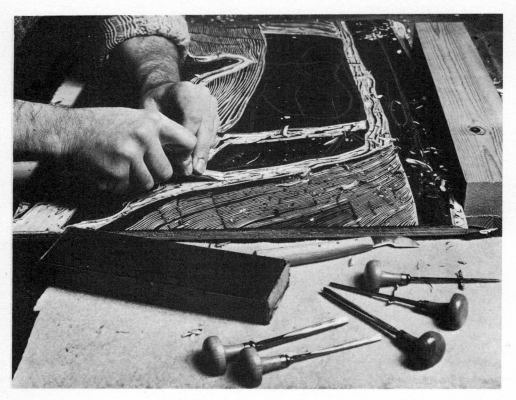

Cutting into the plywood block with a gouge.

prepared in the usual way (dark for white carbon paper, pale for the conventional dark blue carbon paper). Be careful not to press too hard with the pencil.

Linoleum

This is basically the same as drawing on the woodblock; in general, the same drawing materials apply (indian ink, pencil, felt-tip pen etc.), as well as the same methods of tracing and transferring. The surface of new linoleum is sometimes too greasy to take ink or paint, in which case it should be rubbed down with a fine grade sandpaper or scrubbed with detergent and water.

Metal

The application to metal of protective stopping-out varnish is discussed on pp. 81–2.

CUTTING THE RELIEF SURFACE

There is no such thing as an orthodox method of cutting, and there are very few conventions that a skilful and imaginative printmaker cannot break or disregard. One has only to look at the black-line prints of the early European masters, and the colour

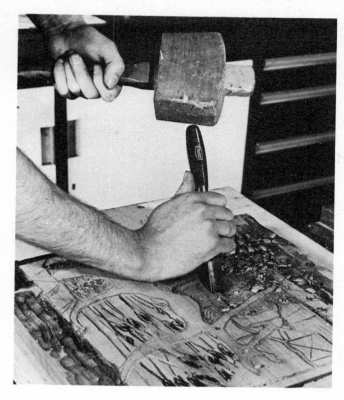

Clearing a fairly large area on the plankwood block with a long gouge and mallet.

prints of the Japanese *ukiyo-e* school and the great painter-printmakers of the late nineteenth and early twentieth centuries, to see the incredible variety of possible approaches and styles. A simplified, conventional approach would be first to define the lines and shapes and the boundaries of the main areas with the knife, and then clean out the negative or white areas with a gouge or chisel. Alternatively, the design can be cut directly into the surface with a 'V' tool. A small 'U' shaped gouge can be used instead, but when used by itself is inclined to produce a monotonous effect which can appear excessively stylized on print; a combination of the two gouges is more usual.

There are a number of suggestions that may help the inexperienced printmaker to avoid some of the common errors that can spoil a perfectly good piece of wood and frustrate an interesting visual concept. To begin with, when cutting a woodblock, make the initial cuts fairly shallow; the tools will be easier to control, which should help to make the cutting more sensitive, and if mistakes are made they are not usually too difficult to repair. Shallow cutting, especially when using a gouge on large open areas, often produces a certain amount of rough texture which tends to collect ink from the roller; some of this texture may be worth keeping, and proofs should be taken before the larger areas are deepened or cleared. There is little to be gained by gouging too systematically, which will result more often than not in boring effects on print.

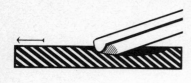

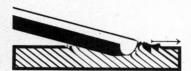

The curved gouge should only be used to cut with the grain, and then not too deeply (*top*). Gouging against the grain is liable to result in undercutting and splintering (*below*).

Wherever possible, avoid cutting against the grain with a gouge, and more so if the grain slopes sharply down through the block: the blade is apt to dig in and undercut the grain, forcing it up above the rest of the surface. Even when cutting with the grain, deep gouging is inclined to lift it, resulting in a splintered surface. It will soon become apparent that gouging with the grain is much easier, but to do so habitually would be to impose a quite unnecessary stylistic restriction on the work. A greater variety of mark, area, edge, line and texture will be obtained by also cutting and gouging across the grain in various directions. This variation in the pattern or distribution of the forms must be considered in relation to the particular character and condition of the block itself: it is an essential feature of woodcut printmaking that the texture, figure, knotholes and imperfections of the block may influence the imagery right from the formative stages.

One of the most common faults when cutting a wood or linoleum block for the first time is the tendency to overcut. It is far better to proceed cautiously, especially when removing the larger areas of surface, and to develop the composition progressively, taking proofs at each significant stage in the cutting. Spontaneity and directness, usually regarded as essential qualities in woodcut, come later, as experience is gained and confidence increases. Normally, the first proof is made as soon as the outlines defining the main shapes and areas have been cut and the composition is more or less established. It is often advisable to work on these proofs with brush and ink in order to establish the next stage in the cutting. At times, when one is eager to reach the stage of final prints, regular proofing will seem a laborious chore, but it is strongly recommended, for without an up-to-date impression of the true state of the block all subsequent work can easily get out of control. Even with considerable experience, it is almost impossible to visualize exactly what an image cut into wood will look like on print. One gets used to the feel of the wood, the shadows formed by the emerging relief image, and even the natural colours of the surface, but such features as these are conspicuously absent from the stark, two-dimensional image in ink on paper.

CORRECTIONS AND REPAIRS

Major errors in cutting are difficult, though not necessarily impossible, to correct; minor slips and slight imperfections in the wood should be easier to repair. For example, a splinter of wood or a relief line accidentally gouged out of plankwood or plywood can in many cases be glued back intact or replaced with a new piece of wood cut to the required size. Small, isolated areas containing minute but irritating imperfections can be entirely removed with a drill and bit, and the circular hole plugged with a piece of dowel firmly glued in.

Unwanted white lines, scratches, gouged hollows or bruises can often be filled in with plastic wood or similar wood filler. On fairly large, open areas, apply the filler in successive layers, allowing each layer to dry before applying the next. Fillers are

Henri Matisse (1869–1954), woodblock for the print *Nude in Profile*, 1906. 19½ × 15¾ (49.5 × 40).

inclined to shrink a little while drying; allow for this by building up the new surface until it is a fraction higher than the original surface. When it is dry, smooth it down if necessary by sandpapering with the grain.

Plastic wood should not be applied to blocks which have been saturated with oil or which contain traces of printing ink. There may not be very much one can do to dry out an oil-soaked woodblock so that it will take a filler. It might be possible to prepare the affected part by cleaning it thoroughly with turpentine and then leaving it to dry. Blocks that have been inked, but not oiled, should also be cleaned with turpentine and allowed to dry before any filler is applied. Another disadvantage with plastic wood is its tendency to work loose and fall out during the printing process, especially if the cavity filled is smooth or shallow. To some extent this can be prevented by deepening the cavity or roughening the surface so that it will grip the filler more firmly.

Larger areas of spoiled surface will need more drastic treatment, such as replaning or plugging, particularly if the block is to be printed in large numbers. Planing down a worked surface is only possible if the block is reasonably thick – at least ½ in. (13 mm)

and preferably over ¾ in. (19 mm), unless the unwanted lines or cavities are very shallow – and the spoiled surface extends to the edge of the block. Try to plane so that the incline from the original to the new surface is gradual. This will necessitate planing an area larger than the spoiled section, and may well mean destroying a certain amount of already completed work. If at all possible, plane with the grain. Remove all plane marks with sandpaper before recutting the block.

A spoiled area in the centre of the block obviously cannot be cut away with a plane. It may be possible carefully to chisel out a specific area so that it forms a smooth hollow, which is then sandpapered until no abrupt edges remain; but it is doubtful whether this method is often worth the time and effort.

A woodblock with an uneven surface caused by replaning or hollowing out a spoiled area cannot be printed on a flatbed press, nor will it print well on an etching press or a platen press. Such blocks are normally printed by hand, and this is the safest method too for blocks less drastically repaired with plastic wood.

Probably the best way, and sometimes the only way, to repair a really bad mistake is by replacing part of the block with an entirely new piece of wood, the method known as plugging. The main advantage of this technique over any other is that a neatly and evenly plugged block can, with care, be printed on most presses.

Plugs can be wedge-shaped, rectangular or circular, depending on the extent and condition of the spoiled surface. Wedge-shaped plugs are used mainly to replace broken relief lines crucial to the design. Cut out the area containing the broken line by making a deep groove with a fine saw or, if preferred, a flat chisel and mallet. The depth of the groove obviously depends on the thickness of the block itself, but it normally needs to be at least half as deep as the block, and in the case of thin plywoods or woodblocks less than ½ in. (13 mm) thick it may mean cutting almost through the wood. The plug is then inserted, the new surface smoothed with sandpaper and the lines recut until they match the rest of the design.

Larger areas are cut out with a chisel in such a way that they can be replaced with easily sawn shapes. The area in question is chiselled out to a depth of at least ¼ in. (6 mm); the sides of the cavity should be vertical and the base reasonably level. The inner surfaces are then roughened slightly and coated with glue before the plug, cut exactly to fit, is inserted. Any gaps remaining – and some will be inevitable – can be filled in with plastic wood and sanded when dry until absolutely even.

Linoleum

Linoleum is comparatively easy to repair. Small lines or shapes accidentally broken off or gouged out can often be glued back, provided the linoleum has been mounted on a wooden base; but normally, if the mistakes are more serious, the whole area is completely replaced. Simply cut out the affected area through to the wood base, and then cut a new 'patch' shaped to fit exactly into the gap. Glue this patch to the wooden base and rework.

Metal

Mistakes etched into metal plates have to be scraped out manually with a steel scraper. This can be arduous and time-consuming, but it is the best way to remove a deep line or rough texture, or even small faults or imperfections surrounded by other work. The steel scraper is triangular in section, tapering to a point, and the sides forming the three cutting edges are slightly hollow-ground, except at the actual point. Each of the blades must be sharpened and polished, and the edges kept smooth and clean. The unwanted metal surface is methodically planed off from every direction by tilting the scraper to a slight cutting angle and pulling it inwards, across the area, almost with a shearing action. The tool should be used with gradually increasing pressure; if the blade is suddenly dragged deeply through the metal, ridges may form. A blunt or rough-edged scraper will merely scratch and score into the metal instead of planing it away. To avoid leaving an abrupt, bitten edge, an area somewhat larger than that of the mistake has to be scraped out, which at times will mean erasing good work.

The scored or roughened surface left by the scraper is then smoothed down with a burnisher. Burnishers are made of highly polished steel and are usually round in section, except at the end, which is flattened out slightly, curved upwards and tapered to a point. They are much more effective if used carefully and deliberately, rather than with a vigorous but erratic action. Before burnishing, the scraped metal should be thinly covered with machine oil.

If the hollowed area is large and deep enough to affect the print, or if a perfect surface is necessary at that point for further work, then the concave surface has to be brought up to the level of the rest of the plate. The method normally employed for this operation is called 'repoussage', and involves hammering up the back of the plate or forcing up the hollow by employing the pressure of an etching press. For further information on these methods, see my *Manual of Etching and Engraving*.

Profile and blade section of the scraper, used for removing mistakes etched into metal.

5 Printing materials and equipment

Recommended materials for ink slabs include light-coloured marble, thick plate glass, a litho stone or a formica-covered table-top. Glass is even more effective for mixing ink on if a piece of white paper is placed under it; but care should be taken to avoid glass with badly broken corners or sharp edges, since soft rollers cut easily. The minimum practical size of the slab is about 10 in. × 15 in. (25 cm × 38 cm); if it is any smaller, it will be difficult to roll out a sufficiently smooth and even layer of ink for transferring to the block. It is obviously more convenient if the slab is large enough to contain more than one area of colour. A larger, possibly communal, inking surface can be made by covering part or even the whole of a table-top with a sheet of plate glass. For safety, edge the glass with a strip of wood cut to the same thickness.

Palette knives (spatulas) are used for removing ink from the tins and mixing it on the slab to the required colour and consistency, for mixing 'additives' such as varnish, transparent whites or extenders into the ready-made ink, or for mixing dry pigments with oil. When mixing fairly small amounts of ink, a conventional palette knife with a 6 in. (15 cm) or 8 in. (20 cm) flexible blade is recommended; two are better than one. A push knife with a less flexible blade 3–4 in. (7·5–10 cm) wide may be preferred for larger amounts of ink, and can be of general use for scraping ink off slabs. Do not use a palette knife to scrape ink off the more sensitive rollers.

OIL-BASED INKS

Inks for relief or surface printing can be either oil- or water-based; oil-based inks are probably more widely used by contemporary printmakers, especially in Europe, where they have been in general use since about the sixteenth century. Good quality ready-made oil-based inks should be easy to obtain, since most printers' inks are adequate for nearly all forms of block printing. Modern printing inks are so highly developed that it would normally be pointless for the relief printmaker to make his own inks, but if ready-made inks are unavailable for some reason or are too expensive, it should be possible to make up a useful ink by mixing oil paint and some form of extender. A serviceable printing ink can be made from dry pigment colour ground and thoroughly mixed with boiled linseed oil.

There is no perfect ink for all forms of relief printing, but a good quality letterpress ink is probably the nearest thing to an all-purpose ink. Lithographic (offset) inks are almost as good – some

printmakers even prefer them to letterpress – but they tend to cost more. Half-tone is perfectly acceptable, but gravure ink, being faster and more volatile, is rather less suitable for most surface printing. All the inks may be used more or less straight from the can, though they might need adapting to suit a particular relief surface. A good quality ink, however, will require the minimum of adjustment. As a general rule, when buying untried inks it is safest to buy the best you can afford; cheap inks are seldom worth the relatively small amount saved, although they may be of limited use in a printmaking department for quick trial proofs. Some dealers in artists' materials supply specially made 'block-printing' inks, both oil- and water-based, made up in cans and tubes; these are worth experimenting with, but the quality is likely to vary rather more than that of inks made by reputable, specialist ink manufacturers. The oil-based dyes used by textile printers are another useful source.

A certain amount of trial and error is inevitable when choosing inks, but expensive and time-consuming mistakes can be reduced by asking the supplier for the best quality permanent colours. Much of the ink used by the printing trade is not 'permanent' – a relative term, of course, but meaning that it will last for years; it is not necessarily of poor quality, but has been manufactured for an entirely different purpose. Permanent inks are obviously more expensive, but 'fugitive' colours which fade rapidly in sunlight, or even change colour in the shade, are clearly of no use to the printmaker. Reputable manufacturers will usually give information on which of their inks are the most permanent or 'light-fast', and some will make up, as a special order, a selection of permanent inks.

Colours which have long been regarded as 'permanent' in artists' oil and watercolour paints are not necessarily the best or most permanent colours available in modern printing inks; the cadmiums, for instance, which are among the safest of all paints, are no longer employed to the same extent in the manufacture of top quality printing inks. But cadmiums and the earth colours generally, such as umbers, ochres and siennas, are still among the most permanent of paints and inks. Monastral blue, ultramarine, viridian, vermilion and chrome yellow are reckoned to be reasonably safe, useful colours. Colours specially recommended by ink manufacturers for their quality and durability include benzidene yellow, quinacridone red and phthalocyanin blue and green. Traditionally suspect colours include violet, purple magenta and several of the blues, but even these need constant reassessment. The colour of black inks can also vary quite surprisingly from a warm brownish-black to a cool greenish- or bluish-black. The variation in covering power or density is just as great.

Tubes of ink are generally thought to be more convenient than cans, but cans work out rather cheaper, weight for weight, which may be a deciding factor. At present, though, 1 lb. cans are gradually being replaced in the trade by cans holding a minimum of 1 kilo (2·2 lb.), which may be too expensive for the independent printmaker. Ink in cans forms a thick skin if lids are left off for long periods; although a skin will also form eventually in the neck

of a tube, there is usually less wastage, since less ink is exposed to the air. On the other hand, it is easy for ink to run out and be wasted if a tube is left without its cap in a warm place. Ink supplied in a can is covered with a piece of greaseproof or waxed paper to prevent surface skin from forming; it is advisable to replace this covering after each quantity of ink is removed. Alternatively, the remaining ink can be covered with a little water, which keeps the body of it moist. A more permanent way to reseal ink is to cover the exposed surface with melted wax. When taking ink out of a can, try to expose the minimum amount by scraping it from the top rather than burrowing down into the centre. It is also easier to replace the paper seal if the remaining ink is kept level. If, by accident, a skin does form on the ink, it should be carefully and entirely removed; flakes of hard skin can be a great nuisance when rolling out a layer on the slab. Dried ink, or ink full of dust and bits of skin, is useless, but a quantity of old ink that has been 'preserved' under a thick crust may still be usable.

Always be sure to use a clean palette knife when taking ink out of a can; this may seem obvious, but is often forgotten. For some of the stiffer inks, a less flexible knife will be necessary. Before replacing the lid on a can, always wipe the inside edge of the lid and the rim of the container itself to prevent sticking. Wherever possible, store all inks at a constant temperature.

Oil-based ink should be stiff in consistency rather than soft, sticky or oily: a stiff ink is easy enough to soften, whereas it is more difficult to stiffen an excessively oily ink, although this can be done by adding powdered magnesium. Most letterpress inks tend to be stiff; canned ink is generally more viscous than that supplied in tubes. The 'correct' consistency of ink on the slab, ready for rolling on to the relief surface, is determined by a number of factors such as the condition of the relief surface, the quality of the printing paper or, in the case of a multi-colour block, the proposed sequence of printing, and can only be judged by trial proofing. A well mixed ink does not cling stubbornly to the palette knife in a sticky lump; nor should it run off the knife in a thin, oily stream. Ink of a good printing consistency falls slowly but smoothly on to the slab. If it is too thick, the ink can be made thinner on the slab by adding a few drops of boiled linseed oil. Cold ink, too, can be softened with a little oil, or simply warmed up. Too much oil in the ink will cause the print to 'bleed': a yellow stain or 'halo' will gradually spread out from the edge of the printed line or area into the surrounding 'clean' paper. A small amount of printers' varnish, lithographic (but not house-painters') varnish, vaseline (petroleum jelly), paraffin or even artists' oil paint can be used to equal effect. The addition of any softener, however, is bound to lengthen the drying time of the ink. It must be emphasized that only the smallest possible amount should be added, especially in the case of vaseline; nearly all modern printing inks are made for specialized uses, and their composition can be dramatically affected by the introduction of a softener. It is safer to rely on the reducing agent recommended by the ink manufacturer, preferably a 'reducing medium' of the same brand name as the ink. Reducing medium has a slightly lower viscosity than printing ink in the can.

It is a matter of opinion whether it is better to buy ready-made transparent or semi-transparent colours, or to buy opaque colours only and make them transparent by adding a tinting medium. The ready-made transparent colours are, of course, specially made for overprinting, but it is obviously cheaper to keep to a range of opaque colours and add tinting medium as required. Tinting mediums, usually of the same viscosity as the ink, are generally obtainable from the usual ink suppliers. The proportion of medium to ink depends on the degree of transparency required, but it could be as much as 60 per cent. All tinting or reducing mediums are bound to affect the intensity of the colour, though some do so more than others.

The drying time of a print can be hastened to some extent by adding a small amount of paste drier to the ink. This is particularly useful when overprinting in several colours. Some print-makers have reservations about the use of driers, but provided such additives are used in moderation they should have little or no adverse effect on the colour or the consistency of an ink. It is advisable, however, to use only the paste drier supplied or recommended by the ink manufacturer.

Metallic inks in several shades of gold, silver, bronze and zinc are now extensively used in most forms of printmaking. These inks are normally available either in the form of a paste, to be used in conjunction with base size and varnish, or as a fine, dry powder; neither form can be used directly. To print with the metallic paste, first print the block or relief surface on to paper using the base size only. Then thin the paste to a smooth consistency with varnish, apply it to the clean block, and overprint on to the first impression before it is quite dry. Follow the manufacturer's instructions wherever possible.

Metallic powder is sprinkled on to a still tacky impression, preferably made with a colour similar to that of the powder. Any surplus powder can easily be shaken gently off the print and re-used.

WATER-BASED INKS

Most water-based inks do not have the body, the covering power or the brilliance of oil-based inks. They need not be insipid by comparison, however, for they are capable of printing with great strength of colour. Water inks are unmatched for their delicacy, subtlety and transparency, especially when applied to the block with a brush in the traditional Japanese manner; and they do not have the rather unattractive gloss that characterizes so many relief prints made with oil ink.

Glycerine-bound water-based inks dry much faster than oil inks. This can be an advantage in some cases, for example when overprinting, but it can create problems when printing from large or complex blocks, and for this reason water inks are generally considered more difficult to work with, especially for multi-colour prints, than the relatively slow-drying oil inks. On the other hand, the fact that water-based inks dry more quickly and are easier to

clean up means that they are particularly suitable for use by younger schoolchildren in the art class.

Some excellent ready-made water inks for relief printing are supplied in both tubes and cans by a number of general dealers in artists' and printmakers' materials. The basic pigments employed in the manufacture of water-based inks are more or less the same as those used in oil-based inks, and pigment in dry powder form can be obtained either direct from artists' colourmen or from local dealers. Tempera, poster colour and gouache are all worth experimenting with. The degree of penetration into the paper, and the covering power and density of the printed effect, vary from pigment to pigment. Permanence is another factor to consider, and this may be rather more difficult to assess than with ready-made oil inks. The better quality ready-made watercolour paints, though often capable of great permanence and strength of colour, are normally only applied by brush to small surface areas, as they are far too expensive for large-scale application with a roller. No watercolour ink should be applied to the block with a gelatine roller, since gelatine absorbs moisture and soon becomes soft and sticky, but rubber and plastic rollers are perfectly suitable.

Japanese colour printers of the *ukiyo-e* school used watercolour inks made from a mixture of pigment and rice paste. Paste gives the ink the necessary substance or body, and also has a certain amount of adhesion which helps to keep the printing paper more firmly on the block during burnishing. It is made by mixing rice flour (starch) and water, thoroughly stirred in order to obtain the necessary smooth consistency, then pouring the mixture into a saucepan with a little more water and heating slowly until it begins to boil. Constant stirring at this stage is essential. If left to boil, the mixture will turn into a clear fluid; it should be removed before this occurs, poured into the appropriate containers and left to cool. The paste is then ready for mixing with the dry pigment – preferably finely ground. The whole mixture should be freshly made before each printing session.

ROLLERS

Rollers (brayers) for relief or surface printing are made of hard or soft rubber – natural, synthetic or composition – gelatine, or polyurethane (a moderately soft plastic). Many are identical to those employed by the printing trade for hand-proofing letterpress type, and can also be used for inking relief etchings. All are obtainable from retail suppliers of artists' and printmakers' materials, from certain general suppliers to the printing trade, or direct from the manufacturers.

No single roller is equally suitable for all relief surfaces. For instance, a hard rubber roller is inappropriate to an uneven block, as it is unable to deposit ink evenly on all parts and consequently produces a patchy print; a soft rubber roller is unsuitable for inking a block containing fine close lines or detail, since it is apt to push the ink down into the lines, causing a loss of definition on the print. Gelatine rollers, though sensitive, are soft and vulnerable.

Probably the best general-purpose roller is made of polyurethane, about 2½–3 in. (63–75 mm) in diameter and 6 in. (15 cm) long. Polyurethane rollers are among the most expensive, but for quality and durability they are well worth the money. Most independent printmakers are unlikely to be able to afford many rollers of this quality; although ideally one would like to have the widest possible range of rollers, it should be possible to achieve a great many effects with, say, one plastic roller and a small selection of rubber or composition rollers, hard and soft, in several sizes (perhaps ranging from ½ in. (13 mm) to 12 in. (30 cm) in length).

Rollers are generally fixed into a strong metal frame, usually of brass, complete with the standard wooden handle. The frame may vary somewhat according to the make, but the majority are shaped so that they can be turned over and placed upside down on the slab or bench, thus protecting the surface of the roller and avoiding spreading ink around. Never leave any kind of roller lying on a hard surface – even plastic will lose its shape in time. Some of the larger rollers have a metal frame serving as a stand on four legs.

Rollers can, of course, be stored resting on the back of the frame, but many printmakers prefer to hang theirs up by the handle. Alternatively, a small wall rack can easily be assembled. As a rule, it is advisable to keep rollers frequently used for oil-based inks separate from those used with water-based inks.

Always clean ink from the roller after printing, preferably by running it across an ink slab covered with the appropriate cleaning fluid – petrol for quick drying, white spirit, turpentine substitute or paraffin, whichever is the cheapest – and wiping dry with a soft clean rag. Any ink left will eventually harden, and will then be difficult to remove without damaging the surface of the roller, although it may be possible to clean it off by detaching the roller – plastic, rubber, but not, of course, gelatine – from its handle and immersing it for half an hour or more in a mild solution of caustic soda. After reassembly, oil the screw nuts and spindle and dust the roller lightly with talc or French chalk before storing it away.

Polyurethane rollers

Polyurethane rollers have the same smooth, sensitive inking qualities as the gelatine rollers, but are tougher and more resilient and therefore less vulnerable to damage from heat, moisture and rough-textured or sharp-edged surfaces. They are available in sizes ranging from 2 in. (50 mm) to 10 in. (25 cm) in length and from 2 in. (50 mm) to 2½ in. (63 mm) in diameter.

The surface of a new roller may feel somewhat soft and sticky, but it will soon lose its stickiness and harden slightly with use. It may, however, begin to soften after a few years of regular use, and should be replaced if a thumb pressed firmly on to the polyurethane leaves a distinct impression. Some manufacturers will fit a new roller to the old frame, which means a considerable saving.

Gelatine rollers

Although largely superseded now by more robust and durable plastics, gelatine rollers – or gelatine composition, as they are

The gelatine roller supported in its frame – no roller should be left lying on a hard surface for any length of time.

sometimes termed – are the most sensitive of all rollers and, if used with care, give the best possible coverage of ink on the widest range of relief surfaces. However, gelatine is an extremely vulnerable substance, easily cut, pitted or indented, and is soluble in water, which makes it quite useless for watercolour inks. It is also badly affected by heat, and can lose its shape on a hot day; a gelatine roller may even sag out of shape when stored in a cupboard which is exposed to direct sunlight. If left to stand on a hard surface for any length of time it is liable to stick, and it will almost certainly flatten out more quickly than the plastic roller. Damaged gelatine can normally be replaced by the makers, and rollers are sometimes supplied without frames for about half the cost of the complete article, but constant replacement is expensive.

Like all soft rollers, the gelatine roller will inevitably deposit a certain amount of ink into the 'negative' areas of a relief block if they are too shallow or too wide. Cutting and gouging needs to be a fraction deeper if a soft roller is to be used and a 'clean' print is intended. However, if a deliberately textured effect is required, then gelatine is ideal. If charged with too much ink or applied to the relief surface with too much pressure, the soft roller may force the ink into the finer work. Normally the weight of the roller itself is sufficient pressure.

A gelatine roller is cleaned and stored in much the same way as any other, except that even greater care in handling is generally needed.

Hard rubber rollers

Hard rubber rollers are among the least sensitive, and tend to produce a rather flat impression with the minimum of texture from the gouged, lowered surfaces. They do not work well on uneven blocks, but are most suitable for making 'clean' prints from flat, level surfaces containing areas of fine detail, which usually require a fairly thin, evenly distributed layer of ink. Whether bought or home-made, rubber rollers are the cheapest of all, and they are certainly the toughest, being resistant to heat, water and rough surfaces.

Several craft firms produce a limited range of hard rubber rollers specially for block printing in the school art room. The best of these, such as the 1½ in. (38 mm) diameter in various lengths from 1 in. (25 mm) to 7 in. (18 cm), in hard black rubber, are inexpensive and useful additions to a workshop, but the really cheap versions, particularly the small, lightweight kind on a wooden core, cannot be recommended for serious relief printing.

It is quite possible to make a serviceable roller out of rubber tubing, which should be available in diameters of 1½ in. (38 mm), 2 in. (50 mm) and 3 in. (75 mm). The inside diameter of the tubing is usually at least ½ in. (13 mm), which allows a piece of dowelling to be inserted as a core or spindle. The roller can be fixed to a single metal frame, and a handle attached. Wooden handles from discarded chisels and files are worth saving for this purpose. For the smaller rollers, a piece of strong wire twisted into shape with two pairs of pliers should be adequate.

Ernst Ludwig Kirchner (1880–1938). *Winter Moonlight*, 1919.
12 × 11⅝ (30·6 × 29·5).

Hard rubber rollers, being heat-resistant, may also be used for applying wax grounds to etching plates, and are generally useful for inking relief-etched metal.

Soft rubber rollers

As a rule, soft rubber rollers – usually made of synthetic rubber or composition – are softer than either gelatine or plastic. They have most of the drawbacks of the gelatine rollers – for instance, they are far from heat-resistant, and will begin to flatten if left on the inking slab for long – without the obvious advantages of the plastic, by which they have now largely been superseded. Soft rubber rollers – mostly quite small – are still being manufactured, however, and have proved to be particularly useful for applying colours – either oil- or water-based – to small areas or for merging different colours on the same block surface. Although unsuitable for inking fine, delicate lines or textures, they are essential for uneven blocks and certain kinds of built-up surface, and for depositing ink into open, shallow areas in order to obtain the maximum textural or 'soft-edged' effect.

Large composition rubber rollers, used mainly in lithography, make a useful addition to the workshop. For unusually large blocks they are invaluable. Not normally available from most printmakers' suppliers, they can be obtained from printers' suppliers or direct from the manufacturers. Sizes vary from 4 in. (10 cm) to 4½ in. (11·4 cm) in diameter and from 12 in. (30 cm) to 15 in. (38 cm) in length, though some manufacturers will make even larger rollers to order. An extra hard composition roller is also available. For information on these individually made rollers, apply to the manufacturers indicated in the list of suppliers.

Alternative inking methods

Ink can, of course, be applied to the surface reasonably well without a roller, which is in fact a comparatively modern device.

The two-handled 'litho' roller.

Until the early nineteenth century, European woodblocks and printing type were always inked with a kind of dabber – a ball or pad made of leather or felt, not unlike the dabber still employed by etchers to lay wax grounds on metal plates. The implement and the method may seem crude, but with practice a fine, even coating of ink can be applied to the most detailed of blocks.

The other 'conventional' inking method involves the use of a brush. Oil-based ink needs to be applied with a stiff brush – hoghair is particularly suitable – and the inevitable brushmarks must be accepted as part of the print quality.

The technique of applying a water-based ink by brush, in the Japanese manner, is far more difficult to control than the conventional Western method of applying ink with a roller. The Japanese polychrome print was a result of highly accomplished teamwork, and the craft of mixing the pigments and applying them to the block demanded a long and exacting apprenticeship, which makes it extremely unlikely that any Western printmaker could convincingly reproduce the qualities of an *ukiyo-e* colour print. However, it should be possible to adapt some of the techniques and achieve at least something of the extraordinarily subtle effects characteristic of the Japanese colour print.

Japanese printmakers use a number of specially shaped brushes, the most common known as the *te-bake* and the *buroshi*. *Te-bake* are straight-handled brushes of horse-, pig- or ox-bristle; they are used to ink small detailed areas and fine lines, and vary in width from about ¼ in. (6 mm) to 2 in. (50 mm). They are held upright, and the colour is applied with a circular motion to ensure that the pigment and rice paste are thoroughly mixed together on the block. For exceptionally fine work, a Western watercolour brush (e.g. sable) may be used. *Buroshi* brushes are shaped rather like small shoe-brushes, with a flat wooden back and no handle, and are made from horse-bristle. They are designed primarily for applying pigment to the larger areas. Colours can be blended or graduated on the block with both types of brush.

It is normal practice to soften the bristles of these brushes by wetting them and then rubbing them against a dried, taughtly stretched sharkskin, which will split or fray the ends of the otherwise over-coarse bristles. A rougher grade sandpaper is a poor but workable substitute for sharkskin.

All these brushes can be ordered direct from suppliers in Japan, but most should also be available from suppliers in the USA and, to a much lesser extent, in England. Sharkskin will obviously be less easily obtained, and most printmakers interested in this kind of work will have to use sandpaper instead.

PAPER

No one type of paper, however finely made, could possibly suit every sort of relief surface. Choosing the best paper for the job is, therefore, an important part of the creative process of making prints. It is perhaps less important for proofing than for printing editions, and quick 'state' proofs can be made on cheap paper such

Applying ink to the block with a watercolour brush. Notice also the Japanese *te-bake* and *buroshi* at the left.

as newsprint, but the later proofs at least should be printed on the same quality of paper as the edition in order that the state of the block may be correctly 'read'. When making a burnished proof it is probably best to use a soft, smooth, thin but strong paper, preferably unsized or only soft-sized.

The papers traditionally employed for woodcut printmaking, especially for editions, are the Japanese hand-made papers. A number of European hand- or mould-made (the best of the machine-made papers) are also extensively used for editions. Some machine-made papers, being less expensive, are well rated for proofing, whether by burnishing or with a press. Machine-made papers consisting chiefly of wood pulp and sulphite do not generally last well and are really only suitable for trial proofing.

Japanese hand-made papers

Japanese hand-made papers are by far the most highly regarded for relief printing, especially for printing woodblocks. Their particular qualities are their softness, sensitivity and absorbency. Each make has a distinctive character of its own; some have a perfectly smooth surface, while others are uneven in thickness and quite rough in texture with a speckled, fibrous surface.

Another distinctive feature of these papers is the colour: a good many are made in subtle, warm, off-white shades, and in natural colours such as cream and buff as well as various browns or a strong tan. A wide range of plain colours is also available.

Many of the papers are unsized (though they are not difficult to size), and are so absorbent that they are frequently printed dry. The presence or absence of size can be an important factor when choosing a paper for a particular relief surface. In a dry state, even the thinnest, most transparent papers are surprisingly strong, but the very thickest, toughest papers are easily torn when damp.

Japanese printing papers are often referred to as mulberry papers, and many are, in fact, made from the inner bark of the

paper mulberry tree; others are made from manila, hemp and other plant fibres such as *kozo* (*Broussonetia kajinoki*), *mitsumata* (*Edgeworthia papyrifera*), *gampi* (*Wickstroemia shikokiana*) and a certain amount of Western coniferous wood pulp. All the fibres are strong, malleable and absorbent, and they can be used singly or in combination. A binder made from a vegetable material known as *tororoaoi* (*Hibiscus manihot*) is added to the fibres to ensure a greater uniformity of thickness. The term 'rice-paper' was widely used to describe Japanese papers, but the name is misleading and is now largely obsolete.

India papers, made largely from bamboo fibres, are similar in character to many of the Japanese papers. The most easily obtainable kinds are usually white and extremely thin, but are excellent for proofing by burnishing if handled carefully.

The following are among the more popular hand-made papers imported from Japan; the majority of these are currently available from main paper suppliers such as Andrews, Nelson, Whitehead of New York and T. N. Lawrence of London.

Goyu: an off-white, smooth paper, rather thin but excellent for fine work. 21 in. × 29 in. (533 mm × 736 mm).
Hosho: a soft, white, moderately priced paper recommended for colour woodcut. 19 in. × 24 in. (483 mm × 609 mm). A smaller, cheaper version or 'student grade' is also made (16 in. × 24 in./ 406 mm × 609 mm).
Hosho-pure: one of the most highly renowned of the traditional *ukiyo-e* school papers; strong, off-white, expensive and available, according to Ross and Romano, only from Japan.
Kitakata: a thin, smooth, natural-coloured and rather transparent paper. Inexpensive. 16 in. × 20 in. (406 mm × 508 mm).
Kizuki-Bosho: specially made for the traditional Japanese watercolour ink method. Sized on both sides. 17 in. × 24 in. (431 mm × 609 mm) and 25 in. × 35 in. (635 mm × 889 mm).
Kochi: an off-white paper with a somewhat uneven thickness. 20 in. × 26 in. (508 mm × 660 mm).
Moriki: a soft, unsized paper available in white and in numerous 'plain' colours. 25 in. × 36 in. (635 mm × 914 mm).
Mulberry: a fairly cheap, useful paper. Off-white, thin and not particularly strong. 24 in. × 33 in. (609 mm × 838 mm). An even cheaper 'student grade' is also made (24 in. × 33 in./609 mm × 838 mm).
Okawara: natural or tan-coloured and even-textured paper. Available in at least two sizes (36 in. × 72 in./914 mm × 1828 mm and 12 in. × 16 in./304 mm × 406 mm); a cheaper form or 'student grade' is also available (18 in. × 25 in./457 mm × 635 mm).
Sekishu: a thin, soft, rather fragile paper. Obtainable in white and natural colours. Inexpensive. 24 in. × 39 in. (609 mm × 990 mm) and 19½ in. × 24 in. (495 mm × 610 mm).
Suzuki: a very large, white, moderately thick paper. 36 in. × 72 in. (914 mm × 1828 mm).
Torinoko: a strong, rich, creamy-white paper, smooth and even; apparently made in various thicknesses. Expensive. 21 in. × 31 in. (533 mm × 787 mm).

The main UK suppliers, T. N. Lawrence, classify Japanese papers by reference numbers rather than by name. Numbered samples can be obtained for a small fee and the selected papers ordered direct.

It is, in any case, advisable to examine samples of papers before ordering. The appearance and feel of a paper is all-important, and experimenting with different papers is strongly recommended.

At present, Lawrence stocks about forty-six 'real' Japanese papers in white or off-white, including a smooth, white tissue paper. All but one are absorbent; some are semi-transparent, while others are only slightly transparent. The dimensions, given in the catalogue, range from 15½ in. × 21 in. (394 mm × 533 mm) to 27 in. × 40 in. (686 mm × 1016 mm). Lawrence keeps a selection of about fifty 'plain' coloured Japanese papers suitable for printing woodcuts. These are available in two qualities, the better quality costing roughly twice as much as the other. There is also a small selection of extra large coloured papers (e.g. 39 in. × 71 in./ 99 mm × 1803 mm).

An extremely varied selection of Japanese papers described as 'fancy', as opposed to plain coloured, is available. These are less commonly used for printmaking.

Hand- and mould-made European papers

The European or Western hand-made and mould-made papers used primarily for drawing and watercolour painting, as well as for intaglio and lithographic printing, are also excellent for relief printmaking. The best of these – strong papers with a relatively smooth, soft surface – are ideal for editions.

Paper for relief printing needs to be porous and absorbent, and therefore the best kinds to use are the unsized ('waterleaf') or soft-sized varieties, with a uniform thickness and consistency. Moderately hard-sized papers can sometimes be adapted by thorough damping, but really hard-sized and glazed papers should be avoided.

The surface qualities of a hand-made paper are referred to by the terms HP (smooth), NOT (matt) and rough. HP (hot-pressed) papers are interleaved with zinc plates and rolled dry through a sort of giant mangle which causes slippage under pressure and therefore polishes the paper. NOT papers are pressed wet in packs three or four inches thick, separated occasionally with heavy zinc plates. Rough-textured papers are not suitable for relief printing. Surface descriptions do not indicate the amount of sizing present in a paper: one can choose a waterleaf NOT or a hard-sized NOT, a waterleaf HP or a hard-sized HP.

In the past, hand-made papers were made of pure linen fibre (flax), shredded cotton rags or linters – the latter, which consists of 95·5 per cent alpha cellulose, being the most pure – for maximum softness and durability. Although these older papers are now almost impossible to obtain, several modern hand-made papers compare very favourably with them. Nowadays, rags are considered less suitable for hand-made papers, since they tend to contain too many synthetic fibres; chemicals and bleach are also detrimental. Pure cotton, which has fibres only fractionally shorter than those of flax, is now more widely employed.

Mould-made papers contain the same raw materials as hand-made, but are manufactured in rolls on a machine and later cut

into separate sheets. These are easily identified by their straight-cut edges, as opposed to the uneven, 'deckled' edges of the hand-made. Until the nineteenth century, deckled edges were often trimmed off; now they are carefully preserved to distinguish the hand-made papers from the machine-made. If a large hand-made sheet has to be halved or quartered, some printmakers tear it against a steel rule to preserve the rough-edged character. The quality of the paper, though, is more important than the deckle.

Hand-made papers also contain a distinctive watermark and in some cases the words 'hand made'; these should be clearly visible when held up to the light, and indicate which is the printing side.

The terms 'laid' and 'wove' refer to the faint pattern (or absence of pattern) in the composition of the paper made by the wire mesh screen used during the paper-making process. Laid paper – made by the older method – has faint parallel lines running across it at regular intervals, clearly visible when the paper is held up to the light; wove paper has no obvious pattern and is therefore preferred for most relief prints, although the lines of a laid paper may be less obtrusive if extra printing pressure is used.

The standard sizes for hand-made papers generally available in the UK for printmaking are as follows:

	inches	millimetres
Crown	15 × 20	381 × 508
Demy	17½ × 22½	445 × 572
Medium	18 × 23	457 × 584
Royal	20 × 25	508 × 635
Super Royal	20 × 28	508 × 711
Double Crown	20 × 30	508 × 762
Imperial	22½ × 30½	572 × 775
Double Elephant	27 × 40	686 × 1016
Antiquarian	31 × 53	787 × 1346

The weight of the paper, calculated by the ream (500 sheets), indicates its thickness. For instance, an Imperial sheet at 90 lb. is obviously thicker than an Imperial sheet of the same type of paper at 72 lb. An Imperial sheet of 140 lb. is moderately thick; the heaviest and therefore the thickest of all hand- or mould-made papers can weigh as much as 300 lb. per ream. This method of calculating weight, which makes it difficult to compare the weights of different sizes of paper, has now been almost entirely superseded by the Continental method of weighing in gsm (grammes per square metre), although some manufacturers of hand-made papers, for example J. Barcham Green (UK), still give the weight in pounds as well as grammes in their catalogues.

Extremely hard or thick papers, even when damp, need the heavy pressure of a printing press; burnishing is really only practicable on the thinner, softer papers. The more absorbent papers require more ink than the thinner or harder papers; the latter may be preferred for precise, detailed work.

'Retree' or 'outsides' are terms formerly used to describe slightly imperfect hand-made papers sold at a discount of up to 40 per cent. 'Retree' was only slightly defective, perhaps with small specks, while 'outsides' may have had a wrinkle or a torn edge or some other slight imperfection; both made good proofing papers.

Barcham Green, the main UK manufacturer, has now abolished these terms and replaced them with the single word 'seconds': a substantial reduction in the price still applies.

English hand-made papers more or less suitable for printing relief surfaces include most of the papers on Barcham Green's current lists. The manufacture of RWS and Hayle Mill, primarily watercolour papers but also good for printmaking, has been suspended: Cotman replaces them. Other Barcham Green papers well worth trying include the following:

Canterbury: light-toned, laid, 44 lb. (125 gsm). NOT. 20 in. × 25 in. (508 mm × 635 mm).
Charles I: grey-green, laid, 25 lb. (85 gsm). NOT. 18 in. × 23 in. (457 mm × 584 mm).
Chilham: white, laid, 44 lb. (125 gsm). NOT. 20 in. × 25 in. (508 mm × 635 mm).
Crisbrook: white, wove, 140 lb. (285 gsm). HP and NOT. 22 in. × 30 in. (559 mm × 762 mm).
Dover: dark-toned, laid, 20 lb. (60 gsm). NOT. 17½ in. × 23 in. (445 mm × 584 mm).
Hayle: white, laid, 25 lb. (115 gsm). NOT. 15½ in. × 20½ in. (394 mm × 521 mm).
Penshurst: light-toned, wove, 110 lb. (230 gsm). HP and NOT. 22 in. × 30¾ in. (559 mm × 781 mm).
Tovil (or Linton): light-toned, laid, 25 lb. (115 gsm). NOT. 15½ in. × 20½ in. (394 mm × 521 mm).

Mould-made papers include Bockingford (22 in. × 30 in./559 mm × 762 mm) at 70, 90, 140 and 200 lb. (150, 190, 300 and 425 gsm).

Among T. H. Saunders's drawing and watercolour papers are several mould-made papers suitable for relief printing. These are all supplied with trimmed edges. The smallest size, Royal, is to be discontinued, but a variety of Imperial papers is available, for example white HP and NOT at 72, 90, 140 and 200 lb. (150, 180, 285 and 410 gsm). Double Elephant sheets are available at 133 lb. (170 gsm) HP and NOT, and Antiquarian (31 in. × 53 in./787 mm × 1346 mm) at 240 lb. (200 gsm) HP and NOT. Other Saunders papers include a white mould-made printing paper at 140 lb. in both Imperial and Double Elephant, manufactured for Messrs R. K. Burt of London. This is obtainable either sized or waterleaf.

Notable among the various European etching and watercolour papers considered suitable for relief surfaces are the following:

Arches cover: white and buff. 22 in. × 30 in. (559 mm × 762 mm) and 29 in. × 41 in. (737 mm × 1041 mm). Moderately priced.
Arches text: white, laid and wove. 25 in. × 40 in. (635 mm × 1016 mm). Moderately priced.
German etching: white, soft. 22 in. × 30 in. (559 mm × 762 mm) and 30 in. × 42 in. (762 mm × 1067 mm). Moderately priced.
Italia: white, soft. 20 in. × 28 in. (508 mm × 711 mm) and 28 in. × 40 in. (711 mm × 1016 mm). Moderately priced.
Rives: light and heavy, white or buff. 19 in. × 26 in. (483 mm × 660 mm) and 26 in. × 40 in. (660 mm × 1016 mm).
Rives BFK: white, described as 'standard' paper. 22 in. × 30 in. (559 mm × 762 mm) and 29 in. × 41 in. (737 mm × 1041 mm), also available (unsized) in rolls. Inexpensive to moderately expensive, depending on size.

Good quality hand-made paper actually improves with age. Really old paper is now difficult to find, although papers sold in many retail shops may already be several years old. Paper ordered direct from the manufacturer is likely to be no more than a few months old.

Hand-made paper should be wrapped in strong paper and stored flat in a warm, dry and well ventilated room. It must never be wrapped in polythene sheet, and on no account should it be stored near a sink or in a damp place or exposed to acid fumes.

Other mould-made papers worth trying, particularly in the USA, include:

Bechet cover: white, permanent. 26 in. × 40 in. (660 mm × 1016 mm). Moderately priced.

Domestic etching: white. 26 in. × 40 in. (660 mm × 1016 mm). Moderately priced.

Pericles cover: white, described as fairly permanent. 26 in. × 40 in. (660 mm × 1016 mm). Moderately priced.

Machine-made papers for proofing

The great majority of commercial printing papers of general use to the artist–printmaker are machine-made from wood pulp and sulphite. Those recommended for proofing include the inexpensive, strong, reasonably permanent white papers such as Tableau (40 in./1016 mm wide rolls) and the much less permanent papers, useful only for general proofing, such as Index (26 in. × 40 in./ 660 mm × 1016 mm), Masa 225 (21 in. × 31 in./533 mm × 787 mm or 42 in./1067 mm wide rolls), Mohawk text (26 in. × 40 in./660 mm × 1016 mm), Newsprint (24 in. × 36 in./610 mm × 914 mm), Opaline parchment (22 in. × 28 in./559 mm × 711 mm), Troya 40 (24 in. × 36 in./610 mm × 914 mm or 30 in./ 762 mm wide rolls) and Tuscan cover (26 in. × 40 in./660 mm × 1016 mm). Most of these either discolour or turn brittle with age, or both, especially Newsprint. Filter paper is also quite commonly used.

Another useful paper, machine-made from esparto pulp, is Basingwerk medium and heavy (26 in. × 40 in./660 mm × 1016 mm, moderately inexpensive), frequently used for litho but recommended also for general proofing.

Offset litho cartridge paper and engineers' cartridge paper have little or no surface character, but are fairly cheap and reliable, though they tend to be too hard for burnishing.

Other useful papers include:

Machine-made unsized paper in 100 ft (30·5 m) rolls: white, both thick and thin, between $11\frac{1}{2}$ in. (292 mm) and 24 in. (610 mm) wide.

Ingrez: laid, toned and coloured. 19 in. × 24 in. (483 mm × 610 mm).

Basingwerk parchment: white and toned, thick and thin. 20 in. × 30 in. (508 mm × 762 mm) approx.

White English tissue: for wood engravings. 20 in. × 30 in. (508 mm × 762 mm).

Most machine-made papers suitable for relief printmaking are now being made in 'A' sizes. The 'A' size range forms part of the

ISO metric paper size system, whose introduction in the British printing industry was governed by recommendation BS 4000 of 1968.

All the dimensions are based on those of the basic sheet, A0, which measures 841 mm × 1189 mm (area 1 square metre); each size is achieved by halving the size immediately above, the division being parallel to the shorter side. The dimensions (in millimetres) are as follows:

A1	594 × 841
A2	420 × 594
A3	297 × 420
A4	210 × 297
A5	148 × 210
A6	105 × 148
A7	74 × 105
A8	52 × 74
A9	37 × 52
A10	26 × 37

Printing papers are also available in 'B' and 'C' sizes, but these are supplementary to the more important 'A' size.

Damping

For intaglio printmaking, hand-made papers have to be totally immersed in water, sometimes for several hours, but for relief printmaking few papers need more than the absolute minimum of damping. It is, in fact, quite normal practice to print on dry paper, especially in the case of the Japanese papers, but a hard-sized or stiff paper like some of the hand-made watercolour papers will probably require softening if it is to print well. As a rule, a slightly damp surface will more readily accept ink, particularly water-based ink; a sodden or 'shiny wet' paper, however, will almost certainly reject it, or at best give an extremely pallid impression. This applies very much more when printing with oil-based ink. Oil inks usually print better on dry or very slightly damp paper. Test proofs should be made on both damp and dry paper to see which gives the best effect. Bear in mind that damp paper tears easily when burnished directly, so burnish only through an additional protective layer of thin but strong paper.

It is advisable to damp relief printing papers indirectly, for instance by contact with other damp papers of an absorbent kind. Place three or four sheets of clean newsprint or blotting paper on a flat, hard, non-absorbent surface such as a thick sheet of glass, an old zinc litho plate or a piece of linoleum, preferably rather larger than the paper, and lightly sponge or evenly spray with water. On top of these place one or perhaps two sheets of printing paper. Cover with more wet (but not saturated) newsprint and repeat the process, alternating one or two sheets of dry printing paper with three to four sheets of wet newsprint or blotting paper. The finished stack is covered with a second 'board' and weights placed on it to help distribute the dampness more evenly. Gradually, the moisture will permeate through until each sheet is thoroughly and

evenly damped. For more precise, controlled damping, place only one sheet of dry printing paper between damp papers, varying the number of these according to the degree of dampness required.

The thinner, softer Japanese papers are generally sufficiently damp for printing after an hour or so; in some cases, even a few minutes might be enough. Thicker, harder-sized papers may have to be left overnight. If the stack is to be left for several hours, especially in a warm room, keep the exposed edges covered with a damp cloth or wrap the whole stack in a sheet of polythene to keep the air from getting to the paper. Do not leave paper in this pressed, dampened state for too long; after a few days it will gradually become mildewed, which can cause fungus spots to appear on the printed papers.

Ross and Romano, writing on Japanese woodblock printing, describe a system of rearranging papers that have already been damped in a stack for about two hours. This rearrangement prepares the paper for printing. Briefly, the papers are laid down on a flat board in staggered layers: starting at one side of the board, each sheet is laid down on top of the previous one, but an inch or so to the left, moving across the board to the other side. Further layers can be laid down in a similar manner on top of the first layer, and the whole process repeated until all the printing papers have been arranged. They are then covered with a single sheet of damp paper, large enough to cover the whole spread, and a piece of wet cotton fabric, and left overnight. Twenty-four hours should be the maximum period of time for damping even the hardest printing paper. Ross and Romano also recommend inserting wet newsprint between every two sheets of printing paper, if this is still too dry. This method can be particularly useful when printing relatively large numbers of prints (say fifteen or more) in one session, because it ensures, as nearly as possible, that all the sheets are consistently damp, an important factor when printing an edition. However, unless there is ample space available, it is probably only feasible with smaller sheets and relatively small editions.

Damp paper can be dried by reversing the process, i.e. interleaving it with dry newsprint or blotting paper. This can take time, and the dry papers may have to be replaced several times. Paper must be allowed to dry out under firm, even pressure if it is to be perfectly flat for future use.

Sizing

Unsized Japanese paper often needs to be sized before printing with a water-based ink. Many unsized papers are so absorbent that the water ink is inclined to spread out into the soft, fibrous surface, particularly if the paper is damp; the presence of a moderate amount of size helps to confine the absorbency to the printed area. Many pre-sized papers look much the same as unsized papers. One way to tell the difference is to place a few drops of water on the 'front' surface of the paper: if they remain more or less whole on the surface, but leave damp spots when wiped off, then the

paper contains some size, but if they are completely absorbed as though into blotting paper then the paper is clearly unsized.

Size is generally made from a mixture of water, dry animal glue and a small amount of alum. Experts differ on the amounts recommended, but a workable solution can be made from 1 oz. (25 g) dry glue and ½ oz. (12·5 g) alum to 1 pint (½ l) water. Some experimentation may be necessary, though, especially in extreme temperatures, to ascertain the absorbency of a specific paper.

Whatever the amounts, mix no more than is absolutely necessary, for size will not remain in a workable condition for long. Choose a pan large enough to take the fairly wide brush needed to coat the surface of the paper, place the dry glue in it with the appropriate amount of cold water, and leave it to soak. When it has become soft, heat the pan slowly until the glue melts. Stir the mixture constantly and do not allow it to reach boiling point; boiling a glue will only reduce its strength. As soon as the glue has completely dissolved, remove the pan from the heat, add the correct amount of alum, and mix thoroughly. Before the mixture cools off, strain it through a piece of fine muslin or cheesecloth to remove any particles.

Size should, if possible, be applied to the paper while it is still warm or even hot. Japanese printmakers normally use a wide, flat brush made of rabbit or badger hair for this purpose. The coating must be brushed evenly and systematically over the entire front of the paper. If necessary, the reverse of the paper can be sized and a second coat applied to the front, but each coat must be at least touch-dry before the next is applied. Sized papers may dry better if hung up on a line.

6 Printing without a press

ROLLING OUT INK ON THE SLAB

The quantity of ink needed on the slab for rolling up and printing will obviously depend on such practical considerations as the size and condition of the relief surface, and consequently the size of the roller, the number of prints needed (although for proofing two would normally be sufficient), the thickness and absorbency of the printing paper, and so on. Clearly, some experience is necessary before the quantity of ink needed can be accurately estimated, and this will apply even more when printing large editions, especially when several different colours have to be mixed. In general, for proofing in monochrome it is better to be somewhat mean with the ink, rolling it backwards and forwards on the slab and gradually building up a thin, even film, rather than spreading a thick, sticky coating all over the slab.

After ensuring that the slab is perfectly clean, place a moderate amount of ink on it and spread this right across the top edge with a palette knife, to accommodate the roller, rather than leaving it piled in a lump in the corner. Depositing ink on the slab in this way is the most efficient way to replenish the roller with a manageable supply during the rolling-out operation.

To distribute the ink evenly over the slab, move the roller to and fro in all directions, occasionally replenishing it with more ink from the supply and frequently lifting it clear so that it can spin freely. The rolling action needs to be easy and rhythmic. It should not be necessary to exert too much pressure, although a little pressure might help to speed up the process. Coloured inks, as a rule, are rather softer than black inks and therefore easier to roll.

Before transferring ink to the relief surface, ensure that the film of ink on the slab is consistently smooth, even and, of course, completely free from any lumps, particles of dust, wood shavings or dried ink. The roller, too, should carry an equally smooth, thin and clean coating of ink.

An excessive amount of ink, especially soft ink, transferred to the block from an overcharged roller will clog any fine work, and if the ink is too viscous even the flat, solid areas can look distinctly pock-marked and mottled on print. If the roller skids and slides through the ink, then the ink is obviously too thick and too 'wet' and sloppy. It will actually sound sticky, whereas with a thin, even consistency the roller should make a light, swift hissing sound. (A fairly generous layer of ink can, of course, be deliberately applied to the block in order to achieve a thick, glossy impression.)

A layer of ink that has been properly rolled out on the slab is similar in appearance to a piece of taut silk or satin; it has quite an

unmistakeable sheen, with no obtrusive texture. A thick coating of soft ink is more inclined to glisten or shine; an inadequate coating has a weak and impoverished look.

A smooth, even layer of ink rolled out on the slabs (these are litho stones) ready to be transferred to the block.

Frequent and systematic rolling increases to some extent the fluidity of ink, which is normally in a heavy, static condition in the can or tube. It prints well in the more fluid state, immediately after being thoroughly rolled out, and it is therefore advisable to roll it on to the block as soon as it has been prepared. If ink is rolled too often it is apt to become rather dull and lifeless, and if left on the slab too long it will grow tacky, which is not conducive to good printing quality.

ROLLING UP THE RELIEF SURFACE

The problem of exactly how much ink to put on a block in order to obtain a clear, positive print is soon resolved by a little experience: one ought to be able to learn a great deal about inking and printing generally from the first two or three proofs. Remember to select a suitable roller and to prepare an ink of suitable consistency.

·Before applying roller to block, make sure the surface of the block is perfectly dry and clean: use a small stiff brush to remove any chips of wood remaining in the lines or cavities.

It may be necessary to find some way of preventing the block from moving during the rolling-up, for instance by fixing a strip of wood to the bench-top against which the block can be wedged. If a press with a locking device is available, use this instead, even

Applying an oil-based ink to the block with a plastic roller.

if the block is to be removed afterwards for burnishing. It is often a good idea to take the first trial proofs by hand; burnishing is usually the best way to bring out the particular qualities of a relief surface. A really small block can be more lightly rolled while being held in the hand.

Rolling up a block, like rolling out ink on a slab, requires a light touch with an easy, rhythmic action. Never exert pressure: the weight of the roller itself should be sufficient. An effective method, especially with larger blocks, is to start by rolling from the centre to the corners and outer edges and then, when the block is well covered, to roll up and down the length of the block from end to end with long, level strokes. For the majority of blocks, regardless of their size and condition, frequent and fairly rapid rolling with a thinly coated roller is better than a few slow turns with a thickly coated roller. Some blocks, however, will need considerably more inking than others.

Stopping the roller on the block in the middle of a stroke, or suddenly lifting it up from the surface, particularly if the surface has already been evenly covered, will leave a mark that could well show up on the print.

The stroke of a roller is approximately three times its diameter, so that a 3 in. (75 mm)-diameter roller, for example, will travel just over 9 in. (23 cm) during one complete revolution. If the stroke is continued along the block, substantially less ink is deposited with each successive revolution. This can be more clearly demonstrated by running a fully charged roller firmly across a clean sheet of paper: the reduction in the strength of the ink, in clearly defined stages, will be obvious. Therefore, when inking a large block – two or three times the stroke of the roller – it will be necessary to replenish the roller several times with fresh ink from the slab, re-inking the block repeatedly in every direction over the entire surface. Rather more ink may be required to make the first proof from a new block than for the subsequent proofs. Wipe all the outside edges of the block before printing; a small amount of ink may have accumulated there, and if left can spoil the clean outer edges of the print.

The surface of an adequately rolled-up block, like a layer of ink on the slab, has a consistent sheen with no conspicuous texture or roller marks, which are usually a sign that the ink has been applied too thickly. The proof should be made as soon as possible after the block has been inked, and before the ink becomes tacky. A degree of stickiness, however, helps the paper to adhere to the block; if there is insufficient ink, the paper is liable to shift during printing (especially when burnishing) and ruin the impression.

PROOFING

In printmaking, the term 'proof' usually refers to a printed impression made at a particular stage in the development of the block or plate, hence the common prefix 'state' proof. However, the term may also apply to an impression taken from the finished block; such impressions – normally restricted in number – are generally known as 'artist's proofs'. Printed impressions which have been signed and numbered as part of a limited edition are 'prints'. The methods employed in making a proof are generally the same as those employed in making the final prints of an edition. A proof is of little use unless it is a clear and well defined impression, and in order to make a good proof one must learn how to print well enough to make an edition of virtually identical prints.

There are several rough and ready ways of making quick working proofs, though none gives entirely satisfactory results: for instance, an obvious way is to apply a thick layer of ink to the block, cover it with printing paper, and then run a hard roller over it several times, exerting moderate to heavy pressure. The resultant impression, though unlikely to be very strong, should give a fair idea of the general lines and masses. The more orthodox methods of printing are by hand burnishing or with a press.

The actual printing paper need not be of the same quality as that used for the edition, although it certainly helps if it is similar. Newsprint will suffice for a working proof in monochrome, especially if only a small area of the block is being printed – normal practice when cutting a large, complex block. When proofing from two or more separate blocks for a multi-colour print, it is advisable to use the same type of paper as that used for the edition; areas of printed colour are easily affected by the colour and texture of the printing paper.

BURNISHING A WOODCUT

Perfectly good relief prints can be made without the aid of a printing press, and indeed there can be distinct advantages in doing so. Many printmakers, notably the Japanese, deliberately choose to print by hand, preferring the more sensitive, intimate contact with paper and block; and there is no doubt that hand printing does enable one to bring out the individual qualities of a relief surface far more than does the heavier, more impersonal pressure of a printing press. In any case, not all relief surfaces are

suited to the hard, smooth printing surface of a platen or cylinder press: more often than not, a warped block or the uneven surface of a found object can only be properly printed by hand. The main disadvantage of hand printing is that it is both slow and tiring. Printing a sizeable edition (more than about twenty prints) by hand involves an immense amount of labour, especially if the block is large and contains a high proportion of inked relief surfaces; but even then, if a particular print quality such as a varied tonal range is required, hand printing is still the best method.

By far the most common method of manual printing is by burnishing – rubbing the back of the printing paper which has been placed on the freshly inked relief surface. Since it is seldom possible to obtain a sufficiently good, clear impression by hand pressure alone, a smooth-surfaced rubbing implement, known as a burnisher or baren has to be employed. The Japanese make the finest quality burnishers: although these are supplied by a few dealers in the USA, they do not seem to be available in the UK. Most printmakers improvise from a wide assortment of articles such as spoons (metal or wooden), the bone folders used by bookbinders, modelling tools, old toothbrush handles, steel burnishers as used by etchers, wooden door knobs, smooth round pebbles or even cloth pads – in fact, any smooth, round object easily grasped in the hand. Of these, wooden spoons are probably the most widely used; the best appear to be Japanese rice spoons or hardwood salad spoons. Ordinary metal spoons can be used, but they tend to heat up due to friction.

Rubbing should always be gentle and careful, and direct rubbing should only be attempted if the printing paper is relatively strong. A number of fine papers, when rubbed, tend to peel off in layers, and many papers will need to be protected during the burnishing with a smaller sheet of thin, tough paper or card to prevent them from tearing or chafing when rubbed repeatedly against the hard edges of the relief.

Before attempting any printing, make sure the printing area is tidy and free from wood shavings and sawdust, and prepare the necessary equipment: inking slab, printing ink (usually black for proofing), roller (hard or soft, depending on the block), palette knives, printing paper, burnisher, cleaning rags and solvent. Cut the printing paper to the required size, preferably with a margin of at least 2 in. (50 mm) all round, as well as a few small pieces of paper or card for rubbing on.

To prevent the relief block from moving during printing, secure it temporarily to the bench top, or perhaps to a registration frame. The *ukiyo-e* printers solved this problem by covering their printing bench with a damp cloth which helped to hold the block in place.

Apply ink to the relief surface as described above, using rather stiff ink and a hard roller for a finely cut, detailed block, a softer ink and soft roller on more freely cut surfaces with larger expanses of solid colour needing a richer, heavier deposit of ink. Remember too that new wood absorbs ink more readily than old wood.

The printing paper is picked up by the two diagonally opposite corners and placed smooth side down on to the inked block.

Helen Frankenthaler (b. 1928),
Savage Breeze, 1974. From
eight blocks. $31\frac{1}{2} \times 27$
$(80 \times 68\cdot6)$.

Trevor Allen (b. 1939),
Ice Cream Sunday, 1975.
$22 \times 19\frac{1}{2}$ $(56 \times 49\cdot5)$.

Philip Sutton (b. 1928), *The Girl from the Folies-Bergère,* 1974. 24 × 22 (61 × 56).

Joan Lock (b. 1922), *Interior with Jug of Lilies,* 1975. 18½ × 13¾ (47 × 35).

Once the paper is down on the block, do not move it even a fraction: it is better to have a good, clear impression slightly 'out of square' than an impression smudged by readjusting it on the block. Registration marks are not essential for one-colour prints, although a simple wooden frame fixed to the bench, or even a line drawn round the block enclosing an area the size of the printing paper, may help to ensure reasonably accurate placing.

Press the paper very lightly on to the inked relief surface with the palm of the hand, and then smooth it out, starting from the centre of the block and working out towards the corners, taking great care to prevent any ripples that may have formed from becoming creases. This light, evenly distributed pressure should be enough to make the inked relief surface just visible through the thin printing paper. Rubbing an already visible image reduces the chance of accidentally pressing the paper down into the negative or white areas. The coating of more or less sticky ink on the block should be enough to hold the paper in place, though it can also be held down with the non-rubbing hand.

Some printmakers reverse this initial part of the process and lay the inked block face down on to the paper; the block, with the paper adhering to it, is then turned over and the impression made in the normal way. Stamping an impression directly with a small block is, in a sense, an alternative to burnishing. Putting paper to block is, for most relief surfaces and especially the larger blocks, the more practical method.

When printing from the surface of a found object, particularly one with an awkward shape or an irregular surface, or from a group of smaller objects distributed over a relatively large area, the paper can be held down at two or three strategic points with weights to prevent it from shifting. If necessary, these weights can be moved around as the burnishing progresses, or when checking to see if the impression is clear enough.

If a spoon is to be used, it is normally held in the right hand – if you are right-handed – with the tips of the fingers pressed into the bowl; the left hand is then free to steady the paper. But if greater pressure is required, the spoon can be held in both hands. Grip the handle in the right hand and place the fingers of the left hand in the hollow bowl so that the smooth, round back of the spoon can be moved to and fro over the block with maximum pressure and control. The particular hold adopted also depends on such factors as the character of the relief surface, the quality of the paper and the size and shape of the burnishing tool employed.

Burnishing should be carried out in a fairly methodical manner. Press the spoon down on to the block with moderate pressure and work it back and forth over the paper with short overlapping strokes – long strokes are harder to control. The most frequently recommended method is to start from the centre of the block and gradually work outwards towards the corners. The strokes can run parallel to the edges of the block or diagonally from corner to corner, or they can be made with small circular movements. All the movements, though relatively short, are made with the arm and not just with the hand. The regularity of the strokes will depend to some extent on the nature of the relief surface: it may

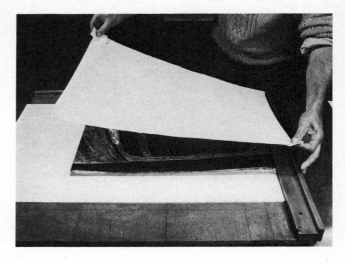

Positioning the printing paper on the inked block, using a register frame to ensure accurate placing. Small tabs help to keep the paper margins clean.

be necessary to change direction, for example, or to emphasize one part or another. Try to complete the burnishing one section at a time, rather than superficially rubbing over the whole block, but overlap the sections to avoid leaving gaps or paler areas between them. The strokes must be smooth and even and the pressure consistent, unless tonal variation is required, in which case the pressure on the spoon is varied accordingly. Another way to obtain a light tone on a specific area is simply to apply less ink to it.

Strokes which are erratic in direction, irregular in length or inconsistent in pressure will produce a patchy, streaky effect on print, especially if the burnisher has a very small contact surface area. This effect is particularly noticeable on large areas of solid black or colour. An area of rich, dense black can only be obtained by careful, firm and persistent rubbing. Rub with special care at the edges of the block; there is less risk of tearing the paper if you rub along rather than across an edge.

If necessary, the bowl of a wooden spoon can easily be refined into a more perfect shape by sandpapering; it can in any case be made more smooth by polishing it with beeswax or furniture polish. A light wooden spoon with a relatively thin bowl is usually more suitable than a heavy thick one, since closer contact with the surface of the relief and the printing paper allows a more sensitive, varied impression to be made. For a particularly delicate area, or if an extremely pale tone is required, rub the paper with the fingertips. With an uneven block or an irregular surface it may be necessary to use the tip of the spoon to press the paper down into a roughly textured area.

Burnishing inevitably produces a slightly embossed impression, but this may be seen as a positive feature of the hand-made print. In most cases, it is possible to tell whether a print has been burnished by the polished outline marks on its reverse side. An impression made with a printing press is usually completely flat.

The quality of the impression can be checked from time to time by lifting a corner of the paper. It should be possible to re-ink the

Burnishing through a small piece of protective rubbing paper with a home-made hardwood burnisher. The free hand steadies the paper.

entire relief surface, in sections, by folding back a corner or even half of the print and applying fresh ink to the exposed relief. The main problem when checking, and especially when re-inking, is to avoid shifting the paper, although at this stage the rest of the print should be stuck to the inked surface. Weights can be used, if necessary, to prevent movement. Even without lifting the paper, though, the quality of the impression should be clearly visible through the thin printing paper.

If lines are seen to have filled up, the block has been over-inked. Wipe all the ink from the relief surface with a rag and the minimum amount of paraffin or white spirit (turpentine substitute takes longer to dry), re-ink and use a clean sheet of paper.

The completely burnished impression should be removed from the block with great care. Hold it by one corner – or, in the case of a large print, by both corners of one edge – and peel it slowly and gently back from the block. Do not lift it straight off with both hands, as this can result in a sudden slip and a smudged image. Nor should it be peeled back from both ends at once, since a print can sometimes stick to the surface of the block and tear, particularly if the block has been heavily inked and considerable printing pressure applied. To protect the print or proof from dirty fingermarks, use small pieces of folded paper (tabs) when lifting it and handling it.

Minor faults in the quality of the print can sometimes be rectified by touching up the impression with a fine brush and the appropriate ink, preferably while the impression is still wet. An obviously spoiled print is seldom, if ever, worth the trouble.

Normally the ink is dry enough in a day or so to make it possible to handle the print without spoiling the impression, but it takes far longer for an oil-based ink to dry completely.

Clean the block carefully after printing with a soft rag and a small amount of white spirit or other solvent. Allow the solvent to soak into the inked relief for a minute or two, then wipe clean.

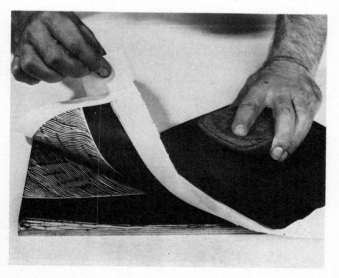

Examining the state of the burnished impression.

A linoleum block mounted on a wooden base is treated just like a woodblock: there are no major differences in methods of applying ink, in the paper used, or in the actual burnishing.

Unmounted lino, however, can also be printed by pressing the paper on to the block with the feet; for larger blocks, this is physically much easier than burnishing by hand. Place the lino cut face up on the floor and cover it with the printing paper. Work over the back of the paper with the ball of the foot, preferably in stockinged or bare feet, if necessary holding the paper in place with one foot and pressing it down with the other. The pressure obtained in this way is obviously far greater than can be achieved by hand, although clearly the method is more suited to rather freely cut, heavily inked surfaces.

As an alternative, lay the printing paper face up on top of several sheets of newspaper stacked neatly on the floor. Press the inked linoleum face down on to the paper, then stand on it and literally stamp on it carefully and methodically with one foot. The relatively soft, pliable linoleum prints surprisingly well when pressed firmly down into an even more pliable layer of newspapers. A rigid woodblock or a block of mounted linoleum usually prints less well by this method, although the latter, because of its softer surface, tends to be more successful.

Such primitive methods are not normally preferred to printing with a press, but presses suitable for exceptionally large lino cuts are not always available, and a large-scale, broadly conceived design or image may not work quite so well when reduced to fit the size of a small relief press.

7 Printing with a press

The main advantage of using a printing press to make relief prints is that it is obviously far easier, in terms of time and physical effort, to produce an edition of more or less identical prints with a press than by hand. This applies especially to colour printing. Press printing should also give a much greater uniformity of impression, and if correctly adjusted and operated a press is actually less wearing on the block than burnishing, which can, in time, cause localized wear. Another advantage – if only for a minority of contemporary relief printmakers – is that the block can be printed simultaneously with type.

There are several different kinds of press suitable for printing reasonably level relief blocks of not more than type height (0·918 in., or 23·3 mm). Most of what are loosely termed relief presses can be separated into two groups, the platen presses and the cylinder presses. Both types are also known in the printing trade as proofing presses, because they are employed for hand-proofing letterpress – although it is unlikely that the older platen presses, such as the Albion or Columbian, will still be used by trade printers. In addition to these orthodox machines, small hand presses, such as the office or screw presses, formerly used for pressing documents, may be useful for printing small blocks.

The majority of full-time art students should have no difficulty in gaining access to a good relief press, whether a platen press in the printmaking department or a cylinder press in the typographic printing department. Many printmaking departments will also have newer etching presses or 'combination' presses which can be adjusted to print a type-high woodblock. Independent printmakers may not find it so easy, unless they are lucky enough to come across an old inexpensive platen or cylinder press or rich enough to buy a modern etching press, and many will probably have to rely on burnishing and print smaller editions.

PLATEN PRESSES

The most familiar of all the platen presses used by relief printmakers are the Columbian and the Albion, heavy cast-iron machines manufactured throughout the nineteenth century. They were developed from the eighteenth-century wooden presses, which were basically the same as those used by the early printers; the Columbian was the American version, the Albion its less ornate British equivalent. The manufacture of both types of press ceased years ago, though not, perhaps, as long ago as one might think, judging by the cast-iron structure and ornate Victorian appearance.

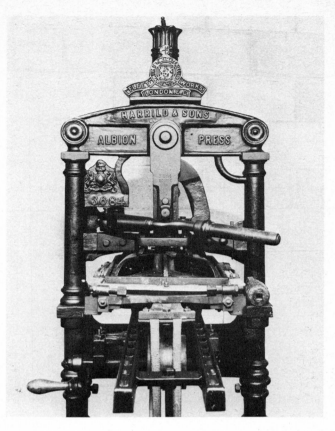

Overall view of the Albion press.

More Albions were made, and consequently more seem to have survived, than Columbians.

Both presses work on a system closely derived from the old lever and fulcrum principle, though they differ slightly in their mechanical detail. In both cases the platen – a heavy iron plate with a flat printing surface, suspended in an iron frame or staple – is lowered on to the relief block by means of a lever; if correctly adjusted it makes contact with the entire surface of the block simultaneously, distributing the pressure evenly and uniformly.

On a Columbian press, the platen is situated at the base of a column which is attached to the centre of a massive crossbeam. This crossbeam, which is actually an enormous lever bolted at one end to the side of the frame or staple, is lowered on to the block and raised again by a system of multiple levers operated by pulling an impression lever sideways across the press. Immense pressure can therefore be exerted on the platen and, consequently, the relief surface with comparatively little effort. A heavy counterweight – often in the shape of an eagle, virtually the trademark of the Columbian – is strategically placed at the far end of the crossbeam to make the lifting easier. Sizes (bed and platen) range from about 21 in. × 16 in. (53 cm × 41 cm) to a maximum of 41 in. × 27 in. (104·1 cm × 68·6 cm) (extra size Double Royal), the latter version weighing over half a ton. Platen presses similar to the Columbian

include the Britannia, the Imperial and the American Washington – or, as the later improved version became known, the Washington Hoe.

Bed and platen sizes of Albion presses are similar to those of the Columbian, the largest – Double Royal – being 40 in. × 23 in. (101·6 cm × 58·4 cm). Smaller 'bench' models were also manufactured. As with the Columbian, the platen is placed under the head of the main frame or staple but, except on a few untypical models, no crossbeam and counterweights are used. Instead, the mechanism consists of a compact internal lever system. The impression lever (also pulled across the press) moves a toggle which forces an inclined wedge or 'chill' into a vertical position, causing it to press down on the platen with considerable power. The platen is raised again by means of a strong coil spring. When operating the larger presses, it is necessary to pull the impression handle with both hands, although in theory the larger the press, the more powerful its mechanism, and therefore the less effort required. The lateral movement of the impression handle is greater than the downward movement of the platen: this is a form of built-in control to prevent accidental damage to type, smaller blocks or delicately engraved surfaces through excessive pressure. To regulate the amount of travel of the lever, and consequently the pressure on the platen and on the block, adjust the stop screw fitted to the staple, starting with too little pressure and gradually increasing. A large block containing a high proportion of solid black surface, however, will need the absolute maximum of leverage and pressure. Not even the largest press will print with complete uniformity a block with a printing surface of the same size as the platen, particularly if the block contains large areas of black. The printing surface should be 1–2 in. (25–50 mm) short of the outside edge of the platen.

The Albion press: operating the impression lever.

On Columbian, Albion and similar machines the flat bed of the press slides under the platen on runners; only when it is withdrawn and fully extended can the block be positioned on it. The bed is moved backwards and forwards by turning a winding handle attached to a roller placed immediately beneath the bed. Leather straps connect the roller to the end of the bed and function in the same way as a windlass.

Platen presses are normally adjusted to allow enough room between raised platen and bed for a type-high woodblock plus packing and 'overlays' – card or paper placed on top of the printing paper to increase or vary the pressure on the inked surfaces of the block. In order to regulate the amount of packing and prevent it from moving during the actual printing, a tympan is fitted to the end of the bed. This is a rectangular metal frame, covered with a tightly stretched material such as parchment, vellum, canvas or linen, and hinged at one end to the bed so that it can be lowered on to the block before printing. Some presses are fitted with a double tympan – two connecting frames which fold together to enclose the packing. The second frame (the one not connected to the body of the press) contains the frisket – a sheet of paper stretched over the frame so that a shape can be cut out to correspond exactly to the shape of the block. The printing paper is held

A double tympan and frisket.

The Albion press: placing
woodblock and paper on the
extended bed.

in place between frisket and tympan; the margins of the paper are
thus protected, and accurate registration is ensured, which is
essential when colour printing from two or more blocks. For
exceptionally large blocks which take up the maximum possible
space under the platen, removing the tympan altogether may
provide a small amount of extra space.

Blocks that are substantially less than type-high can be built up
to the standard height with sheets of card or even wood; more
sensitive adjustments are made on top of the block with overlays.

Printing with a platen press

Having prepared the printing paper, ink and equipment, apply ink
to the surface of the block with the appropriate roller. In general,
less ink is needed when printing with a press than when burnishing,
since the ink does not have to act as an adhesive. Ensure that the
underside of the block and the bed of the press are clean and free
from splinters of wood or lumps of hard ink, then position the
block face up on the fully extended bed at a point corresponding
with the centre of the platen. Cover the surface of the block with
the printing paper, smooth side down. Place a few sheets of paper
(e.g. newsprint) on the back of the printing paper, or enclose it
within a double tympan. Carefully lower the tympan on to the
block, and then wind the bed slowly under the press until the
block is positioned exactly beneath the centre of the platen. Try
not to stop the bed too abruptly or jolt it as it reaches the end of
its run, as this can jog the block and cause the printing paper to
shift on the inked surface. Any movement of the paper at this
stage will almost inevitably result in a blurred impression.

It is always difficult at first to estimate the exact amount of
pressure required to print the block. Applying excessive or sudden
pressure can damage the relief surface. Increase the printing pres-

sure gradually, not by pulling harder on the impression handle but by adding to the packing under the block and inserting a few extra sheets of paper packing into the tympan. Exactly how much packing will be needed can only be determined by trial and error. As a rule, woodblocks with a smooth, even surface containing fine lines and precise detail need less packing than more uneven surfaces or blocks made up of coarse lines, ragged edges and rough textures. A fairly hard, thin packing is better for fine work and a softer, more pliable packing for rougher or slightly warped blocks with a greater variety of relief surfaces. Soft packing allows the printing paper to be pushed farther into the recessed surface; this produces a slightly embossed effect more characteristic of a burnished print. This effect can, of course, be exploited. Certain papers, especially if printed when damp, will retain every detail of the emboss, rather like a paper cast. Apart from sheets of paper, a smooth manila card may be useful for placing over the block, but thick, hard, patterned or rough-textured cards are to be avoided, for obvious reasons. The use of special overlays designed to vary the printing pressure on the surface of the block is discussed on p. 152. A slightly warped or uneven block can also be partially built up with localized packing underneath; blocks with a very slight warp tend to flatten out after a few printings.

After applying the pressure, remove the packing and then the print itself. Examine the print to see if more pressure is needed for subsequent printing, and adjust the packing accordingly.

ETCHING PRESSES

For many students, an etching press may be the only form of press available for printing sizeable relief blocks. Although etching presses are designed specifically for impressing a sheet of damp, soft printing paper into the inked recesses of a thin metal plate – the opposite of relief or surface printing – most can be adjusted to print from the surface only. It is therefore useful to know how to adjust and operate the etching press.

On a conventional model, a rectangular steel bed or 'plank' about 1 in. (25 mm) thick is driven – usually by hand, sometimes by motor – between two heavy rollers supported at either end by an upright iron or steel frame. On many older presses the lower roller, on which the bed rests, is actually a hollow cylinder; the upper roller tends to be more solid and provides the weight and the adjustable pressure on the printing surface. On more recent presses the rollers are usually smaller in diameter and more equal in size. Pressure on the roller can be increased or decreased by regulating two screws placed on top of the press, one at each end of the roller. The press is operated by turning a handle – either a star-shaped wheel, on the older models, for direct drive, or a flywheel for single- or double-geared drive – which may be fixed to either roller. The bed is forced between the rollers until fully extended, being arrested at the end of its run by small metal stops, usually fitted to the underside of the bed. At each end of the main frame are two small rollers, one at each corner, which help to

The etching press: close-up of the adjustment screws.

Checking the impression after printing a plywood block on the etching press. Note the felt blanket used as packing.

support the weight of the bed when extended and to facilitate its movement. These small rollers are usually flanged to prevent any lateral movement of the bed.

The downward pressure obtainable from an etching press is even greater than that obtainable from a platen press of similar size. The platen, powerful though it is, distributes the pressure over the entire relief surface simultaneously, whereas the cylinder as it travels over the block is in contact with only a narrow strip at a time, exerting a heavier pressure progressively over the whole surface. Because of this progressive, rather than immediate and overall contact, woodblocks printed on an etching press do not have to be absolutely flat; a very slight warp does not necessarily affect the print.

When the press is adjusted for intaglio printing, the gap between upper roller and bed – containing the metal plate and the printing paper covered with a layer of four felt blankets – is seldom more than about $\frac{1}{2}$ in. (13 mm), and usually less. This tight squeeze is necessary in order to provide enough downward pressure to impress the damp printing paper into the ink-filled intaglio lines. Such concentrated pressure is not necessary when printing from relief surfaces; the weight of the roller alone may be adequate for some blocks. To utilize the weight of the roller without any extra pressure, simply release the two screws. When printing a small woodblock on a large etching press, even the roller itself may be too heavy; in that case, place the block among supporting blocks of equal height which will act as bearers.

On some of the older etching presses, the upper roller cannot be raised high enough to print a woodblock of type height, but they should all be capable of printing unmounted linoleum. If possible, place strips of uncut linoleum on either side of the lino cut, parallel with the bed of the press, to help prevent the printing area from stretching or becoming distorted under heavy roller pressure.

When printing in colour from two or more blocks, provide some means of maintaining accurate registration, for instance by marking out the bed of the press with masking tape – one area for

the block and a larger area for the paper – or by taping a sheet of non-printing paper to the bed and drawing guidelines on it. Alternatively, small pieces of cardboard, approximately half the thickness of the block, can be taped to the bed to act as 'stops' for each of the blocks – provided all the blocks are exactly the same size.

Even when printing an edition in black and white from a single block, each successive sheet needs to be placed in more or less the same position on the block to ensure that the printed area is central or square on the paper; registration marks are therefore just as necessary.

A single felt blanket can be used as packing, plus a few sheets of thin paper such as newsprint, depending on the particular relief surface. It may be advisable to experiment with various thicknesses of packing and with adjusting the screws to obtain the best results. Before attempting to use an etching press in a printmaking department, always ask for technical advice from an instructor.

Kimber's proofing press

Some years ago, Kimber of London made a number of small presses designed for printing type-high wood and lino blocks. These presses were modelled closely on existing etching presses and work on more or less the same principle, the main difference being that along each side of the bed is a metal bar or bearer about $\frac{3}{8}$ in. (10 mm) wide by 1 in. (25 mm) high. It is on these two bearers that the upper roller rests, leaving sufficient clearance between roller and bed to take a type-high woodblock plus a little packing. Another difference is the addition of a tympan, a useful device on platen presses but totally inappropriate on an etching press.

It should not be too difficult to convert an old, conventional etching press into this kind of relief press simply by fitting metal bearers to the sides of the bed or plank – a tympan is not essential.

To print a relief block on a Kimber's press, ink up in the normal manner, place a sheet of printing paper on the woodblock and cover it with a few sheets of packing paper. If a double tympan is fitted – an uncommon extra – insert the packing as if using a platen press. To begin with use only a little packing, increasing the amount in stages until the correct thickness is obtained. Always make sure there are no folds in the packing, as these can adversely affect the quality of the impression. The roller is then turned slowly over the relief surface. It should pass over the surface of the block fairly easily, with only a slight resistance; if excessive effort is required, stop the roller, turn it back clear of the block and remove some of the packing. Never force the roller over the block: this can damage the relief surface and, more importantly, the press. The tympan is then lifted and the print carefully removed. Examine the quality of the inked impression, and if necessary adjust the packing accordingly. A very slight impression mark may be visible around the edge of the printed area, but it should not be plainly visible on the back of the print, unless a positive embossed effect is deliberately sought.

Printing a type-high woodblock with a Vandercook press. The block is locked into the chase with a single locking bar, and the paper secured to the roller by grippers.

CYLINDER PRESSES (LETTERPRESS PROOFING PRESSES)

The larger, flat-bed cylinder presses designed for proofing letter-press are now widely used for printing relief blocks. Many print-making departments keep one of the older models solely for this purpose. It may also be possible to use one, under supervision, in the typographic printing section of a design department.

A typical flat-bed proofing press is the Vandercook. This is a single-roller cylinder press: whereas on the conventional etching press the bed or plank is driven between two heavy rollers, on the Vandercook a single cylinder passes over the relief surface of the block which is locked into the stationary bed. Tympans are not fitted to these presses.

Flat-bed presses vary somewhat according to the age and complexity of the model. Most of the newer models are fitted with inking rollers, many of which are power-driven, and these, when supplied with ink, deposit a fine, even layer on to the relief surface each time the press is operated. When using an older press which is not fitted with inking rollers, ink must be applied to the relief surface with a hand roller or brayer.

Normally, the printing paper is not placed directly on to the inked relief, but is placed over or around the main cylinder where it is trapped along one edge by clips or grippers fitted to the press. Some of the older presses, however, may not have these grippers, in which case the paper has to be placed directly on to the inked block on the bed of the press. This creates a number of problems, for example preventing the paper from shifting as the cylinder passes over it. (When a relief block is printed on an etching press the paper is held in place by a single felt blanket; on a platen press, the pressure is applied vertically down on to the paper, so that in both these cases the problem should not arise.) This difficulty is unlikely to occur when printing with a thin, soft paper, which can easily be made to adhere to the surface of an adequately inked

block, especially when an oil-based ink is used; but thicker, harder papers are less inclined to stick to the surface.

The paper should not move if the correct amount of packing is used. Packing is usually inserted into a slightly recessed area on the surface of the cylinder. Clearance between the printing cylinder and a type-high relief surface is extremely finely adjusted: excessive packing – even by a thousandth of an inch – can cause the paper to move slightly, but too little packing will invariably produce a weak impression. The best way to check the packing before printing is to place a steel straight-edge across the packing between the cylinder bearers (the metal outer edges of the printing cylinder, which rest on the two raised edges on the flat bed, known as the travelling bed cylinder bearers): the packing must be in line with the cylinder bearers.

As a general rule, when printing from a finely cut relief block with a hard paper, use a fairly hard packing: a roughly cut or coarse-textured surface may require a soft paper and therefore a correspondingly soft packing.

Printing a large edition of prints in colour from two or more blocks with a press not fitted with grippers can be more difficult. One useful way to obtain reasonably accurate registration is to secure the printing paper around the cylinder with masking tape – on dry paper only – or with rubber bands fastened together with small wire paper clips or string.

A more practical and no less reliable method is to first lock the relief block into the bed of the press so that each sheet of printing paper can be placed directly on it in exactly the same position throughout. Securing the block into the bed of the press in order to prevent movement during printing and to ensure accurate registration is known as 'locking up' – normal practice in the printing trade.

Most flat-bed presses are now fitted with an adjustable locking bar, a useful device which simplifies the job of securing the block. Blocks can also be wedged into position with square-cut pieces of wood; those immediately surrounding the block are generally of type height, the same as the relief block, and act as bearers for the cylinder, thus helping to reduce wear and tear on the printing surface, especially on the outer edges of the block. Printers refer to the strips of hardwood they use for a similar purpose as 'furniture'; this is of less than type height. Metal, plastic and even magnetic furniture is also used, as well as various devices such as 'quoins' and 'keys' which tighten, lock into place and then, after printing, release both furniture and block: but these are less easily obtained and in most art colleges are likely to be available only in printing departments.

In normal letterpress printing the composed page of type and illustration blocks, known as the 'forme', is locked into a 'chase' – a metal tray which fits into the bed of the press.

Using bearers, furniture, and locking bar or chase should help to solve the problems of maintaining accurate registration. The use of bearers and furniture alone provides the opportunity to employ a simple but practical registration method: insert a few pieces of stiff cardboard or hardboard vertically between the wooden furniture

and the bearers, perhaps one at the top and two at an adjacent side of the block. Position these stops a few inches away from the edges of the block in order to allow for a reasonable margin between the edge of the paper and the edge of the image. Each sheet of paper can then be lined up against the card stops, which project slightly above the furniture. They should be no higher than the printing surface, of course, or they will be crushed during the first printing.

Relief blocks which are less than type-high can easily be built up with sheets of card: these should be cut a fraction smaller than the block to allow the furniture to fit tightly against the edges of the block.

Do not attempt to print from blocks which have an uneven surface or are noticeably warped or more than type-high on a flat-bed proofing press; these machines are designed to print from an absolutely flat, type-high relief surface. Slightly uneven blocks may be printed on etching presses, and to some extent on platen presses, but not on flat-bed presses. Very slight variations in the relief surface resulting in an uneven impression can usually be evened out by carefully built up overlays placed among the packing sheets around the cylinder. Fine adjustments in the packing can make a considerable difference to the quality of the impression.

The simplest and most inexpensive cylinder or flat-bed press is the small galley-proof press, which consists of a flat bed and single cylinder, seldom more than a few inches in diameter, operated by hand. These small presses are of limited use to the relief print-maker, but they are perfectly adequate for proofing small type-high wood or lino blocks and can be extremely useful when making large editions of prints that do not require elaborate inking, overprinting, complex registration or finely adjusted overlays.

SCREW PRESSES

Probably the simplest and cheapest of all presses suitable for relief printing are the various screw presses; these are known also as 'nipping', 'pinching' or 'office' presses, since they were employed primarily for pressing documents. A useful, though obviously limited piece of equipment, the screw press is normally too small to print anything wider than about 10–12 in. (25–30 cm); there is no restriction on the length of a print, though, providing it is made in stages. Pressure is applied directly to the relief surface by turning the central screw, which lowers a heavy iron platen on to a flat bed. Apart from the small size of the press, its main dis-advantage is the considerable physical effort required to print a full-size wood or linoleum block. It is obviously easier to apply pressure if the press has been securely fixed to a solid table-top or workbench. Some printmakers advise lengthening the press handle in order to obtain greater leverage.

A brief but informative description of printing linoleum cuts with a screw press is contained in John Newick's book *Making Colour Prints*.

Regulating the pressure is something of a problem with this kind of direct press, and the correct use of packing – underlay and

overlay – is crucial. Blocks that are very much smaller than the platen should be protected from the heavy, downward pressure by the use of bearers; such blocks must always be placed under the very centre of the platen.

Moving the block in and out of the press is made easier by placing the inked block (face up) and the printing paper on a piece of flat board cut to about the same size as the platen. On top of the printing paper place an overlay consisting of a few sheets of paper and a sheet of smooth manila board or thin zinc. Insert the board holding block, printing paper and overlay between bed and platen, then turn the screw down tightly. Alternatively, when printing with more than one colour from separate blocks, especially with linoleum, lay the printing paper down first on the board – which has been covered with a few sheets of packing – and then place the inked block face down on the paper. This method makes the accurate registration of all subsequent blocks easier. A rubber pad, not too thick or soft, cut to the same size as the bed and inserted between the board and the printing paper, helps to reduce the physical effort involved in printing; it should also help to improve the quality of the print.

OTHER PRESSES SUITABLE FOR RELIEF PRINTING

Other presses that can be used to print relief blocks include various 'jobbing platens' such as the Adana. This is a small, self-inking proofing press, operated by hand, treadle or power, and suitable for printing small type-high wood or linoleum blocks.

A number of firms now manufacture small relief presses for printmakers; these are advertised sometimes in the art magazines.

Some printmakers have built their own presses. Manley Banister, in his book *Prints from Linoblocks and Woodcuts*, gives a detailed account, complete with diagrams, of building a home-made block-printing press based on the conventional screw press.

Domestic mangles, especially the older, larger models with wooden rollers and gears, have quite often been successfully converted into useful printing presses, and can be employed with or without an improvised flat bed. Unfortunately, this kind of mangle is no longer easy to find.

One obvious, though not very common, type of press that does not seem to have been employed much by printmakers is the wood veneer press. This is normally a large, heavy but simple piece of equipment, designed for pressing glued veneers on to boards and holding them in place until dry and flat. Apart from their use in the trade, such presses are occasionally found in the woodwork or three-dimensional design departments of art and technical colleges. The main and perhaps the sole advantage of the veneer press is its sheer size; it will normally print a block far larger than any conventional printing press could hold. Considerable experimentation with the application of pressure and the amount and kind of packing used is clearly needed.

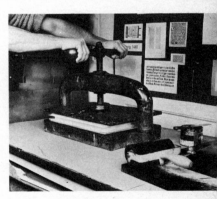

Printing with a simple screw press: *top*, the block in position; *centre*, the block covered with the printing paper and an overlay; *bottom*, pressure being applied.

A far wider-range of papers can be used for press printing than for hand printing. Extremes such as hard, coarse-textured papers or soft, fluffy papers should be avoided. Thin Japanese and India papers may be too fragile for press printing, especially on the heavier models such as etching presses: under heavy pressure the ink can be forced through the delicate paper. The best papers to choose are the smoother soft-sized kinds, preferably reasonably thick and strong.

It will soon become apparent that for certain blocks, especially those containing a wider range of linear or textured effects, a consistent layer of packing does not necessarily produce the best results. Some areas of the surface may well need more pressure than others: for instance, a solid black or generally dark area will need a heavier printing pressure than the finely cut or light passages. The finer, lighter areas, especially fine black lines close to the edge of the block, require a less emphatic pressure anyway if they are not to wear out prematurely or break down during the printing of an edition. Therefore, in order to bring more pressure to bear on specific areas of the block and consequently less on other parts, additional and localized packing must be used.

Special overlays, though used chiefly in printing wood engravings, may be equally useful for woodcut. An overlay is prepared – the correct term for this is a 'make ready' – by taking a proof and gluing pieces of thin but strong paper on to those areas of the impression that correspond exactly to the dark areas on the block. The actual thickness of the layers at any one point obviously depends on the degree of pressure required: the thicker the overlay, the heavier the pressure. Three or four different thicknesses should be adequate for the most complex block. It may be necessary to make two or three printings, each followed by further work on building up the overlay, before the various thicknesses are effective. Carefully tear the shapes out, rather than cutting them: hard, clean-cut edges can be disturbing on the print, whereas torn, frayed edges are less obtrusive. Shapes can, of course, be cut for the sake of accuracy and the edges subsequently tapered with a razor blade or even fine sandpaper. Several layers of thin paper, neatly applied, are better than one or two pieces of thick paper. When building up a fairly substantial thickness, make each piece of paper progressively smaller: abrupt edges are to be avoided, and at no point should the maximum contrast in levels be too great. Any distinct edges on the overlay can be softened, to a certain extent, by inserting the overlay into the packing under two or three sheets of paper.

Placing the overlay in exactly the right position on the block can be a problem. One obvious way is to cut all the packing sheets to the same size as the overlay, fix them and the overlay together with adhesive tape, and place this package on the block.

Blocks which are intended to print from lowered areas should not require such elaborate overlays. Fairly soft packing is normally quite adequate. A hard packing will prevent the printing paper from entering even the shallowest of the lowered areas.

RECTIFYING FAULTS IN THE PRINTING

Most faults that occur on relief prints made with a press should be easy enough to trace and rectify. For instance, if the print is too pale, the problem is usually solved either by further adjustments on the press or by an increase in one or both layers of packing. If necessary, use localized packing on the overlay. If the fault remains when the press seems to have been correctly adjusted, it may be the result of inadequate inking or of printing paper that is too dry, greasy, or too damp. Very slight dampening can sometimes make an over-dry paper print perfectly well, but excessively damp paper will tend to reject the ink, particularly oil-based ink. Paper which is too hard, thick or roughly textured can make even the heaviest printed impression look thin.

Prints which are too dark, sticky or lacking in definition have probably been over-inked. Remove at least half of the ink rolled out on the slab with a palette knife, and roll out a much thinner layer with what remains. (Do not scrape ink off the roller with a palette knife.) Clean excessive ink from the block by running it through the press two or three times, printing on to a soft, absorbent paper such as blotting paper, then re-ink the block less generously and resume normal printing. Make sure the surface of the block is completely free of any grease or solvent before being inked with the roller.

It is not uncommon for relief printmakers to print a block with a press, then remove the block with its printing paper still attached and improve or enrich the impression by burnishing certain areas or even the entire surface. To some extent this method can be employed on specific areas which, for one reason or another, have failed to print well; at any rate, it is worth trying.

Printing faults are less likely to be due to the consistency of the ink itself; the ready-made block-printing inks in tins or tubes are much easier to use than, for example, intaglio inks, which often have to be mixed from pigments and oils to suit the character of the particular plate. If, however, the ink does seem to be the cause of poor printing, the chances are that it is either too dry or too stiff, in which case add a little oil or varnish and mix very thoroughly.

There is always a possibility that the fault lies with the press, especially an old platen press: for instance, the platen may be out of alignment (check first that the block was correctly placed under the centre of the platen), or the tympan may be loose or in need of a new, tighter covering. Such defects are usually obvious and should not be too difficult to repair. The alignment of a platen, i.e. whether or not it fits absolutely flat on the bed, is easily tested by measuring the gap between the raised or partly raised platen and the bed at each of the four corners with a block of wood. Most platens have four adjusting screws, usually set close to the central column. If the defect is more structural or mechanical, it is advisable to have the press examined and, if necessary, repaired by a skilled printer's engineer. Presses should, of course, be kept clean, and all working parts well oiled at regular intervals.

8 Colour printing

For many artists, especially those concerned chiefly with wood or lino cuts, colour printing is the most fascinating and rewarding part of the whole creative process of making prints. To the creative printmaker, of course, colour printing is not simply a means of tinting or enlivening black outline drawings to achieve a more decorative effect, but rather a way of using colours for their own sake as an integral part of the design.

The methods described in this section are, with a few exceptions, the most commonly used by contemporary printmakers, but almost all have been in use since at least the eighteenth century, and some since the early sixteenth century. Very few entirely new ways of making colour prints from relief surfaces have been developed since the *ukiyo-e* period, although modern materials – inks, plastics and acrylics, and rollers – have undoubtedly opened up new possibilities. The various approaches to colour printing have here been separated for the sake of simplicity into a number of distinct methods, although to a large extent this is an artificial classification. Few experienced relief printmakers confine themselves.to any single, orthodox method: the majority probably use a combination of several, while others may adopt a highly personal approach which, though based on an orthodox method, is too idiosyncratic to be conveniently labelled. The following methods should therefore be thought of as starting points for experimentation, although a practical, well tried method should not be ignored just because it is orthodox. The chief problems common to all these methods are those connected with overprinting and ensuring accurate registration. These aspects will therefore be discussed in separate sections.

MULTI-BLOCK PRINTING

The traditional method developed and perfected – though not invented – by the colour printers of the *ukiyo-e* school is still one of the most widely practised, though usually in a much cruder, simplified form. Briefly, Japanese colour prints were made by overprinting several woodblocks, all cut to the same size, each containing part or parts of a composite design and each inked in a different colour, on a print made from a master or key block, usually in a black or dark outline. In other words, there was one block for the drawing and a separate block for each colour. Although this method has persisted until the present day, it has seldom, if ever, produced anything to compare with the colour prints of the *ukiyo-e* masters, where the lines of the key block

Jonathan Kaufman (b. 1940),
2nd Avenue, Midtown, 1974.
20 × 11¼ (50.8 × 28.6).
Woodcut in black, from a soft-
wood block, with three colours
applied from a separate lino block
printed first.

rarely dominate the colours and patterns which are equally
important in the overall design.

A more modern version is to print from several blocks, each
inked in a different colour, but leaving out the key block which
can so easily dominate the composition: even this approach was
by no means uncommon in *ukiyo-e* prints. With this method, the
use of colour – particularly in overprinting – becomes a main
theme. One can still retain the use of a key or master block con-
taining the most important elements of the composition in a
particular colour, but using shapes rather than lines or contours for
the initial printing. The individual woodblocks are not likely to
be of much use by themselves; only when printed together in the
correct sequence do they make any sense in terms of composition
or colour relationships.

Proofs made from the master block – whether it contains lines or shapes – are useful for drawing on in order to work out the next stage.

One obvious drawback to this multi-block approach, especially when using large blocks, is the sheer quantity of wood needed to complete each print. The usual way to get round this is to print the additional colours from cheaper, thinner plywoods or even linoleum rather than thick and expensive plankwood. In some cases, however, two or even more colours can be printed simultaneously from the same block. If the relief areas are fairly well separated, it may be possible to apply different coloured inks to them with small rollers. If the areas are closer together, apply the colours with paint brushes. Avoid making too many textured brushmarks, and keep strictly to the relief area as defined with knife and gouge, otherwise the print, however interesting the effect, becomes a monoprint.

The main problem with multi-block printing, apart from registration, is overprinting; this should perhaps be regarded less as a technical problem than as a creative process. Successful overprinting is, in any case, something that can only be achieved by trial and error. There are a few useful generalizations to be made regarding the use of coloured inks (see pp. 165–7), but first-hand experience is far more valuable.

The composition of a multi-block colour print can be based on an existing drawing or painting, but unless this was made to be translated into the medium of woodcut a second, adapted drawing may be necessary. Ideally, the latter should be made in a medium capable of being applied in transparent washes, such as watercolour paint or inks, so that the overprinting possibilities can be more easily worked out. It must be emphasized that the purpose of the second drawing – which may, in fact, be simply a diagram – is to organize the distribution of the shapes and colours and possibly the order of printing. Tracings may also be required to maintain accurate registration. This approach may seem too methodical, even clinical, for some printmakers; but a clear 'working drawing' is the best way to avoid confusion, unnecessary expense and time-consuming mistakes.

An alternative and rather more spontaneous method is to work directly on to the woodblock with poster paint or gouache. Make a careful tracing of the completed drawing and put it on one side. Then cut round those shapes that are to be printed in the dominant colour: this first block then becomes, in effect, the master colour block. In the process, of course, the drawing on the first block is destroyed; all subsequent blocks have to be drawn and cut from the tracing.

It is not necessary to make multi-colour prints from blocks which are equal in size or even rectangular or straight-edged: small, irregular shaped blocks can be overprinted on to an impression made from a large block, whatever its shape. Alternatively, they can be printed directly on to a sheet of paper and – if the paper is large enough – placed apart from each other to form the composition, rather than confined to a single overprinted unit or image.

THE JIGSAW METHOD

The obvious alternative to multi-block colour printing is to use one block only. There are several ways of doing this: one is to cut the block into a number of smaller shapes, ink each in a different colour, reassemble them into a complete unit and print them together on to the paper. This is commonly referred to as the jigsaw method, because of the way the shapes interlock; it was used extensively by Edvard Munch. Woodblocks can be cut into quite elaborate shapes with a fretsaw or bandsaw, but in most woodcut prints the shapes tend to be fairly simple, the cuts being made along a clearly defined boundary, for example between earth and sky or between a figure and the background, as in several of Munch's prints. Before attempting to saw the block, clamp it firmly down to the workbench. Sawn blocks do not always fit tightly together again; there are usually gaps, visible on the print as white lines, or rough, splintered edges to contend with. Wherever possible, these should be considered as part of the design and deliberately exploited as one of the positive features of the print. However, if the white line is too incongruous or disturbing, one way to hide it is to print over it with a further block carrying another colour – not necessarily a full-size block.

THE REDUCTION METHOD

The other recognized method is to cut into a single block in several stages, printing each stage in a different colour and gradually reducing the relief surface of the block until it is almost totally removed. This 'reduction' or 'elimination' method is used most

Jonathan Kaufman, *Approaching Train, Kansas,* 1976.
$8\frac{1}{2} \times 13$ (21.6 \times 33).
Woodcut in three colours made by the reduction technique.

frequently with linoleum; Picasso produced numerous multi-colour lino cuts which are outstanding examples of the method.

The most straightforward approach is to make a preliminary drawing in several colours which can be clearly separated in terms of shapes or areas. Print the block – either as a complete, intact surface, or with a minimum of cuts – in the first colour. Take enough prints at this initial stage to make up the entire edition – say twenty to thirty, plus a few extra in case of errors in printing. Once the surface has been cut into for the next colour, the original area obviously cannot be reprinted, so study the drawing carefully before cutting away more of the surface, remembering to leave enough for the other colours and to allow for overprinting. Ink the block with the second colour and print this on to the first impression. Repeat the process until all the colours have been printed. The last colour will probably be printed from only a fraction of the original surface area. Although it is theoretically possible to print a wide range of colours by this method, too many layers of ink can create printing problems. Try to limit the range of overprinted colours to a manageable number – usually four to five is ample – in order to avoid a build-up of thick ink.

It should not be necessary to keep strictly to the drawing, even if this were possible: the somewhat unnatural process of removing parts of a relief surface in progressive stages is difficult enough without the added problem of imitating a drawing made by a completely different process. The drawing should serve as a guide only.

STENCILS

Stencils provide a quick and simple means of applying additional colours to the relief surface, whether for a single-block or a multi-block print. A stencil is a sheet of thin but tough paper or plastic out of which shapes are cut – preferably with a sharp knife held in the vertical position – so that ink can be applied to specific parts of the surface of the block with a roller or a paint brush. Special stencil paper is available from dealers; thin paper can be strengthened by brushing shellac on both sides. Proofs can also be cut up and employed as stencils, providing the paper is strong enough; otherwise, for registration purposes, trim the stencil paper to the same size as the printing paper. Fairly simple shapes, if they can be integrated with the design, work best from the cutting and rolling point of view; elaborate shapes are inclined to stick to the inked roller and tear.

Granular, mottled and tonal effects, repeatable up to a point, can be obtained by printing through a layer of tissue paper. The tissue is placed between the freshly inked surface of the block and the printing paper and then printed with a press. Depending on the thickness of the ink and the amount of pressure applied, a certain proportion of the ink is forced through the fine tissue and on to the printing paper. The process can be repeated, the block being re-inked with a different colour, to create a more richly textured area.

BLENDING COLOURS

Several different colours can be blended together by controlled rolling and applied directly to the relief surface; the effect is then printed with a press in the normal way.

Mix a small selection of different coloured inks, perhaps three or four, and place these in a row, a couple of inches or so apart, at the top of the inking slab. Then, with a palette knife, apply a little of each colour to a large rubber roller (about 12 in. (30 cm) long by 3 in. (75 mm) in diameter), again keeping them apart. Roll these colours out over the rest of the inking slab, moving the roller slightly to the left and then to the right in order to merge the colours. If necessary, recharge the roller with fresh ink from the supplies at the top of the slab. Try not to let the darker or stronger colours obliterate the lighter or weaker colours.

When the inks on the roller have blended smoothly together, roll up the relief surface and print. Blending colours in this way may appear to be an almost fortuitous method, but with a little practice, and provided the effects are not too complex and are confined to specific areas of the relief surface, they can be repeated numerous times before there is any noticeable change. The method can be particularly useful when combined with small or irregular shaped blocks and with stencilling.

Colours can be applied in a similar way to the inking rollers of a Vandercook press; the same merging by overlapping occurs, but with even more dramatic effects and less effort. It is difficult, however, to maintain the effect for very long, so the number of prints is limited. The larger hand rollers are probably easier to manage and control.

REGISTRATION

A multi-colour print which involves printing from several blocks in succession poses a two-part problem of registration: firstly, the position of the colours on each block must be accurately worked out before cutting so that each area of colour appears in exactly the right place on the print, and then the printing paper must be accurately positioned on each block in turn. In some cases a gap of $\frac{1}{16}$ in. (1·5 mm) or even less between one area of solid colour and another, due to a very slight error in registration, can have the most detrimental effect on the composition or colour relationships. If the composition is not so tightly organized, or if most of the colours are meant to overlap one another – some of the colours being achieved by overprinting – a slight error need not be so crucial. But even with comparatively freely cut blocks, if at any stage the print is carelessly placed, or if the blocks themselves are not all exactly the same size or are out of square, the misprint which might otherwise be of no consequence within the design is usually blatantly obvious around the outer edges of the impression. The Japanese solved this problem by pasting proofs taken from the key block, complete with registration marks, on to all subsequent blocks, thus ensuring exact and consistent registration throughout

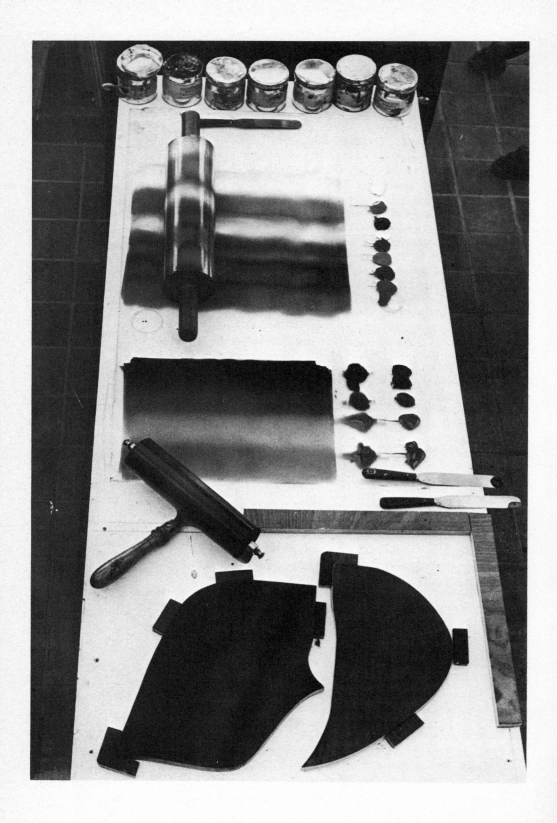

the whole process of cutting and printing. It is possible to achieve this kind of accuracy without adopting the Japanese system, although several of the more practical methods now in use are based upon it.

Registration for cutting

One of the most straightforward ways to register the position of the coloured areas on each block is to make a tracing of the original or master drawing and carefully trace this in reverse on to each block. Use a sheet of tracing paper larger than the blocks, if possible, taping the margins to the back of the block and indicating the edges of the block on the sheet; this is easier than trying to cut the paper to match the shape of the block exactly. Carbon paper can also be used at this stage. The main disadvantage of tracing is that it is laborious and time-consuming, and not necessarily exact.

A quicker and more efficient method is to offset the image from the 'master' block on to all the remaining blocks. All subsequent colour areas can then be related to those cut into the first block. To ensure consistent offsetting, the printing paper and each new block in turn must be held within a rigid frame.

A register frame is simple to make: it consists of a flat, rectangular board, e.g. ¼–½ in. (6–13 mm) plywood, to which are attached two strips of wood, e.g. 2 in. × 1 in. (50 mm × 25 mm) nailed or glued, longer side down, to form a right-angle at the lower left-hand corner of the board. The woodblock is placed on the board and is held firmly against these strips during the printing. A small gap of about 2–3 in. (50–75 mm) is left in the corner so that the printing paper can be lifted or adjusted. The overall size of the frame is determined by the size of the blocks; it should be a minimum of 2 in. (50 mm) larger than the largest woodblock, so that it can easily contain both block and printing paper, leaving a paper margin of at least 2 in. (50 mm). The depth of the two wood strips which form the right-angled corner should be similar to, or slightly less than, the depth of the woodblock, so that they can support the margins of the printing paper. Unmounted linoleum or thin plywoods, therefore, will require only very thin strips, perhaps of hardboard. Type-high woodblocks need a substantially thicker surround; since thin blocks are easily built up, the higher frame is probably more practical for all-round use.

Finally, two additional lengths of thin wood are fixed to the outside edges of the wooden strips, projecting about ¼ in. (6 mm) above them. These serve as paper guides: the paper can then be positioned in exactly the same place on each block.

When the first woodblock has been cut, apply a rather thick layer of black ink and place the block in the frame where it should, if 'square', fit neatly against the two walls. Make the first print by burnishing on tracing paper cut to exactly the same size as the printing paper; fasten the paper to the near edge of the frame with masking tape or drawing pins and leave it in place throughout the whole offsetting process. The tracing paper with its thickly inked impression is then lifted and the first block replaced with the second, uncut block. Lower the inked paper on to the second block

A simple register frame with paper guides.

Opposite: Blending colours on the slab.

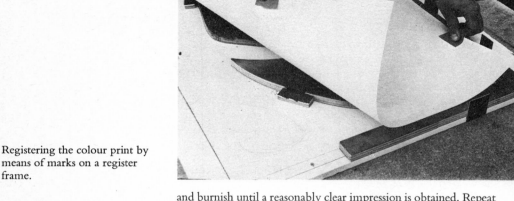

Registering the colour print by means of marks on a register frame.

and burnish until a reasonably clear impression is obtained. Repeat this process with each new block. If sufficient ink is applied to the first block, the tracing paper should retain an adequate amount to offset the image on to three or four surfaces. These identical offset images, placed in exactly the same position on each of the blocks, are then left to dry. A little French chalk or talcum powder can be used to 'fix' the wet image.

The image on the second block is then developed further, if necessary, by referring back to the original drawing. This second block is cut, fairly thickly inked – but in a different colour – and burnished on to a clean sheet of tracing paper. Fasten the tracing paper to the frame and again offset the image on to all the remaining blocks. Repeat the process until all the blocks have been offset, worked upon and cut, using a different colour for each one – though not necessarily the colours to be used in the edition.

There is no point working to a hairbreadth: rather than risk ending up with white lines or gaps between areas of colour because of a minor error in registration, where necessary cut each new image a fraction larger than the actual offset image.

Remember to clean the offset colour off each newly cut block after completing each separate stage in the development of the print.

Registration for printing

An obvious way to print from more than one block – but not one to be particularly recommended for complex registration, or when working with large or irregular shaped blocks – is to lay the first proof face up on a flat bench or table-top and place the second block face down on to the proof. Carefully turn both over – holding the proof firmly in place to prevent it from slipping – and then burnish or print with a press. Repeat the process for each colour.

Blocks can, of course, be printed face down with a printing press, in which case most of the packing will need to be underneath the printing paper and the block.

A far more accurate method is to employ the register frame used in the cutting process. Its main function is the same – to ensure accurate and consistent placing of the print on each block. All the printing paper must, of course, be pre-cut to a uniform size, preferably with two straight edges to fit neatly into the paper guides (hand-made papers with deckled edges will need trimming). Hold the paper in the normal way, by the two diagonally opposite corners, and lower it gently on to the surface of the block, taking great care to keep both straight edges in line with the paper guides. Rub the paper down lightly with the hand until it sticks firmly to the inked surface, then, if necessary, remove both together and print by burnishing or with a press. Repeat the registering process for each colour.

Blocks can also be burnished in the frame, the print remaining hinged to the frame throughout, but this is only practical for printing 'wet on wet' in one printing session. Some printmakers use this method for colour proofing, completing the actual edition by burnishing in stages or with a press.

A solidly built register frame can be kept and re-used for blocks of various sizes, provided they are 'square' and not too large; it can even be adapted to suit an irregular block. Alternatively, an even simpler, temporary frame can be quickly assembled to fit a specific block, and this may be more convenient for a block with an irregular shape. Such a frame might consist of a flat board (large enough, as before, to contain the printing paper) on to which are glued a number of small wooden blocks or supports, some to hold the relief block in place and others for the paper to rest against. The former can be positioned to form the usual right-angle or, with an irregular block, they can be positioned at strategic points on an outline drawn round the block. The paper guides are carefully placed on a line drawn round the edge of the printing paper. For thin relief blocks, these stops need be no thicker than ¼ in. (6 mm), but when printing from type-high wood the margins of the paper should rest on wider supports, contained by small vertical pieces of cardboard glued to the outer edges of the supports.

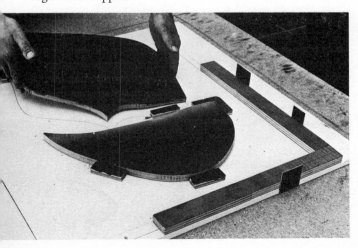

A temporary register frame for irregular-shaped blocks.

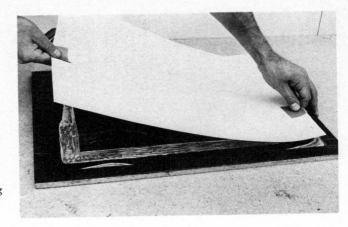

Registering the colour print using *kento* (registration marks cut into the block).

No external frame of any kind is needed for the traditional Japanese method of registration, in which registration marks are actually cut into each block. Since the block therefore has to contain nearly the whole sheet of printing paper, and allowance must be made for the margins, the actual relief area is substantially smaller than the block, which could be a disadvantage when using the more expensive and usually smaller fruitwood blocks. When employing this particular registration method for large-scale prints, use plywood for economy.

An impression from the key block which includes the register marks is transferred to all subsequent blocks, either by pasting proofs or by offsetting. The registration marks are cut into the surface as notches, a straight notch on the longest side and a right-angled notch at the corner. To cut a notch, make a vertical cut about $\frac{1}{16}$ in. (1·5 mm) deep, with a sharp knife, on a line marking the outer edge of the printing paper; then, with a chisel, make a shallow sloping cut towards and into the incision from within the block. Leave a gap of 2–3 in. (50–75 mm) between the notches and the edge of the impression for the margins. Usually, a channel of wood is cleared away all round the printing area, the notches being cut into the remaining outer border. The printing paper must be pre-cut exactly to size, so that two edges of each sheet fit perfectly into the depressed notches.

Small colour prints can be registered with reasonable accuracy by positioning them on each block with two needles which fit through the print into minute holes drilled close to two edges or at two diagonally opposite corners of the block. The needles should be fairly long and fitted for convenience into wooden handles, rather like etching needles. Register the position of the holes in the first block by inserting the needles through the first proof while it is still on the inked surface. Transfer this proof to the second block, offsetting the impression in the usual manner, and drill new holes. Repeat the positioning and drilling until all blocks are marked in exactly the same place.

The most awkward part of this process is lowering the print on to the inked surface. Insert the needles through the print and into

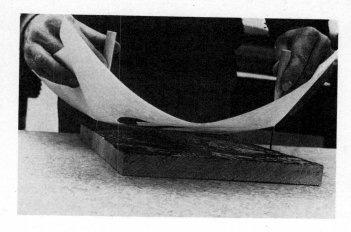

Registering the colour print
using needles inserted into
previously drilled holes in the
block. The needles shown here,
for clarity, are thicker than those
which would normally be used.

the block itself before the print actually touches the ink. The paper
should be held flat and fairly taut and then released gently on to
the block: do not let it flop loosely down, and avoid making
further adjustments after it has touched the inked surface.

COLOUR PROOFING

The final state in which the edition is to be printed is normally
arrived at only after a period of 'trial and error' printing known as
colour proofing. The usual approach is to work initially from a
colour rough made on white paper with drawing inks, water-
colour paints, gouache or crayons. But effects obtained with such
materials bear little relation to those achieved with printing inks;
they serve only as a means of working out and indicating a general
colour scheme. The real work takes place during the mixing of the
inks on the slab, rolling out on to the block and printing from the
relief surface on to the paper, and when colours are printed next
to each other or overprinted on to each other. At no stage in the
development of the print is an empirical approach more essential.
Practical experience with oil painting and a knowledge of colour
theory can certainly help, but the behaviour of coloured inks is not
something one can accurately predict, even with considerable
experience of other printmaking techniques.

Each block, with its particular relief shape or shapes, is assigned a
colour according to the drawing or plan; but these colours should
not be worked out in isolation. Since each has a part to play in the
whole scheme, each must be carefully considered in relation to all
others. Deciding the best order of printing is crucial. As a rule, the
greater the number of separate blocks or different colours used, the
more complex the colour relationships, although sheer quantity of
blocks and colours is no guarantee that the final printed state will
be correspondingly rich or subtle. Multi-block printing, especially
with oil-based inks, is rarely successful with more than three or
four blocks. Always try to limit the number of blocks and colours
to the minimum required to achieve the desired effect.

There are no golden rules to follow when printing with coloured inks, but there are a few general points regarding coloured oil-based printing inks that may be worth bearing in mind when colour proofing. To begin with, the tradition of always printing the lighter colours first can be largely disregarded. Light colours can be printed first, but in some cases, for example when overprinting with the more transparent colours, it is often necessary to print the dark colours first: the order depends entirely on one's concept of the final printed state. Printing dark on light and light on dark should be tried out whenever possible. It will soon become apparent that some colours are naturally more transparent than others, and that no single colour is completely opaque. The more transparent a colour, the more vulnerable it is to other colours during overprinting. To compare the degree of transparency of two colours, simply print one on top of the other, then reverse the order. The resultant colour can vary considerably: a green made by printing yellow over blue will no doubt be quite different from that made by printing blue over yellow, and the same will be true of the purples made by printing red over blue and then blue over red. Even black ink can be quite noticeably affected when printed over another colour; a black printed on to a red, for example, will usually produce a rich, warm black, darker even than the original black. Although key blocks in a black or dark outline are traditionally printed first, they may also be printed last, on top of a number of coloured areas. The order here is determined by such factors as the tonal importance of the black line, for it may be that certain heavy or semi-opaque colours printed over the black line will effectively obscure its importance as drawing.

It is often necessary to use quite generous amounts of transparent white to increase the transparency of a particular colour (see also inks, p. 113). Colours which are already transparent, such as lemon yellow, obviously need only the minimum amount, if any.

The colour of the printing paper is also an important consideration when overprinting. Printing on to off-white, cream, pale green or grey paper is bound to affect the density, brightness and transparency of the colours. It may, in fact, be a dominant feature of the print, affecting the atmosphere and unity of the work. There is not much point colour proofing on to white paper if the edition is to be printed on a pale grey paper; develop the later proofs, at least, using the actual edition paper.

White is generally among the most opaque of all the printing inks, and a certain amount of white mixed with a coloured ink is almost bound to increase the opacity of that colour. Used by itself, white ink has considerable covering power. Its opacity is therefore another factor to consider when overprinting. Pale, semi-opaque colours containing white can be extremely effective when printed over dark colours.

The other major factor is whether to print 'wet on wet' or 'wet on dry' ink. A light colour will tend to print more successfully on to an area of dark colour if the latter is reasonably dry; in fact, most colours print more successfully on to colours that are touch-dry or perhaps tacky. Most inks are touch-dry in a few hours, but some will need to be left for a few days before they are dry enough,

depending on such factors as the thickness or viscosity of the ink, the absorbency of the paper, or the room temperature. Printing 'wet on wet', on the other hand, is advisable when working with two rather similar colours. The main drawback when overprinting before the first colour has dried is that the block, rather than depositing ink, is inclined to pick up ink from the wet print – more so if the print contains large areas of inked surface. Usually, though, the second colour can be printed directly on to the first because the remaining clean paper absorbs a certain amount of the oil. This will apply even more if the second colour is a darker, heavier colour than the first. The third and all subsequent colours should not normally be printed until the print is touch-dry, to prevent 'picking up'.

Printing on to ink that has dried thoroughly after having been left for too long can result in the new, fresh ink refusing to 'take' on the drier ink. Colours overprinted on a dry, hard layer of ink are often characterized by a shiny appearance; as the layers of overprinted ink increase, so the surface becomes even glossier. This is one of the main disadvantages with commercial oil-based inks. Some printmakers add artist's oil paints and a few drops of turpentine to the ink to help reduce the unpleasant shine. Avoid applying an excessively thick layer of ink to the surface of the blocks: thin, smooth layers are far more suitable for overprinting, and are less inclined to build up into a glossy, opaque surface.

Always mix an adequate supply of each colour during the proofing. Once the individual colours have been decided upon and the correct printing order established, put aside a small quantity of each colour. This should be carefully wrapped, labelled or numbered for reference, and accompanied by a list of the colours, as well as the proportion of transparent white, if any, that made up the mixture – in other words, a recipe. A sample of each colour, plus information on its composition, is essential if large amounts of exactly the same colour are to be mixed for the edition.

The ink samples can be kept in small packets made of a non-absorbent paper such as tracing paper or thin cellophane. These should be folded and bound with a rubber band so that although the ink is sealed in enough air leaks in to harden the edges, thus preserving the main body of ink in a workable state. Carefully wrapped, inks should last in a good condition for up to two years. They can also be kept in jars or tins, covered with a little water to prevent skin forming, but this is a less convenient method. A chart containing a solid area of each colour applied directly to the paper with a roller might also prove useful when mixing more ink for the edition.

To match the fresh colour with the samples, mix the ink according to the formula, roll it on to the slab and offset, by thumb pressure, on to a sheet of printing paper. Compare this with the original ink (cut off a corner of the sample packet and squeeze a little ink on to the slab), and also with a solid area of the colour on the proof. In order to isolate the colour so that an accurate comparison can be made, mask off all but a small area of the colour on the proof with white paper, then compare this with a similarly isolated area on the test paper.

Once an acceptable colour proof has been achieved and sufficient quantities of the colours mixed, the edition is made in one of two ways. Each block can be printed on to all the prints in turn – first all the red shapes of the first block, then, when these are ready for overprinting, the blue shapes of the second block, and so on. This may take several days, of course, or even a couple of weeks, depending on the printing methods. The obvious risk with this approach is that a number of prints of each colour are almost certain to be spoiled during printing, thereby reducing the total number suitable for the edition. Extra prints can be taken to allow for misprinting, but this is even more time-consuming.

The other method is to complete the printing in stages, producing batches of, say, six to ten during a single printing session and completing the entire edition later on if and when the prints are required.

Most students working in college departments or group workshops will find that their approach is conditioned by such factors as the availability of the printing press. The independent printmaker with a press of his own has more freedom of choice. The alternative is to hand over the work to someone else, but few printmakers can afford to do this, nor are there many 'printers' able or willing to take on this sort of work, especially with complex relief prints.

DRYING THE PRINTS

Relief prints are normally dried by hanging them from a wooden rack or frame suspended from the ceiling; they are not normally dried and flattened under boards, like intaglio prints. Hanging racks are easily made with strips of wood, to which are fastened rows of cup hooks and metal clips to hold each print. Ball-clip racks in single lengths, moderately cheap and extremely practical, are available in the UK from a number of dealers in printmaking equipment. Ideally, racks should be hung just low enough to reach, but above or away from the main working area so as not to take up valuable space. They are even more useful if they can be lowered and raised with a rope and pulley device.

One of the simplest and cheapest ways to hang up a number of wet prints is to clip them to a taut wire, perhaps stretched between two walls, with metal clips. A single wire is adequate for small prints, which require only one clip; larger prints can be hung from two parallel wires about 18 in. (45 cm) apart. The simplest idea of all is to hang the prints from a nylon clothes line with wooden or plastic clothes pegs (spring-loaded clothes pins).

Other home-made drying racks include various 'shelf' types, built from metal shelving (e.g. Dexion) or 2 in. × 1 in. (50 mm × 25 mm) timber, containing numerous open shelves or flat boards on which the wet prints are placed. Since most of these racks are made to stand on the floor, they naturally take up more room, but with a bit of ingenuity they can be made to fold up against a wall when not in use.

By far the most efficient and convenient type of folding or movable drying rack is the commercial screen-printing rack, commonly used in the trade and now fairly common in the screen-printing sections of most college printmaking departments. These can be made of lightweight wood strips, but they are more frequently made of metal with wire mesh shelves or trays. The latter are expensive, but ideal for large numbers of relief prints.

Whichever method is used for drying prints, the whole point is to separate them so that they do not come into contact with each other; nor should the inked surface come into contact with anything else. They should be stacked so that air (but preferably not dust) can circulate around them.

Some printmakers tape their prints to flat boards with gummed tape to prevent cockling. The edges are trimmed later. Use this method only if the prints have been made on thick damp paper; if possible, avoid taping any prints, and never tape prints made on dry paper.

NUMBERING AND SIGNING THE EDITION

The generally accepted way to number a print which is one of a strictly limited edition is to indicate the order of printing and the total number of prints in the edition, one over the other, e.g. 1/25, 2/25 and so on up to 25/25. The numbers are written with a medium pencil and are usually positioned in the lower margin of the print, immediately below the impression or plate mark, at the left-hand side.

The title is placed in the centre of the lower margin and the artist's signature, followed by the date, at the far right. There are, in fact, several variations, but this conventional sequence is still widely used by the majority of printmakers. The numbering of prints does not mean that there is any greater value attached to the low numbers; it merely records the order of printing.

A signature on the print means that the artist has approved of its quality and authenticity; it does not necessarily mean that he has printed it himself. If the signature is printed, having been cut into the block by the artist, it is not an autograph in the accepted sense and does not mean that the artist has made, approved, or even seen the print.

The artist is normally entitled to retain 10 per cent of the total number of prints in the edition as his own proofs. These should be marked 'artist's proof' and numbered separately, either by Roman numerals, e.g. I/V, II/V, III/V or by letters, to distinguish them from prints in the edition. Artist's proofs are not the same as 'states' or working proofs, but are identical with the prints that make up the edition.

A working proof is usually one of the trial and error impressions made during the development of the blocks and the final printed state. It may lack some of the later work; on the other hand, it may contain work that has subsequently been erased, or it may have been printed in a slightly or entirely different colour scheme. These are marked as 'working proofs' and numbered accordingly.

Occasionally the artist may be asked to print a second edition. Normally, when the complete edition has been made, the blocks are deliberately defaced or cancelled by cutting, scratching or scoring across them. No further prints can then be made without the cancellation marks showing. Impressions that have been made from old, reworked or cancelled plates are generally referred to as 'restrikes'; for obvious reasons, these do not occur much in contemporary printmaking. If, however, the artist plans a second edition, cancellation is deferred and the blocks reprinted, more often than not after minor alterations or 'improvements' have been made, such as changes to the colour scheme. A second edition should always be described as such on each print as well as being numbered, titled, signed and dated in the normal way.

Most printmakers keep a notebook in which they record the facts and figures regarding the production, distribution, and sales of prints, for example the edition number of each print sold, its price, and the name and address of the gallery, dealer or buyer.

Below: Page decoration by Vanessa Bell (1879–1961).

Further reading

I TECHNICAL

BANISTER, Manley: *Prints from Linoblocks and Woodcuts*. Sterling Publishing, New York, and Oak Tree Press, London, 1968.

BIGGS, John R.: *Woodcuts*. Blandford Press, London, and Copp, Toronto, 1958.

BRUNNER, Felix: *A Handbook of Graphic Reproduction Processes*. Hastings House, New York, and Alec Tiranti, London, 1962.

BUCKLAND-WRIGHT, John: *Etching and Engraving*. Studio Publications, London, 1953; Dover, New York, 1973.

DANIELS, Harvey: *Printmaking*. Hamlyn, London, 1971; Viking Press, New York, 1972.

GREEN, Peter: *Introducing Surface Printing*. Watson-Guptill, New York, 1967.

GROSS, Anthony: *Etching, Engraving and Intaglio Printing*. Oxford University Press, London and New York, 1970.

HAYTER, S. W.: *New Ways of Gravure*. Oxford University Press, London and New York, 1966 (2nd ed.).

HELLER, Jules: *Printmaking Today*. Pitman, London, 1959; University of Southern California, 1971 (rev. ed.).

NEWICK, John: *Making Colour Prints*. Dryad Press, Leicester, 1964.

NEWMAN, Thelma R.: *Plastics as an Art Form*. Pitman, London, 1964; Chilton, Radnor, Pa., 1969.

PETERDI, Gabor: *Printmaking*. Macmillan, New York, 1971.

RASMUSEN, Henry: *Printmaking with Monotype: a Guide to Transfer Techniques*. Pitman, London, and Chilton, Radnor, Pa., 1961.

ROBERTSON, Ronald: *Contemporary Printmaking in Japan*. Crown, New York, 1965.

ROSS and ROMANO: *The Complete Printmaker*. The Free Press, New York, and Collier-Macmillan, London, 1972.

ROTHENSTEIN, Michael: *Linocuts and Woodcuts*. Studio Vista, London, 1962; Watson-Guptill, New York, 1963.

— *Frontiers of Printmaking*. Studio Vista, London, and Reinhold, New York, 1966.

— *Relief Printing*. Studio Vista, London, and Watson-Guptill, New York, 1970.

RUSS, Stephen (ed.): *A Complete Guide to Printmaking*. Thomas Nelson, London, and Viking Press, New York, 1975.

WOODS, Gerald: *Introducing Woodcuts*. Batsford, London, 1968.

YOSHIDA, Toshi, and Rei YUKI: *Japanese Printmaking, a handbook of traditional and modern techniques*. Tuttle Co., Rutland, Vermont and Tokyo, 1966.

II THE JAPANESE COLOUR PRINT (HISTORICAL)

BINYON and SEXTON: *Japanese Colour Prints*. Boston Book and Art Shop, Boston, Mass., and Faber, London, 1960.

BROWN, Louise Norton: *Block Printing and Book Illustration in Japan*. Routledge, London, and Dutton, New York, 1924.

CRIGHTON, R. A.: *The Floating World: Japanese Popular Prints, 1700–1900*. Victoria and Albert Museum, London, 1973.

HILLIER, J.: *Utamaro*. Phaidon, London, and Doubleday, New York, 1961.

MICHENER, James: *The Floating World*. Random House, New York, 1954; Secker & Warburg, London, 1955.

RUFFY, Arthur W.: *Japanese Colour Prints*. Victoria and Albert Museum, London, 1952.

STERN, H. P.: *Master Prints of Japan – Ukiyo-e Hanga*. Abrams, New York, 1969.

STRANGE, E. F.: *The Colour Prints of Hiroshige*. Cassell, London, 1925; Stokes, New York, 1926.

— *Japanese Colour Prints*. Victoria and Albert Museum, London, 1931.

TAKAHASHI, Seiichiro: *Traditional Woodblock Prints of Japan*. Weatherhill, New York and Tokyo, 1972.

TURK, F. A.: *The Prints of Japan*. Arco Publications, New York and London, 1966.

III GENERAL

BLAKEMORE, Frances: *Who's Who in Modern Japanese Prints*. Weatherhill, New York and Tokyo, 1975.

BLAND, David: *A History of Book Illustration*. Faber, London, 1958; University of California Press, 1969.

CLEAVER, James: *A History of Graphic Art*. Greenwood, New York, and Peter Owen, London, 1963.

DUBE-HEYNIG, Annemarie: *Kirchner: His Graphic Art*. New York Graphic Society, 1961.

EICHENBERG, Fritz (ed.): *Artist's Proof* (magazine and annual). Pratt Graphic Art Center, New York, 1961–

GEISER, Bernhard: *Pablo Picasso: Fifty-five years of his graphic work*. Abrams, New York, 1955; Thames and Hudson, London, 1966.

GESNER, Konrad: *Curious Woodcuts of Fanciful and Real Beasts*. Dover, New York, 1971.

GREEN, John Barcham: *Papermaking by Hand*. Maidstone, 1967.

HAYTER, S. W.: *About Prints*. Oxford University Press, London and New York, 1962.

HIND, Arthur M.: *An Introduction to the History of Woodcut*. Houghton, Boston, Mass., and Constable, London, 1935; reprinted by Dover, New York, 1963.

HOLBEIN, Hans (facsimile): *The Dance of Death*. Dover, New York, 1971.

IVINS, William M.: *How Prints Look*. Metropolitan Museum, New York, 1943.

— *Prints and Visual Communication*. Routledge, London, 1953; Da Capo, New York, 1969.

KNAPPE, Karl-Adolf: *Dürer: Complete Engravings, Etchings and Woodcuts.* Thames and Hudson, London, and Abrams, New York, 1965.

KURTH, W. (ed.): *The Complete Woodcuts of Albrecht Dürer.* Foyle, London, 1927; Dover, New York, 1963.

McMURTRIE, D. C.: *The Book: The Story of Printing and Bookmaking.* Oxford University Press, London and New York, 1943.

MAYOR, A. Hyatt: *Prints and People.* Metropolitan Museum, New York, 1971.

NAGEL, Otto: *Käthe Kollwitz.* Studio Vista, London, 1971.

PANOFSKY, Erwin: *Albrecht Dürer.* Princeton University Press, 1943; Oxford University Press, London, 1945.

ROGER-MARX, Claude: *Graphic Art of the Nineteenth Century.* McGraw-Hill, New York, 1962; Thames and Hudson, London, 1963.

SOTRIFER, Kristian: *Printmaking: History and Technique.* Thames and Hudson, London, and McGraw-Hill, New York, 1968.

STRAUSS, Walter L.: *Chiaroscuro.* Thames and Hudson, London, and New York Graphic Society, 1973.

STUBBE, Wolfe: *A History of Modern Graphic Art.* Thames and Hudson, London, 1963. Published in US as *Graphic Arts in the Twentieth Century.* Praeger, New York, 1963.

WECHSLER, Herman J.: *Great Prints and Printmakers.* Thames and Hudson, London, and Abrams, New York, 1967.

WOLFFLIN, Heinrich: *The Art of Albrecht Dürer.* Phaidon, London and New York, 1971.

ZIGROSSER, Carl: *The Book of Fine Prints.* Crown, New York, and Peter Owen, London, 1956.

ZIGROSSER, Carl, and Christa M. GAEHDE: *A Guide to the Collecting and Care of Original Prints.* Crown, New York, 1965; Arco, London, 1966.

Glossary

ACID RESIST An acid-proof substance, normally in liquid form (e.g. stopping-out varnish), applied as a protective coating to the back and relief surface of a metal plate before etching.

BAREN Normally, a circular pad about 5 inches in diameter, used by Japanese relief printmakers for burnishing. The traditional version is made of bamboo fibres.

BENCH HOOK A device used by printmakers to steady the woodblock during the cutting, consisting of a wooden base-board with a strip of wood along the top edge to hold the block in place and another underneath to hook the board against the workbench.

BENI-E A form of early Japanese colour print in which the colour – a soft pinkish-red (*beni*) – was applied by hand; mainly produced after 1715.

BENIZURI-E A stage (*c.* 1740–70) in the development of the Japanese colour print in which two colours (usually pink and green, sometimes yellow or blue) were printed from blocks.

BURIN See graver.

BURNISHER Small hand tool, usually of steel or bone, round in section, slightly flattened and highly polished at one end, used for smoothing rough areas on intaglio or relief-etched plates; can serve as a baren.

BURNISHING Manual printing technique which involves rubbing the reverse side of the printing paper, placed over the inked relief surface, with a baren or similar smooth, rounded object.

BUROSHI Japanese term for a brush with a short, flat handle and horse-hair bristles, used for applying pigment to the larger areas of a woodblock or for initial dampening of the wood.

CHASE A rectangular metal tray or frame into which the composed type forme (or woodblock) and furniture are locked; the whole forme is then placed on the bed of the press for printing.

CHIAROSCURO WOODCUT A method of printing from one or more woodblocks in two or more colours or tones, used chiefly by 16th- and 17th-century printmakers to imitate the effect of a wash drawing.

COLLOGRAPH Print made in both intaglio and relief, usually in several colours, taken from a plate or block with a complex surface built up from assembled materials; a comparatively recent development, chiefly in the USA.

What about H Moore's work in the
Thirties Forties (

Japanese term for a liquid size made from animal glue and alum diluted with water; used mainly for sizing absorbent papers. — DOSA

A limited set of identical prints taken from a worked block or plate in its final state; this is then 'cancelled', for instance by scoring a line across it, to prevent further printing. — EDITION

A block of hardwood sawn across the grain, used for wood engraving. — END-GRAIN BLOCK

The act of incising lines or dots into a hard surface with a sharp, finely pointed steel tool. Where the printed image is obtained by filling the lines with ink and impressing these on to paper, the process is referred to as intaglio (e.g. copper engraving); where the image is obtained by rolling up the relief surface with ink, leaving the incised lines to print white, it is known as relief printing (e.g. wood engraving). — ENGRAVING

The process of corroding lines, shapes and textures into a sheet of metal – usually zinc or copper – with a solution of acid. — ETCHING

Generally, the visible surface pattern on a piece of timber; not the grain. — FIGURE

A term used in etching to describe the accidental corrosion of the protected parts of a metal plate, especially through a thin or faulty layer of protective wax or varnish. — FOUL BITING

A sheet of thin, tough paper stretched over the tympan (normally the outer frame of a double tympan) from which a shape is cut to correspond exactly with the shape of the woodblock or printing surface; it holds the printing paper in place and protects the margins. — FRISKET

A burnishing implement, normally the cloth pad stuffed with wool used before the invention of printing presses. — FROTTON

Pieces of wood or sometimes metal, usually less than type-high, used to fill in the spaces round the type forme or woodblock when it is locked into a chase. — FURNITURE

Printing from an uninked relief or intaglio block, relying on the embossed effect produced on the paper. Also known as 'blind printing'. — GAUFFRAGE

A paste-like substance compounded of an inert pigment, such as plaster of Paris or chalk, and glue. — GESSO

A small woodcutting or carving tool, rather like a chisel, with a curved or 'V' shaped cutting edge. — GOUGE

A term often used loosely to describe the appearance of wood; correctly, the direction of the fibres relative to the axis of the longitudinal surface of a piece of timber. Grain may therefore be straight, diagonal, spiral, irregular, interlocked, wavy, etc. — GRAIN

The basic engraving tool, consisting of a steel blade, square or lozenge-shaped in section, set into a small half-round wooden handle. The cutting point is normally set back at a steep angle (45–60° for metal, 30–45° for wood). — GRAVER

HP	Abbreviation for 'hot pressed', the smoothest of the hand-made papers, whose slightly glazed surface is produced by pressing the dry paper, interleaved with hot, polished zinc plates, between rollers under high pressure.
IMPRESSION	A mark, image or design printed on to a sheet of paper from the inked or uninked surface of a worked plate or block, either relief or intaglio.
INK BALL	A smooth round leather or felt pad, fastened around a wooden handle, commonly used by early pressmen for applying ink to type and woodblocks.
INTAGLIO PRINTING	See engraving.
KEY BLOCK	Usually, the black outline or master block from which all subsequent colour blocks are registered.
LAID	A term used to describe paper (machine- or hand-made) which, when held to the light, shows a series of closely laid parallel lines with stronger and more widely spaced lines running at right-angles.
LINTERS	Cotton fibre, a basic raw material used in the manufacture of hand-made papers.
LOCKING UP	Locking the type forme or woodblock into the chase with quoins and furniture before printing on a press.
MAKE-READY	A paper overlay placed on the block or plate during printing in order to bring increased pressure on to specific areas, thus obtaining a clearer, darker or more varied printed impression.
METAL GRAPHIC	A collage or assemblage of pieces of metal (wire, tin, industrial waste) usually printed intaglio, sometimes intaglio and relief simultaneously; mainly developed by the Norwegian printmaker Rolf Nesch during the 1930s.
MONOGRAPHIC	A single or 'one-off' print taken from a worked plate or block from which it is possible to take duplicate prints.
MONOPRINT	A 'one-off' printed effect that cannot be repeated, usually transferred on to paper from a drawing made with ink or paint on a non-absorbent surface.
MONOTYPE	See monoprint.
NISHIKI-E	Japanese term for the true polychrome print developed about 1765, in which all the colours are printed from blocks. Also known as 'brocade prints'.
NOT	A technical term for hand-made paper which has not been hot pressed or glazed.
OFFSETTING	A method used to transfer a printed impression taken from one surface on to another, usually with a roller.
OTSU-E	Japanese term for the brush drawings on paper sold in large numbers in the 17th century before the development of the polychrome print.

Imperfect sheets of hand-made paper, more seriously spoiled than retree, sold cheaply for proofing or cutting into small 'good' sheets.	OUTSIDES
Wood sawn parallel to the grain, used in woodcut printmaking.	PLANKWOOD
Process involving printing from an entirely flat surface, e.g. lithography, screen printing.	PLANOGRAPHIC PROCESS
The imprint made on a sheet of damp, soft paper by the outer edges of a metal plate when printed with a press.	PLATE MARK
A small wooden peg or wedge inserted into a hole which has been cut into the surface of a woodblock to erase a mistake.	PLUG
(e.g. Albion, Columbian) An older form of relief printing press consisting of a travelling bed, on which the relief block is placed, and a heavy iron plate which is lowered on to it and pressed firmly down with a lever.	PRINTING PRESS: PLATEN
(e.g. Vandercook) A press consisting of a flat metal bed, on which the relief block is placed, and a roller (or cylinder) which travels over it. Also known as flat-bed or letterpress proofing press.	CYLINDER
A press consisting of a heavy, flat metal bed, on which the plate or block is placed, driven between two heavy rollers. Also known as copperplate or intaglio press.	ETCHING
A finished print identical with those forming the numbered edition; one of a number (between 5 and 10 per cent of the edition) retained by the artist and numbered separately.	PROOF: ARTIST'S
A printed impression recording a specific stage in the development of the print (usually an etching, rarely a woodcut).	STATE
A printed impression taken from an unfinished block or plate, normally worked on with pencil or crayon before any further cutting is carried out.	WORKING
A wooden base-board edged with strips of wood to hold the woodblock in place for registration purposes.	REGISTER FRAME
Ensuring the correct alignment of each plate, block, screen etc. when printing in several colours on to a single sheet of paper.	REGISTRATION
Printing from the upper or raised surface of a worked block or plate.	RELIEF PRINTING
Slightly imperfect sheet of hand-made paper. See also 'outsides'. Both terms have largely been replaced by the simpler classification 'seconds'.	RETREE
Applying a layer of ink to the relief surface with a roller.	ROLLING UP
Small steel hand tool, triangular in section, with hollow-ground sides and sharp edges tapering to a point; used in etching and engraving for removing burr and for making corrections or scraped effects; occasionally employed in woodcut for hollowing out or scraping down the surface of a block.	SCRAPER
A fine sharpening stone, usually with tapered or rounded edges for removing burr from the inside edges of hollow-ground tools.	SLIP-STONE
See acid resist.	STOPPING-OUT VARNISH

SUMI	Japanese term for a cake or stick of black ink made from carbon.
TAN-E	A form of early Japanese colour print in which the colours were applied by hand; also known as 'vermilion prints' because of the predominant colour used.
TE-BAKE	Japanese term for a brush with a long straight handle, made of ox-, pig- or horse-hair, used for applying pigment to small areas on the block.
TEXTURE	A term often used in an aesthetic sense to describe the feel, or even the appearance, of a wood surface; correctly used, it refers to the prevailing size of the cell cavities, ranging from very fine to very coarse according to the species of wood.
TINTING MEDIUM	A colourless ink used to diminish the strength of an ink, or to make transparent tints without excessively reducing the consistency.
TYMPAN	A metal frame covered with a taut sheet of vellum, linen, canvas etc., fixed along one edge of the bed of a printing press (usually a platen press) so that it can be lowered on to the relief block to hold the printing paper in place. A *double tympan* has a second frame attached to the first in such a way that it can be folded in, enclosing frisket and printing paper.
TYPE HEIGHT	The traditional height of type used in letterpress printing, 0·918 in. (23·3 mm).
UKIYO-E	Paintings or prints of the Edo period, generally referred to as the Floating or Passing World school.
URISHI-E	A form of early Japanese print characterized by the varnish-like glossy black ink used; sometimes printed with a metallic surface. Also known as 'lacquer prints'.
'v' TOOL	A 'V' shaped gouge, also known as a scrive or veiner.
WA-SHI	Japanese papers produced by the traditional hand-made method.
WATERLEAF PAPER	Unsized hand-made paper.
WOVE	Term used to describe paper (machine- or hand-made) having a characterless, even structure without any impressed translucent mark.

Appendix: Suppliers of materials

A number of suppliers listed in recent books on printmaking are no longer in business. Also, a number of the larger firms have actually asked to be omitted from lists; others have ignored enquiries. It can therefore be assumed that the latter either no longer exist or no longer supply printmaking materials; or it may be that they are simply not interested in being listed as direct suppliers for what are invariably small individual orders.

Although several of the firms that are listed here operate as retail shops, many are wholesale or deal only with written orders, and may also require a minimum order. It would be advisable to write to these firms asking for information on range of stock and a current price list, and to check whether or not a minimum order is required.

Most of the basic tools for woodcut and lino cut – knives, gouges, mallets etc. – are, of course, obtainable from general hardware stores or tool shops; plankwood and plywood are readily available; letterpress inks are often obtainable from local firms; hand-made or fine quality papers suitable for printing can often be purchased from local suppliers of artists' materials, who occasionally also stock Japanese papers.

UK

Ault & Wiborg Ltd, 71 Standen Road, London SW18
Rollers and printing inks.

Barcham Green & Co. Ltd, Hayle Mill, Maidstone, Kent ME15 6XQ
Hand-made papers (also obtainable from agents: Falkiner Fine Papers Ltd, London; Paperworks Gallery, Vancouver; Andrews / Nelson / Whitehead, New York).

Berol Ltd, Northway House, High Road, London N20 9LP
Water-based and emulsion printing inks.

Buck & Ryan Ltd, 101 Tottenham Court Road, London W1
General tools.

Coates Brothers Inks Ltd, Grape Street, Leeds LS10 1DN
Letterpress printing inks (small orders usually supplied from branch factories or local agents).

Croda Inks Ltd, 170 Glasgow Road, Edinburgh EH12 9BE
Letterpress printing inks.

Dryad, Northgates, Leicester LE1 4QR
Caslon printing press (max. block size 11½ in. × 9 in.); printmaking materials (inks, papers, tools) for lino cutting; woodwork tools suitable for woodcut (knives, gouges, mallets, clamps, saws etc.).

Essex Printers' Supply Co., Elektron Works, Norlington Road, Leyton, London E10 6LB
Reconditioned proofing presses and general equipment.

Falkiner Fine Papers Ltd, 4 March Street, Covent Garden, London WC2
Hand-made European and Japanese papers, mould-made and machine-made printing papers.

Fitchett and Woollacott Ltd, Willow Road, Lenton Lane, Nottingham NG7 2PR
Hardwoods, softwoods and plywoods (supplier of timber for craft work).

Hunter-Penrose Ltd, 7 Spa Road, London SE16 3QS
Etching presses and general printers' supplies (e.g. rollers); etching and engraving tools.

Inveresk Paper Company Ltd, Clan House, 19 Tudor Street, London EC4Y OBA
T. H. Saunders drawing and watercolour papers (mainly dealt with by agents: T. N. Lawrence; R. K. Burt, 37 Union Street, London SE1; Paper Point).

Knight Machinery Ltd, Knight Printplant, Secondhand and rebuilt printing press unit, Westland Road, Leeds LS11 5XN
Secondhand and rebuilt letterpress proofing presses.

T. N. Lawrence & Son Ltd, 2 Bleeding Heart Yard, Greville Street, Hatton Garden, London EC1
Tools and materials for woodcutting and lino cutting; hand-made papers, European and Japanese.

Milthorp International Ltd, Monckton Road, Wakefield, West Yorkshire WF2 7AL
Secondhand and rebuilt proofing presses.

Paper Point (Wiggins Teape Ltd), 63 Poland Street, London W1V 3VF
Fine quality printing papers, chiefly machine-made.

A. A. Reckner & Co., 68 Newington Causeway, London SE1
Hand-made papers (supplies running out – mould-made papers only to be stocked when supplies exhausted) and various printing and drawing papers.

Sansom Brothers (London) Ltd, Howley Park Estate, Morley, Leeds LS27 0QT
Mainly lithographic materials, but also letterpress inks.

Alec Tiranti Ltd, 70 High Street, Theale, nr Reading, Berkshire (London shop at 21 Goodge Place, W.1)
Woodcutting tools.

E. C. Young, P.O. Box 118, Carpenters Road, Stratford, London E15 2DY
Specialist in timbers for the craftsman.

USA

Aiko, 714 North Wabash, Chicago, IL.
Japanese papers and tools.

Glen Alps, 6523 40th Avenue N.E., Seattle, WA. 98115
Etching presses suitable for relief printing from type-high woodblocks.

American–French Tool Co., Route 117, Coventry, R.I. 02816
Etching presses suitable for relief printing from type-high woodblocks.

American Printing Equipment and Supply Co., 42–25 Ninth Street, Long Island City, N.Y. 11101
Graphic arts equipment and supplies: proofing presses, tools etc.

Andrews / Nelson / Whitehead, 31–10 48th Avenue, Long Island City, N.Y. 11101
Leading US supplier of fine papers for printmaking (smaller orders generally dealt with by numerous retail dealers).

Apex Printers' Rollers Co., 1541 North 16th Street, St Louis, MO. 63106
Rollers (brayers) for all kinds of printmaking.

Fezandie & Sperrle, Inc., 103 Lafayette Street, New York, N.Y. 10013
Colour pigments for making printing inks.

Fine Art Materials, Inc., 539 LaGuardia Place, New York, N.Y. 10012
General printmaking materials (papers – agent for Andrews/Nelson/Whitehead, tools etc.).

Graphic Chemical & Ink Co., P.O. Box 27, 728 North Yale Avenue, Villa Park, IL. 60181
Extensive range of printmaking materials (papers, tools, inks, rollers etc.); printing presses suitable for relief printing.

J. Johnson Co., 33 Matinecock Avenue, Port Wash, N.Y. 11650
Tools, inks, rollers, papers.

Jomac Inc., 863 Easton Road, Warrington, PA. 18976
Rollers (brayers) for letterpress or relief printing.

Martech Etching Presses Ltd, P.O. Box 504, Bayside, N.Y. 11361
Etching presses suitable for relief printing from type-high woodblocks.

M & M of Madison, 402 Hilldale Court, Madison, WI. 53705
Etching presses suitable for type-high woodblocks (enquiries to John McFee, 402 Hilldale Court, Madison; and to Professor Dean J. Meeker, University of Wisconsin Art Department).

Edward C. Muller, 3646 White Plains Road, Bronx, N.Y. 10467
Complete range of woodcutting and engraving tools.

Rembrandt Graphic Arts Co. Inc., The Cane Farm, Rosemont, N.J. 08556
Extensive range of printmaking materials (papers, tools, inks, rollers etc.); printing presses suitable for relief printing.

The Sander Wood Engraving Co., Inc., 212 Lincoln Street, Porter, IN. 46304
Complete range of woodcut and wood engraving tools and materials.

Sculpture Associates Ltd, 114 East 25th Street, New York, N.Y. 10010
Complete range of tools and equipment for woodcutting.

Vickers Engineering, Box 334, Red Arrow Highway, Harbert, MI. 49115
Etching presses suitable for relief printing from type-high woodblocks. (These presses are manufactured by Vickers, but sold by William F. Crull, 150 South Lakeshore Road, Lakeside, MI. 49116.)

Yasutomo & Co., 24 California Street, San Francisco, CA. 94111
Mainly wholesale supplier of fine papers for printmaking.

Zellerbach Paper Co., 245 South Spruce Avenue, P.O. Box 2127, South San Francisco, CA. 94080
Papers for relief printmaking (serves exclusively the Western United States and the Pacific Islands).

AUSTRALIA

Oswald-Sealy (overseas) Pty Ltd, 4 George Place, Artarmon, N.S.W. 2064
Wholesale importer and distributor of artists' materials, including some printmaking materials: willing to inform artists of nearest retail stockist.

CANADA

Paperworks Gallery, 1815 West Broadway, Vancouver, B.C.
Papers for printmaking (agent for Barcham Green, UK).

Heinz Jordan & Co. Ltd, 42 Gladstone Avenue, Toronto, Ont. M6J 3K6
Main wholesale dealer for printmaking materials: handles small orders, or refers them to the appropriate retail dealer.

JAPAN

The Yoseido Gallery, 5, 5-Chome, Nishi Ginza Chuo-ku, Tokyo
Tools, barens, brushes and papers for woodblock cutting and printing.

Index

Page numbers in italics refer to illustrations